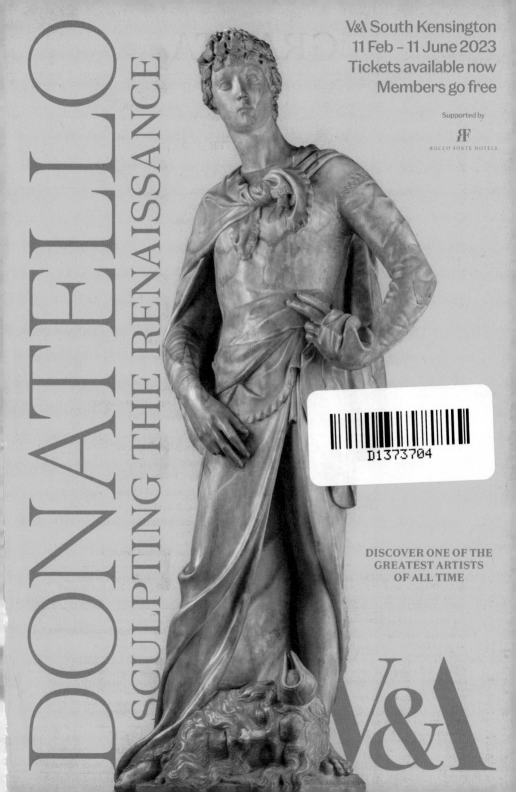

DONATELLO

SCULPTING THE RENAISSANCE

V&\ South Kensington
11 Feb – 11 June 2023
Tickets available now
Members go free

Supported by

RF
ROCCO FORTE HOTELS

DISCOVER ONE OF THE
GREATEST ARTISTS
OF ALL TIME

V&\

D1373704

GRANTA

12 Addison Avenue, London W11 4QR | email: editorial@granta.com
To subscribe visit subscribe.granta.com, or call +44 (0)1371 851873

ISSUE 162: WINTER 2023

p.115 extract from 'Refugees' by Louis MacNeice, from *Collected Poems* by Louis MacNeice, published by Faber & Faber, reproduced by permission of David Higham Associates; pp.35–40 extract from *Hôtel Casanova et autres textes brefs* by Annie Ernaux used by permission of Editions Gallimard © Editions Gallimard 2011, 2020

MIX
Paper | Supporting
responsible forestry
FSC
www.fsc.org FSC® C023419

LUND HUMPHRIES

Hot Topics in the Art World & New Directions in Contemporary Art

Censored Art Today
By Gareth Harris
£19.99 / ISBN 9781848225411
September 2022

How Not to Exclude Artist Mothers (and other parents)
By Hettie Judah
£19.99 / ISBN 9781848226128
September 2022

The Art of Activism and the Activism of Art
By Gregory Sholette
£29.99 / ISBN 9781848224414
September 2022

Memory Art in the Contemporary World: Confronting Violence in the Global South
By Andreas Huyssen
£29.99 / ISBN 9781848224223
June 2022

The Art Fair Story: A Rollercoaster Ride
By Melanie Gerlis
£19.99 / ISBN 9781848225039
December 2021

The Rise and Rise of the Private Art Museum
By Georgina Adam
£19.99 / ISBN 9781848223844
September 2021

The Culture Factory: Architecture and the Contemporary Art Museum
By Richard J. Williams
£19.99 / ISBN 9781848223974
October 2021

Biennials: The Exhibitions We Love to Hate
By Rafal Niemojewski
£19.99 / ISBN 9781848223882
March 2021

Curating Art Now
By Lilian Cameron
£19.99 / ISBN 9781848224834
June 2022

Restitution: The Return of Cultural Artefacts
By Alexander Herman
£19.99 / ISBN 9781848225367
September 2021

Decentring the Museum: Contemporary Art Institutions and Colonial Legacy
By Nina Möntmann
£29.99 / ISBN 9781848225503
June 2023

The Ends of Art Criticism
By Patricia Bickers
£19.99 / ISBN 9781848224261
May 2021

Visit www.lundhumphries.com to find out more & place your order

WORLD PREMIERE
SWAN THEATRE
STRATFORD-UPON-AVON
1 APRIL – 17 JUNE 2023

ROYAL SHAKESPEARE COMPANY AND NEAL STREET PRODUCTIONS
IN ASSOCIATION WITH HERA PICTURES

HAMNET

BY
MAGGIE O'FARRELL

ADAPTED FOR THE STAGE BY
LOLITA CHAKRABARTI

DESIGN: RSC VISUAL COMMUNICATIONS

rsc.org.uk/join

 £10 TICKETS
FOR 14-25s

The work of the RSC is supported by the Culture Recovery Fund
Hamnet is supported by RSC Production Circle members Peggy Czyzak-Dannenbaum and Marcia Whitaker
New Work at the RSC is generously supported by The Drue and H.J. Heinz II Charitable Trust

Supported using public funding by
ARTS COUNCIL
ENGLAND

CONTENTS

Introduction

Our working title for this issue was Loss, but suddenly loss was all around us, friends and colleagues disappearing, most lately Ian Jack, *Granta*'s former editor and a dear friend, who died unexpectedly in hospital in October last year. Ian was a profoundly gifted writer and editor, and he had a knack for conversation, too. I tried to commission a piece from him in June last year, but he couldn't do it, and told me so in the nicest possible way. 'Dear Ian, I understand,' I responded. 'Please don't worry. Perhaps another theme/another time. I am alright – quite low. Back in Sussex. Is the world coming to an end or was it always like this?' He responded – characteristically – with an edit of his own previous email, noting that he had described someone as scrupulously 'keen' instead of 'clean':

> Clean, not keen, in the below, though I like the idea of scrupulous enthusiasm. Yes, it's hard to look properly at the world and not think of it ending. I think that feeling now feeds a lot of human behaviour, whether we know it or not. Young people aren't fools. Fortunately I live in a cheerful household, which busies itself with the Green Party, reading groups and other good causes, which means the mood of the house isn't set by me. Praise be!

That was our last exchange.

Not Loss, but Definitive Narratives of Escape, then, words drawn (and reversed) from Roger Reeves's essay in this issue about how to tell, and how to understand, stories of slavery now. Reeves, a poet and an academic, considers the experience of reading work at a literary event taking place in a plantation house in South Carolina, and the fate of the people who once inhabited the slave cabins next to the lavish house. Photographer Rahim Fortune documents Reeves's journey, and we have placed some of those images in the text, so that Reeves seems almost to embody the ghosts of the people who once

lived there. He notices a child's fingerprint in a brick and imagines a burnt hand; he sees the bare earth whipped up by eddies of wind and thinks about what escape meant and what it took: 'And, there in the wind, in the dirt, the memory of the dead moving off into the pines behind the field. There is no definitive narrative to escaping, to freedom. It is – only is.'

This issue begins with Des Fitzgerald's profound essay, 'Reproducing Paul', about the death by suicide of his brother Paul and the birth of his own son, Paulie. In between these two events is the continuous social practice that makes culture. Fitzgerald, who studied anthropology (as I did), understands life as a series of rituals and exchanges, including the rituals that manage the transitions of the dead and the newly born, and the emerging rituals in the fertility clinic. But our rituals, perhaps, are not enough, though one senses from Fitzgerald's essay that the work of writing may be one of them, not a ritual exactly, but at least a way to organise thoughts and find language for the unsayable. I think of Keats, and the connection he made between beauty and truth. How beautiful it is, Fitzgerald's angry sadness at his brother's act, the angry sadness with his child who insists on being carried – not a baby now, but a 'dead weight' in his arms, a 'thick dense child'. The moment resolves into evening – birds calling from rooftops – and a sense of grief emerges, '. . . that slight sense of numbing shock, like a bereavement, that you sometimes get at the end of an unexpectedly hot day'. Grief is work, and carrying a child is work, and through the practice of work comes resolution: 'This is enough, I thought. Paulie, it has to be enough.'

Enough grief. Enough, enough.

'As surely as the sadness never leaves and that music / heals the night with its deeps and neon', writes Peter Gizzi in his poem 'Ecstatic Joy and Its Variants'. The poem ends: 'and in my outrage, I am immortal / because I love, I am here'.

Still here. ■

Sigrid Rausing

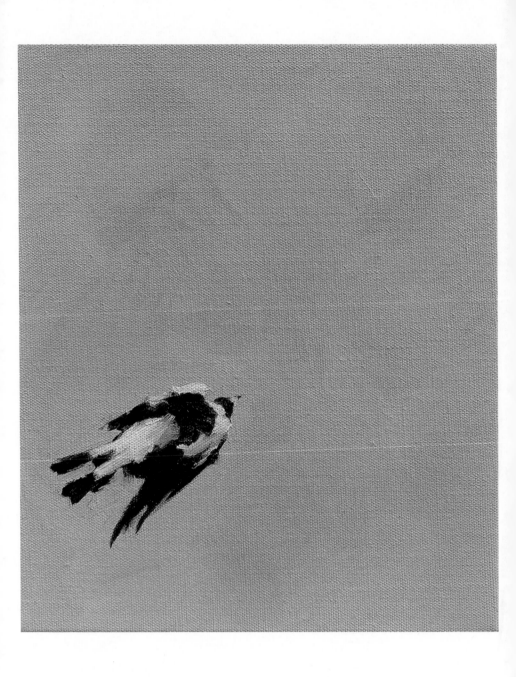

MATTHEW KENTMANN
Magpie, Garru, Messenger Bird 4, 2020
Courtesy of PIERMARQ*

REPRODUCING PAUL

Des Fitzgerald

For a year or two after my brother Paul died, my parents would see a bird – maybe a magpie or a blackbird or another well-known species – that was behaving strangely. This bird (they would report later) would seem to follow them, or would reappear a few times over the course of a day, or else it wouldn't fly away when one or both of them approached. And, half joking, they would associate the presence of this bird with the absence of their son, Paul, as if the creature was somehow also Paul, only now in bird form. This annoyed me the few times they told me about it, though I didn't really know why at the time, and I'm ashamed now of how priggish I was.

Three weeks before his twenty-third birthday, sometime after one in the morning, about two weeks after Christmas, Paul left a bar and called my phone a few times without success. After a while he sent a text message to say goodnight, and that he loved me, and that he loved our parents too. And then at some point, at the edge of the harbour, when he would have been about halfway home, he took off our father's leather jacket, folded it carefully on the ground and entered the water. How do you understand something like that through an afterlife of birds?

Thinking back, though, I'm not sure that this attention to birdlife came from a very direct belief in reincarnation on the part of my

parents. It seems more likely to me now that they were simply open to the idea that some part of a person might become present again after death; that a dead person might make themselves known, if only obliquely, and in forms that are not always predictable; that birds and cats, occasionally baby foxes, were as likely a channel as any other for such an encounter. For a while, though I would certainly not have admitted it then, I too looked with particular intensity at birds. But I never saw anything strange. After a while, my parents stopped noticing these incidents, or at least they no longer said anything to me. Maybe these acts of mediation stopped altogether. Or maybe the media themselves took on different forms. Either way, I never heard any more about it.

In an essay published in the *Année sociologique* in 1907, a young French scholar, Robert Hertz, proposed that a person's death should be thought of as a collective or social event, and not simply an individual calamity. 'When a man dies,' Hertz wrote, 'society loses in him much more than a unit; it is stricken in the very principle of its life, in the faith it has in itself.' Hertz had recently returned to Paris from London, where he had been researching a project on death rituals in the British Museum. He was trying to show that what we call 'mourning' is not really about grief or sadness. Rather it is about managing the transition of the soul to another realm, such that the missing person – and thus the social world of which they were part – might go on.

Hertz had drawn much of his evidence from writings about peoples he called the Dayak – a loose term to describe different non-Muslim Indigenous groups in Borneo. The island, including its many Indigenous groups, had been caught up in European imperialism since the mid-nineteenth century, and been made visible in the kinds of anthropological and orientalist writing that often travelled with colonisation. In an introduction to a much later translation of Hertz, the English anthropologist Rodney Needham notes that the word 'Dayak' is an invention of early Dutch 'ethnographers' and that Hertz

was likely talking about a group that Needham called the Olo Ngaju, in south-eastern Borneo. How much Hertz's description can be related to people who identify with, or are identified by others with, Dayak communities today – the term is currently used particularly in Indonesia – remains unclear.

Nonetheless, having studied these texts with some care, Hertz argued that what was at stake in the funerary practices of peoples within some Dayak communities – in the management of decomposition, the practice of double burial, the lengthy social isolation of the dead person's kin – is not a simple act of grieving or remembrance, it is rather a collective attempt to overcome, even to undo, death. He described how, among one group, the custom was to keep the coffin at home for some time, pierced at the bottom, and with a basin underneath, to catch the liquids that escape during the process of decomposition. These liquids were mixed with rice, which was then eaten by the dead person's family during the mourning period. Thus, says Hertz, 'the living incorporate into their own being the vitality and the special qualities residing in the flesh of the deceased'. After all, he reasoned, if a person is truly a social being as much as a corporeal one, then their death, which is in one sense the death of the social order itself, is literally unconscionable. 'The last word must remain with life,' Hertz argued, 'the deceased will rise from the grip of death and will return, in one form or another, to the peace of human association.'

Hertz was a pupil of Émile Durkheim, whose own study, *Suicide*, now regarded as a foundational text of European social science, had been published ten years before. By comparing patterns of suicide in different European countries, Durkheim showed that what we often imagine as the most supremely individual and psychological act – the act of self-killing – in fact follows a regular and predictable social pattern. Men are much more likely to kill themselves than women, he wrote, and divorced men even more so. Protestants are more likely than Catholics to take their own lives, as are soldiers more likely than civilians. People kill themselves in warmer rather than colder months, during economic crises and periods of upheaval,

in Denmark more than in Norway or Sweden. These findings, he argued, and their clear patterning, tell us that suicide is not a great individual reckoning with the world. It is, like everything else, a product of culture. Whatever else one might say about Durkheim, it has always struck me that there is a kind of perverse, even cruel, genius in observing that even the desire for obliteration might be part of the mundane human work of remaking the social order – in turning even a suicide into a kind of regeneration. Such, at least, are the doleful lessons of undergraduate social science: nothing belongs to you, not even your own self-destruction. No less than Durkheim, the stakes of Hertz's texts are not so much with Indigenous peoples in Borneo – here, as ever, anthropology is at best a partial guide – but are rather more to do with a group of European men, conjuring death and reproduction on the eve of catastrophe. Hertz died less than a decade after publishing his essay, at the age of thirty-three having volunteered for service in the First World War. He was one of several of Durkheim's pupils killed in that conflict, though whether Durkheim thought of this collective self-sacrifice as the mere unfolding of social order is not known. Here we are, at any rate, surrounded by war, colonisation, murder and suicide. Society, indeed, stricken in the very principle of its social life.

I first read these texts in detail about five years after Paul died. By the time I was reading them, I had left my parents' house for a small university town in the east of England, to try to become an anthropologist and begin a lifelong study of mental distress in comparative and cross-cultural contexts. I had spent the years before in a generalised torpor. At home, this had been understood and made legible as a depression, a situation that, in its treatment and narration, including by a very good psychiatrist, was not understood to have much to do with Paul – though, obviously, it had a lot to do with him. I don't mean that it came from a sense of sadness about Paul's death. This torpor came, rather, from an anger with him, even from a kind of hatred that, so many years later, could not be neatly packaged up as

grief. What a fucking idiot he had been, truly, it seemed to me. Stupid, destructive, melodramatic, *predictable* Paul.

What we call mourning is hard, says the psychoanalyst Darian Leader, 'not because we loved someone too much, as common sense might suggest, but because our hatred [is] so powerful'. This hate can turn inwards, settling into the state of self-loathing we sometimes still call melancholia. In his famous essay on mourning and melancholia, Freud suggested that there is sometimes even a kind of 'sadistic satisfaction' in continuing to produce the pain. Under conditions of melancholia, says Freud, the melancholic himself becomes a secondary figure. His true interest is in inflicting punishment on the lost object or person – the dead or departed whose absence he finds so unbearable that he has come to replace them, wholly, with himself.

I don't know. In my own case, the simple fact of departure from home – and in its own way, of reading – had had an unexpected therapeutic effect. Somewhere in deepest England, where I spent most of my time concerned with the Trobriand Islands and highland Papua New Guinea, with Azande witchcraft, and Samoan adolescence, eventually, too, with the very different ways that humans make sense of madness and death and remembrance – something began to move. I remember first encountering Hertz's story about the decomposition and the rice. There was something in that very careful and deliberate act of ingestion, its mixture of tenderness and aggression (the corpse is always, Hertz reminds us, an ambivalent and transitional object) that told me something important about what it could mean to truly mourn someone like Paul, and about what such mourning was for. It also contained a lesson – though I did not quite understand this at the time – about what such mourning might yet do.

Just before the embryo that eventually became our son, Paulie, was implanted, my wife Aoife and I were waiting, very bored, in an anteroom at a public fertility clinic – this was about fifteen years after Paul's death – and a woman approached us and introduced herself as our embryologist. She said that she had graded our embryos – these

had been growing in a dish for seven days – and the news was not great. There are four grades, she said, from A to D, for measuring the quality of an embryo. Only two of our embryos were viable in the first place, and these were both grade C. Because the chance of our now having a live birth from either of these was not so great, she was willing, if we wanted it, to transfer both embryos. However (she warned us) transferring both would increase the odds of a multiple birth, and all the extra risks that this brought. Did we want this?

About an hour later, Aoife was strapped into an inverted dental chair in the operating theatre, while I was directed by the obstetrician towards a large flat-screen television in the corner. On the screen there was an enormous, milk-grey image of two embryos, silently, but very clearly, dividing on a glass plate, pulsing at the edges of their own membranes, as if at any moment they might break free, slide their way out through the empty hospital corridors and into the rainy streets outside. 'It's okay to take a photograph,' the doctor said, though in fact I had no desire at all to take one. What could I do? I took a photograph and gave a weak thumbs up.

Then very quickly the television went off. The embryologist emerged rather suddenly and theatrically from a side room holding a thin plastic wand. She handed it to the obstetrician, who, in a single unbreaking motion, took the rod and inserted it with a very straight, deliberate movement into the centre of Aoife's body. All four of us stared at a tiny monitor that showed an image of Aoife's insides: the rod entered stage right, there was an almost imperceptible jerk back, and then the obstetrician just as quickly withdrew. On the screen a tiny white dot drifted slowly, uncertainly, into the cavernous womb, like an astronaut, I thought, abandoned by his ship. The rod returned and the consultant repeated the motion. A second dot flashed onto the screen and moved anxiously, but unstoppably, towards its sibling.

What ever happened to that second embryo? Where is the sibling of the single boy who was pulled – late, grey, shocked into silence – from Aoife's womb, more than forty weeks later? Did he disappear or was he absorbed into her body? Did he give up? Did he wither

away? This second figure, this brother embryo as I have chosen to gender him, was never mentioned again. And if such terms seem ludicrous for an entity barely visible off a glass plate – a crustacean at the end of a wand; a small blast of light in the space-womb – if there is something suspicious, maybe even a bit religious, certainly very heteronormative, about asking after him, still I want to ask after him. I want to conjure this tiny, white pulse, however uselessly, into a single moment of life. And I want to place him within the family constellation, at least to the extent that his unspoken disappearance becomes worthy of consideration. I know this is madness. But oh Paul, Paulie, I think, remembering that awful television screen. Which one was you, and which was me?

W hen a baby is born, there is some work of figuring out – of laying claim to – who the baby looks like. At least this is the case in Irish families, where questions of generation and inheritance – of who or what belongs to whom or what – are rarely far below the surface. Does the child have a gap between his teeth? Weird eyes? Red hair? Is she like Uncle Pat or Aunty Mary? This work of looking and noticing is itself, of course, much like the funerary ritual at the other end of life, a performative act. Which is to say, it is not simply about the recognition of ties, but rather their creation. To trace Uncle Pat's nose across the unlucky child's face is not an innocent process of seeing; it is an argument and a claim. My father is insistent that Paulie looks like him, though the resemblance is obscure to me. Nonetheless, I recognise, and even respect, this as an active labour of making something – someone – familiar.

This process of familiarising can be tense, but it is not in principle controversial. And yet I have been repeatedly caught short, in my own stuttering reproductive efforts, by what is actually at stake in this collective labour of continuing and repeating, of ending and doing again, this work of making people and families. If reproduction is, by definition, nothing new, then there is an important question of what – whose – habits and feelings an individual reproductive act puts

back into the world. In spite of many hours of discussion about facial features, no one in my own family has ever been much interested in this question. Still, in his first months of life, I watched Paulie keenly. I saw his face rise, like bread, as it took on first the likeness of Aoife's father, then something of my own still-living grandmother, and finally, unmistakably too, in the slight downward cast of his eyes, an element of Paul.

There is much that is melancholic about new parents, and not only in the obvious or legitimately psychological ways. Here they are, after all, in the throes of a private drama, full of passionate intensity, beset on all sides by novelty, joy, struggle, triumph. And yet to anyone looking in, these domestic scenes are as predictable as they are dull. This is of course why books by parents, books about being parents, books about parents' astonishing and overwhelming love for their new child etc., etc., are rarely good. 'We know the story,' says Rachel Bowlby, 'and the story is not very interesting.' But what if the parents' story is not only – or, indeed, not much at all – about the child? As the first months of Paulie's life passed, and he became fatter, and sprouted red hair in an unfortunate tonsure around his head, it became clear that being his parent was not, as I had at least half imagined it, an earnest, intergenerational reproduction of the living family – even in an abstract way. Having a child, I came to see, was more a kind of haunting. I became fixated by the question of how my son and my brother might have passed one another along the way, how they might have become connected in a way that I myself would never quite understand. How, I thought, could it be possible to understand either of them in the absence of the other, when they exist, at least to me, in large part as absences of one another?

If the dead can never die, but only ever pass to somewhere else, so a child can never really be born, but only ever get renewed. 'The individual leaves the invisible and mysterious world that his soul has inhabited,' Hertz wrote, 'and he enters the society of the living. This transition from one group to another, whether real or imaginary, always supposes a profound renewal of the individual.' The child and the

corpse, the one barely alive, the other long dead, hold one another close: 'The veil of the bride, and that of the widow' – this is Hertz again – 'are of different colours but they nonetheless have the same function.'

This question of how death and birth go together, which is of course the central question of reproduction – of how things like families persist over time; of how individuals fall through generations; of how siblings become children; of how dead relatives come to inhabit the not-quite living – has also haunted me for some years. I have been concerned not so much with undoing Paul's death (I do not wish to undo his death), but with how the weight of his presence in the social order might be felt again, as the family, whether it wishes it or not, reproduces and renews itself, unravelling the limits of the bodies that carry it forward. I have become anxious – but why anxious? – that when I see my son, I can see Paul too. Denise Riley describes a feeling, nine months after the death of her own son from a heart condition, of a kind of anti-birth, of a pregnancy 'wound backwards past the point of conception and away into its pre-existence'. Something breaks, temporally. 'Instead of the old line of forward time,' Riley writes, 'now something like a globe holds you. You live inside a great circle with no rim.'

'I am a toilet of unhappiness,' said a handwritten note under my brother's bed that my father and I found while we were cleaning out his room some weeks after his death. This seemed to us both, if no comfort, at least a rebuff to easy ideas of rash, drunk, romantic, regrettable etc. decisions – which was a stupid if well-meaning explanatory logic that we were to become wearingly familiar with. 'I'm glad he did it,' my father said, holding the note, 'if that's how he felt.'

Mourning, says Freud, is work – this is part of what makes it different from the everyday melancholia that it superficially resembles: one is absorbed in actually doing something. But if mourning is work, it seems to me, then it is also reproductive work: it's an attempt to bring some version of a person or an object back into consciousness, back into one's own life, in a way that is somehow both sustainable and

bearable. Might gestation and childbirth not be understood as kinds of mourning, in this sense? Might they not at least provide space for a certain kind of grieving to take place?

Later my father said to me something like: 'It's not so bad for you. Of course there's residual stuff from when you were kids. But you'll be okay.' This was not kind, necessarily, but it was also not wrong. I *was* fine in the grand scheme of things. But then in the middle of the period when we were trying to have a baby – I can't remember why the subject came up, but I remember it was the early morning, and we were in bed – Aoife asked me if I thought about Paul very often. And I answered, truthfully: no. No, I said. I barely think about him at all. And she said: I think about him every day.

When Paulie was about eighteen months old, he became quite ill – not at all seriously or very worryingly, but enough that his temperature was high for several days, and he was forbidden from the nursery, left to linger at home, sweating and coughing in a burning fit of self-pity and recrimination. We also felt sorry for ourselves, as a sick and raging Paulie became impossible to manage around the house. He wailed to be held, and, when he was picked up, wailed to be put back down again. He screamed for objects, and screamed harder when the object was presented to him. This sounds comical but it wasn't. Several days in, Paulie tried to prise a space between his parents, insisting, for example, that only one of us could perform a particular task and screeching if the other attempted it. At one point he would only eat sitting on my knee – and, desperate for him simply to eat, but also perhaps quietly satisfied that he had chosen my knee, I let him do this, and Aoife became annoyed.

Paulie, I think, felt this tension, and started to pull at it, settling further into my lap with something approaching pleasure. I began to wonder if he was angry with us – but why? Did he blame us for his illness, or for keeping him at home? Was his the normal if wretched infant sensation of feeling the gap between your capacities and your desires? Was this even a kind of transference, in which I

had somehow attributed my own anger to him? Or was it – and this was a possibility that only occurred to me about five days in, when we were all very miserable and wrung out and, it's true, no one was thinking very clearly – was it because he could sense the new baby somehow? Aoife was by now thirty weeks pregnant, and though we had been talking and joking about the baby, his sibling, he was much too young for us to have attempted to formally tell him what was happening. But was he now playing at rejecting us, I began to wonder, before – he feared – a baby sibling arrived, and we rejected him?

Throughout this period Paulie insisted on me carrying him everywhere and I did so, though by now he was no baby but rather a thick and dense child – a dead weight in my arms as I staggered up the road, Paulie himself crying quietly into the side of my head. In desperation one afternoon, I took him into town. It was horribly, unseasonably warm. Paulie cried for the entire walk, and eventually I took to carrying him in one arm, pushing the pram in the other. In the end, he lost control of himself entirely outside a mid-market watch retailer, and I picked up and held his body tight over my shoulder as he screamed and flailed. We made it, somehow, to a park, and both fell, dazed, into a shady corner. For what felt like the first time in days, Paulie's sobs eased. There were seagulls flying over the harbour, and I pointed them out, though I hate seagulls. 'Look, Paulie,' I said, 'birds,' and Paulie looked. After a while, I was able to pick him up without protest, and together we walked slowly up the road towards home. At some point Paulie stopped crying altogether, and he nestled into me. It was evening by now and the sun was going down over the empty warehouses. There was that slight sense of numbing shock, like a bereavement, that you sometimes get at the end of an unexpectedly hot day. I hugged Paulie tight into me, and we manoeuvred our bodies around one another until I could walk and carry him more easily. He leant back over my shoulder, completely silent now. In the distance, birds settled on the tops of the buildings and began to call to one another, settling in for the night. I could feel my son's breath cooling on my ear. This is enough, I thought. Paulie, it has to be enough. ∎

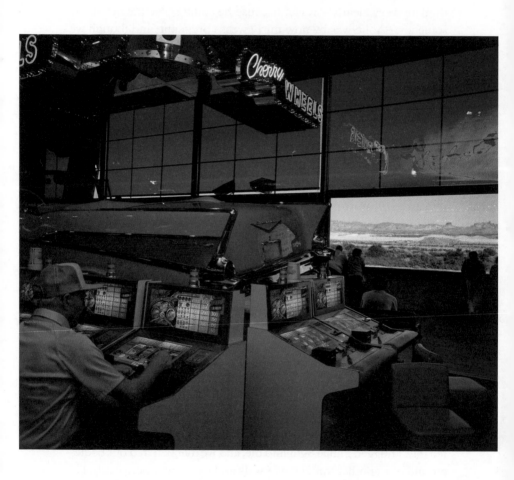

CARL DE KEYZER / MAGNUM PHOTOS
Casino, Las Vegas, USA, 1993

FOR THE LOVE OF LOSING

Marina Benjamin

For two years in the mid-1990s, I worked on and off as a professional gambler, touring the world as the rookie member of a long-standing blackjack team. I had been casually recruited into the 'Odds and Sods', as they sometimes called themselves, by a colourful Peruvian woman with owlish grey eyes, who correctly pegged me for a drifter when we'd met over a platter of spicy prawns at the home of a mutual friend. Her husband, Ken, a former research chemist, was the blackjack pro. 'But I pick all his assistants,' she told me, pressing her business card into my palm before she left.

I remember the frisson of excitement I'd felt at her approach, at having been singled out, and the justification that swiftly followed. I told myself that it would be an adventure: something I could write about as I embarked on a career in journalism. But perhaps it was a measure of how little control I felt I could exert over things in my twenties that I didn't so much jump at the opportunity as offer nothing in the way of resistance.

In the event, I wrote about those years once or twice in a splashy style that didn't feel true to me, but after a while I stopped talking about falling into blackjack since it had a way of hijacking the conversation. I began to notice that each time I rolled out my tale I felt outside of it, almost as if in getting too close I feared tasting the bitter

edge of my own desperation. Something in me shifted over time, allowing me to see the experience in more nuanced light. I began to wonder if running off with a blackjack team to spend long weeks holed up inside casinos wasn't my way of throwing down the gauntlet to my father – a couturier in thrall to glamour, who had gambled all his life. Was I tempting fate to see if I wouldn't make a better gambler than he was, by which I mean, not become an addict – as if my pro gambling was some kind of self-administered test.

The team I toured with roved across those US states where gambling was permitted and thrived, but it was decided my debut may as well be in Las Vegas so I could enjoy the full colour and drama of the pro experience. The trip had been pulled together by Ken – who knew the how-to blackjack literature inside out, and had devised a few tricks of his own besides – and a couple of Dutch entrepreneurs. Tomas was a computer nerd, a cowboy coder long before Silicon Valley made the designation cool. The other, Lenny, owned a string of bars in Amsterdam and had been up before the courts more than once, charged with running illegal gambling on his premises.

Tomas looked even more out of place in casino-land than I did. A doughy man with shoulder-length hair and thick-rimmed specs that he kept pushing up his nose, he insisted on wearing his rumpled grey suit when everyone else had changed into baseball caps and sweats so as to better blend in. But he was kind to me and openly acknowledged the time I'd be buying them at the tables as the team's only woman – unlike Lenny, a flinty-looking character, who I barely exchanged two words with before he left us in a huff to play on his own, accusing us of cramping his style.

The first time I sat in a car with the three of them, driving to our low-rent apartment from the airport in Las Vegas in a hired convertible, the hot evening breeze caressing my skin, I was exhilarated beyond words. Fresh from having walked out on a PhD, and with a string of temping jobs behind me and a nagging sense that ahead of

me time was simply lazily turning pirouettes, I had never embarked on anything so racy.

L as Vegas. City of myth and promise, of neon glory, fizz and glitz, the roads in and out of it lined with giant billboards promising riches beyond imagining – one of them, making a regular appearance, pictured a couple of golden chips under the word 'Arrival' and a glinting mountain of them under 'Departure'. Everyone, a winner! My father would have given anything to have been in my shoes then. But the reality is so much more precarious: a desert city fighting for its life against the elements and, slowly but surely, losing.

On the outskirts of town, our apartment was part of a sprawling development of identikit houses arrayed around fractally repeating cul-de-sacs, all of them shaped like keyholes. I never saw anyone out and about in the streets. In fact, the streets themselves seemed to exist in a state of tension, with the desert continually trying to assert its primacy over the man-made. Sand kept drifting into roads, tennis courts and backyards, filling potholes and piling kerbside in gentle slopes. It blew in through our open windows, getting into everything. An omen of transience.

My first few days on the job left my head thudding. The noise on the casino floor was unbelievable, everything blinking, boinking and buzzing. We played Harrah's, one of the older casinos on the Strip rumoured to have Mob connections, its riverboat design harking back to the old paddleboat casinos of the American South. I remember that it took a while for my eyes to adjust to the twilight inside. As we sat down at the blackjack tables for the first time, I could feel my heart pulsing in terror: all I could think of was whether I'd actually be capable of throwing away Ken's money at speed. Among blackjack's great appeal to gamblers, aside from its ease – is any card game simpler than twenty-one? – is the swiftness of play: there's no time to fool around, only to bet and bet again. The first time the dealer swept the board clean, and my unlucky bet with it, my impulse was to snatch it back.

More troubling, in hindsight, is how quickly I grew accustomed to the casino's artificial world. To the gaudy throb of flashing lights, the ceaseless din of the slot machines, the clatter of chips and coins. I stopped noticing the smell of stale food ground into the swirly-patterned carpets, the total absence of daylight or clocks, or the way the fishnet tights the cocktail waitresses wore were always torn. I began to focus small on the green baize in front of my nose, drifting towards a meditative space as I played like an automaton, on endless repeat, my emotions effectively cauterised.

Most days we'd be stationed at the tables for eight hours, ten if we were on a roll, my tired eyes swooning with images of hearts and spades and diamonds, and square-faced kings and queens. At night I dreamt of those cards, a chubby Michelangelo hand in the sky reaching down from a fluffy cloud to turn them face up on my box in slow motion.

Here was something I had not expected, a kind of self-intoxication I found relaxing, even if behind the scenes our play was anything but passive. It was minutely calibrated, moment by moment, the result of being grounded in Tomas's customised mathematical modellings of the game, which used tens of thousands of computer dry runs to determine the probability of us making money over long stretches of time.

In his short story 'Gambler's Luck', the German novelist E.T.A. Hoffmann distinguishes between two kinds of gambler: those, like my teammates, given to 'cabalistic calculations', and those whose wins and losses were governed by 'a lucky star'. I had plenty of opportunity to observe this second group as we silently crunched numbers and perfected memory tricks – the better to mine the thin seam of advantage Tomas had squeezed from his models.

Superstitious creatures, one and all, the good-luck crew was given to mysterious rites and rituals meant to curry favour with capricious gods. They were easy to spot, too, by their hot-headed play and 'notice me' volubility; the way they kissed and coddled lucky charms; wore lucky caps and clothing; crossed fingers and curled toes. They bet on numbers that meant something to them personally – birthdays,

anniversaries, customised red-letter days. 'I know you've got an ace, honey,' the Vegas hucksters crooned, tipping their cowboy hats at stone-faced female dealers who had heard it all before. Then they'd put $500 or $1,000 or $3,000 on their box in a tremble of anticipation. 'Go on, hit me!' they'd say, their faces shiny with sweat as they turned grinning faces towards the gathered company to make sure they were seen.

Most of the time they lost, as did we – just like our algorithms predicted. But when we wanted to bet big and profit from our ability to accurately track aces, we'd ape their neediness and their swagger. We'd high-five and holler, and do silly seat-dancing. So much of our gambling was performative. We were always trying our best to look like regular losers. I learned to see them coming. They'd join our table, hoisting one butt cheek onto the stool as if unsure whether to stay or go and chuck a desultory chip or two onto their box, emitting a sigh of defeat. 'Go home!' I wanted to tell them. 'Do something nice for someone, for yourself, for your dog.' But they'd lurk around, step away from the table and back again as though it were magnetised. After they lost a bit more, they'd shake their heads, saying, 'I just don't seem to have it today,' before moving to another table in hopes of tapping better juju elsewhere. Other times I'd see people play with a kind of relentless doom, chasing their losses with ever greater stakes and ridding themselves of cash as fast as they could, their impatience palpable, any trace of humanity in their faces wiped out in their determination to punish themselves. It was difficult to watch, this public self-flagellation.

It was easier for us, and more enjoyable, to imitate the loud high-fivers. Ken would wear a white shell suit, I'd pull on baggy shorts and a fanny pack, and we'd leave our apartment in high spirits, wondering if we'd be taken for high rollers, or for the idiots we pretended to be. On the whole the tactic worked, until it didn't, and then black-suited staff from the casino's security team would appear at our sides, leaning in like heavies, and politely instruct us to leave: all casinos are private clubs, with punters admitted, or kicked out, at the discretion

of the management. Although we never once made an illegal move at the tables, I was always embarrassed by the unwelcome spotlight of being singled out as a pro. We drew glowering looks from people. We were not good sports.

In time, blackjack became almost humdrum. I learned to count cards, assigning a positive or negative value to each one as they were dealt in real time and accruing a hair's breadth advantage over the house. I timed the shuffle. Tracked aces one by one. I can't say I relished the mental labour involved in having to make constant calculations over extended hours of play. But then, for me, blackjack was work, and of a kind I'm all too familiar with as a freelancer: one with no regular pay cheque.

I have always been terrible with money. It slithers from my grasp like some slippery sea animal, and on the rare occasions when I've come into it, the anxiety of having it and of not understanding how to husband it have led me to misspend. Caught up in the dot-com mania of the late 1990s, I invested small sums in a handful of start-ups whose stock values vacillated like crazy. Tracking their fortunes was a hobby I indulged with a writer friend, both of us equally in thrall to that tang of The Future, which the nascent tech industry seemed capable of bringing tantalisingly near. We'd call each other up all the time. 'Do you fancy Webvan's chances?' I'd say, and he'd bounce back with 'What about Napster?' Neither company made it. We studied 'form', like racegoers diligently doing their homework on the horses, but the two of us were equally bad at spotting winners. He used to joke that we ought to set up a company ourselves and call it Bellwether Investments, its tag line being: 'We fail, so that you don't have to.'

Perhaps my experience of pro blackjack had softened me up for those dot-com wagers. Or perhaps not: a dedicated penny-pincher, bargain-buyer and saver, in the overheated climate of speculation around everything digital I somehow went rogue. Living in San Francisco at the time, I got caught up in a Bay Area-wide mania

for what the financial journalist Michael Lewis famously called 'the new, new thing'. It was a tangible excitement that charged the very air. You'd walk out of your apartment and people barely out of their teens were talking about money on the street, speculating, scheming, innovating. Punching the air with their optimism.

In my tentative forays at gaming the future alongside them, was I gambling? I'm still not entirely sure, because unlike its flow through stock markets, money is not money in a casino. In casinos money is soft currency – its power proxied by chips. There is no point-to-point relationship it maintains between cost and value. Nor is it indexically linked to anything real. In casinos money is more like social capital, even a psychological liability: with money in your pocket you are a victim merely posing as king. If you rid yourself of it, it is a perverse kind of triumph.

If I remain baffled by the way some people seem able to blithely chuck away something I find so difficult to retain, it is not because I do not understand the rules of capitalism so much as I marvel at the hidden workings of the human mind. With the life's work I've chosen and settled comfortably into, the writing and editing that sits at the centre of my world, moneymaking less an objective goal as it is a scarce by-product. It preciousness waxes in proportion to the difficulty of its extraction. But watching people gamble firsthand, their dedication to it, the hours they put in as they empty their wallets and take their chances, I can't help feeling that they're in it to lose.

I have seen men and women at the blackjack tables itching to leave, batting away the real-world commitments constantly tugging at their sleeves – removing thier wristwatch and placing it in a pocket – and watched them 'push' whatever money they had left onto their box, piling it high, wanting to lose, despair gnawing at them as the cards were dealt, their defeat a blessed release when it finally came.

Up and down the slot machine alleys of American casinos, I witnessed people who were pinned uncomfortably to the spot on account of still having coins sloshing about in their giant plastic baby-cups, and who were desperate to empty them into the machines.

People who could not dispense with their money fast enough. At Caesars Palace one time, I saw a middle-aged woman hit a jackpot, setting off a full-scale mechanical fanfare: lights blinked, artificial trumpets sounded and coins roared spewing from the machine. A small crowd gathered round her to drink in the win, but the woman herself appeared wholly impassive. I lingered a while longer, watching as she continued to stuff money into the slots even more energetically than before. It was as if winning had made her only more determined to lose. If anything, she now seemed irked, her features set *against* emotion.

Winning, it turns out, was the cracking whip that meant gamblers had to stay where they were until they lost their money all over again – occasionally even brazening out the shame of soiling themselves because they cannot bear to tear themselves away from the action. A win brought no joy, but instead a rare kind of punishment. It was a punishment that jolted players out of a self-induced anaesthesia – something they may well have come to the casino to seek out – a soothing hypnotic reverie that, even as it numbed the pain of everyday living, made them little more than button-pressing drones.

Slot machine players in particular seem to crave what the cultural critic Michael Crawford terms 'automaticity' – or a state of pure passivity in which they are at one with the machine, reactive, responsive, but no more than that; the whole of their sensorium shrunk down to a tiny forcefield. Press the button, or don't. In such a state their gambling qualifies as 'play' only in a twisted fashion, in relying on an absorption born not of focus or concentration but its opposite: an alienation so profound they can no longer connect to the world. Once unplugged they empty themselves of everything.

They don't care about the money any more. They know it's hopeless.

I believe that losing, in this sense, triggers a kind of emetic impulse, a desire to vomit up one's fears about the uncontrollable nature of the world and to purge oneself of deeply lodged hurts. In losing there can be tremendous relief, even rebirth, in that only once you have lost everything can you walk away and start over, or start again,

living out the mundane reality of your life until the tension once more becomes unbearable. Winning is far more problematic, because there is responsibility in the win – what to do with all that money! It's the opposite of release.

You want to lose. Out of what writers Frederick and Steve Barthelme, accounting for their own haemorrhaging losses at the tables, call a 'unique despair'.

The thought is so powerful that it winds me. The gut punch comes from the way that gambling at full throttle turns losing into a species of self-harm. I think of my father and his roulette compulsion, and I wonder if behind his dapper and gregarious front he might have secretly reached the end of himself, too: the point at which however much luck he believed he owned, he had given up on hope. My mother tells of countless nights she spent alone, when I was small, consumed with worry as she waited for my father to return from God knows where. She'd hear the lock turn at 1 a.m. or 2 a.m. or 3 a.m., and discover him on the stairs, polished shoes paired in one hand, tiptoeing his guilt, his dark suit glistening with London mizzle. When she demanded he hand over his cash, he'd turn out his pockets to prove he didn't have a penny to his name. Next time, he promised, making a clown frown. Next time it would be different. But his routine was always the same, predictable as a vaudeville act.

In the minds of most gamblers, money barely matters. What matters is the play it buys and the existential drama of the self that unfolds within it. Joseph Mazur, a professor of mathematics in Vermont, who has long studied randomness and the illusions people entertain when they imbue it with meaning, argues that gamblers see luck as practically corporeal. They view it as something that may be captured, ensnared or pulled onside. It comes in strings or runs (until it runs out) and you can be in it, out of it or down on it. To the gambler, luck is constitutional rather than circumstantial: they can possess it and also be possessed by it. Mazur's research has convinced him that this psychology is closely linked to an 'optimistic bent'. A

precise term in his lexicon, having an optimistic bent has nothing to do with a sunny disposition but rather a tendency to consistently overrate the likelihood of a favourable outcome. In effect, it's a form of magical thinking that persistently confounds cause and effect.

Gamblers get into trouble, not least vortices of debt, because they cannot help pitting themselves against fate. They know that luck is capricious, evasive, flighty, which is part of its dangerous appeal; but they're also convinced that they can somehow divine it. It's why gamblers like my father – a man whose entire life floated on a cloud of magical thinking – are so easily intoxicated with a sense of their own agency. If they're special or charmed, or 'touched' in some way, the odds of a given bet become far less important than whether or not it chimes with something meaningful to them: their children's birthdays, the anniversary of their grandmother's death, the day they proposed to their partner or acquired a new car.

When gamblers pay any attention to the odds at all, they prefer it when the odds are long – since when the odds are long, the stakes are greater, the wins higher and the thrill dearer. The rational alternative of betting cautiously on lengthy odds is a buzzkill; plodding probability so prosaic compared to luck's fleet and tricksy ways. I had trudged through such play myself at the blackjack tables, noted the dreary nature of making finely tuned, though correct, calculations, time after time – especially the way it flattened me. In this emotionally weighted reckoning with fate, the one thing gamblers do get right is that luck is a pick-me-up. More: it is in play by definition when the odds are long, because in order to beat them and win you have to take your chances.

My father was a classic chancer. I've come to understand that, for him, roulette, more than any other game, modelled the randomness of the universe, mapped its chaotic swerves, its jumps and deviations, its endless surprising turns. It made sense of the inherent disorder of things. Chimed with his sense of being a creative soul who needed chaos in order to thrive.

For someone lacking in analytic skills, as he was, this understanding

of how the world works is as good as any other. But my father's story is also, in part, an immigrant's story: if you are an outsider, you do not know how things work.

My father was skilled at grafting himself from place to place. Born to an Iraqi-Jewish family in what was then called British Rangoon, he'd fled to Palestine before the Japanese invaded, and then to France to study couture, arriving in England just as austerity was ending. He was a classic citizen of nowhere, happily residing in a place – working there, raising a family, finding friendship and purpose – but never belonging. England remained a mystery to my father for the duration of his adult life here, not because he didn't try to blend in, but in great measure because so many doors were closed to him. For the most part, he didn't even notice the doors.

It is true that he lacked a flair for business. That at the time his gambling took serious hold of his psyche (and his heart), he struggled to comprehend that his chosen trade, haute couture, was heading for extinction in a fast-changing climate now teeming with new evolutionary forms – all those prêt-à-porter upstarts like Biba and Mary Quant snapping at his heels like raptors, usurping old-fashioned glamour with laid-back boho chic.

However, at some level he didn't care. In Joseph Mazur's terms he was immune to cause and effect, and to a large extent he was happy in that ignorance. He enjoyed blowing money he didn't have on expensive holidays and fancy furniture. Got a kick out of throwing it willy-nilly at shares issued by companies he simply liked the names of. It may not be an exaggeration to suppose that inside his head there sat a symbolic roulette wheel, whirling with outlandish possibilities that might, with a bit of luck, be realised.

As I push my thinking on this subject out to its furthest edges, I am reminded once again of my father's desire to live eternally close to the brink, financially, emotionally and creatively. Even before prêt-à-porter altered the landscape of high fashion, his business was forever on the verge of going bust, his bank accounts miraculously running on empty, his prayers to Fortuna increasingly fierce and desperate.

Here he was then, running out of hope. Which only made the thrills more urgent: every move he made was do or die, just like it was at the tables.

Unlikely as it may seem, gambling emboldened my father to navigate life's essential unpredictability. Instead of making rational choices, he went where whim, instinct and appetite took him, his inner tuning fork sympathetically resonating to mysterious whispers from the far side. Losing at the tables may even have been the antidote to his losing in real life. A balm for someone who found it near impossible to make money or to compete in a cut-and-thrust world, and who was unable to benefit from the protection that patriarchy extends to men more comfortable with their masculinity than he was.

Perhaps this was his unique despair. The thing he could barely endure.

But if gambling offered my father a fantasy life in which he could finally feel some agency, just like one of life's winners, what did it offer me?

I am no longer convinced that playing pro blackjack was my thinly disguised attempt to discover whether the apple had fallen far from or uncomfortably close to the paternal tree: to know if the addiction I so clearly disdained in my father lurked somewhere, latent, inside of me. I now think it more likely that I was toying with loss itself – as one might toy with fire! – trying to figure out at a time of profound change in my life, my entry into the adult world, just how much, and what kind of loss I could comfortably tolerate. I had lost my father as someone I could respect and count on. Lost my sense of belonging to a diaspora pinched uncomfortably between old and new, and, with that, my place in a cultural continuum that would have seen me lead a more cosseted life than I wanted. I had also lost my bearings in a grown-up world I felt ill-equipped to participate in. I was, in short, winging it, living precariously on my wits, and my bottle, and so gambling felt no riskier than any other undertaking.

Those who study the phenomenon of loss aversion point out that

what someone is willing to lose is always related to a reference point, and usually that reference point is the status quo: most people will put up with some degree of loss if it doesn't upset their world too much. But if the point of reference is less stable the logic shifts. If you believe, as my father did, that you were born to have riches beyond compare then you will risk much more to lessen the gap between reality and expectation. If like me, however, the bar of your expectations is set differently, calibrated for reality, then your approach to risk is more calculated.

I wish that I could go back and tell my younger self that the world is kinder than I knew, or believed it to be. That opportunity did sometimes come knocking out of the blue. That emotional precarity is a state that one might gird oneself to wait out instead of put to the test, while expecting to fail. But I guess there are always some things one needs to learn the hard way. That cannot be learned in any displaced arena, or field of play, or even a funhouse palace, however defanged or neutered to protect against real loss. ∎

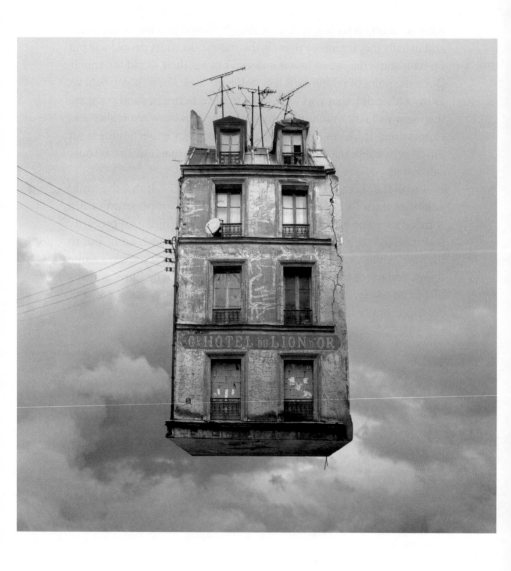

LAURENT CHÉHÈRE
The Golden Lion Hotel, from the *Flying Houses* series, 2012

HÔTEL CASANOVA

Annie Ernaux

TRANSLATED FROM THE FRENCH BY ALISON L. STRAYER

I found a letter from P in a file of invoices from the eighties. A large white sheet of paper folded in four. Semen stains had made the paper yellow and stiff and had given it a transparent and grainy texture. All he had written, in the top right corner, was 'Paris, 11 May, 1984, 23.20, Friday'. It is all I have left of this man.

I met P, a publicist, a few weeks after my mother was admitted to hospital in a severely disturbed state. Her condition deteriorated with each passing day and she had suddenly become an old woman. I wondered how I was going to endure it. I would leave the hospital in a kind of stupor, putting on music, a tape or the radio with the volume turned all the way up, it was the time of Scorpions and 'Still Loving You'.

P called me for I no-longer-remember-what project. His voice on the phone unsettled me, and I felt a desire to see him. But when I caught sight of him, already seated at the table in the restaurant on rue de Rome where we had agreed to meet, he appeared tired and quite ordinary, probably close to fifty. I felt it had been a mistake to accept the lunch date. I would never sleep with him, no matter how much I longed for a man, as I did then. Even though his voice and conversation, at once brilliant and aggressive, appealed to me, I made

up my mind never to see him again when we parted. But later that night I was astonished by the violent urge to give myself an orgasm while thinking of him.

So when he rang a few days later to invite me to the Roberto Matta exhibition at Beaubourg I did not turn him down. With P, as often happens when I begin to desire a man, I wanted to make love as soon as possible to end the wait that keeps one from thinking of anything else and recovering a sense of calm.

When the day came, we had lunch at the restaurant on the rue de Rome and visited the Matta exhibition – nothing more. All we did was kiss in the taxi on the way back to the Gare Saint-Lazare. On the commuter train, angry and discouraged, I thought of how I would have to wait some more, see my sick mother a few times more, before getting laid (to use the expression I use only with myself).

Over the following week, P contrived to make my desire unbearable with repeated phone calls in which he talked about his own desire. I received his proposal to meet for an hour at noon to make love in a hotel in the Opéra district – a time and place convenient to his work and which did not conflict with his obligations as a married man – as a deliverance.

After a silent, almost tense lunch, we took a cab which halted on a small and busy street between rue de la Paix and avenue de l'Opéra. The hotel we entered had a NO VACANCY sign hanging in the foyer. A man appeared and P had a quiet word with him while I stood aside. The man motioned for us to go upstairs. On the first floor, a middle-aged woman appeared in the dark hallway, and I saw that P was giving her money. She opened the door of a room and discreetly withdrew. It was windowless and gave onto a little sitting room which overlooked the street. The bed was covered in fake fur and surrounded by mirrors. I remember that we found ourselves naked in less than a minute and that he made me come with a gentleness

and skill which for me have not been equalled since on any first time with a lover. The woman with shining eyes I saw in the mirror, just as I was leaving, did not seem to be myself. I touched my hair. A strand was damp with semen. We had been in that room for barely an hour.

Afterwards, all I wanted was to get home quickly. On the suburban train, I felt the strand of hair – dry now, matted and stiff – brush against my cheek. I wanted to forget that afternoon and the man who had taken me to a hotel that obviously rented rooms for paid sex or, at any rate, for clandestine affairs. In my state of fatigue and satiation, I was certain I would never want to sleep with him again. But by evening, I no longer saw any reason for leaving him: my sole desire was to sleep with him again.

Over the spring of that year, as my mother's condition inexorably deteriorated, I made love like a madwoman with P at the hotel where we had gone that first time, the Hôtel Casanova. It was a hushed place where, despite all the comings and goings (the faint noise of doors could be heard), you never met anyone. All the rooms were dark, and all had mirrors, sometimes a two-way mirror hidden by a curtain at the head of the bed. The fact that we could only stay for an hour – the time P paid for – made our touching and embraces greedy. The place itself, where every detail signalled transient sex, whether or not it was for money, was an incitement to excess and the most obscene language imaginable, which, at that time, would come back to me in flashes, a simulacrum of prostitution.

In these rooms, I sometimes thought of my mother. It seems to me that I needed to feel pleasure in order to endure the image of her shrunken body, her soiled underwear; that I needed to go as far as possible in the exhaustion of pleasure, to a state of dereliction through sweat and semen, in order to erase – or perhaps attain – her own dereliction. Obscurely, Casanova's rooms merged with my mother's room at the hospital.

'Fucking as if to die from it', the phrase had never rung so true for me as it did that spring. And that it was possible for me to do so seemed to me great luck, almost a kind of grace.

If I arrived early for our meeting, I would stroll through one of the department stores on Boulevard Haussmann, Printemps or Galeries Lafayette. Here, at all hours of the day, there are women who burn under their skirts and who shop as though nothing was going on: I was one of them.

After the hour at the hotel, we would walk to Gare Saint-Lazare. Spring was early and hot. I lived in a sweet state of torpor devoid of any thought of past or future, apart from the need to take the commuter train to return home. If P had a little more time, we might go to an art gallery or a museum. In the deserted rooms we caressed each other recklessly. In the late afternoon, P would call me from his office, reminding me of what we had done earlier and proposing a scenario for the next time we went to 'salute Casanova', as he said. He possessed an extraordinarily refined imagination, which X-rated films and *Penthouse* so desperately lack.

I never asked myself if I loved P. But nothing could have kept me from going to make love with him at the Hôtel Casanova. He had no illusions, saying, 'You just like my cock, nothing else.' But isn't it already a lot to desire a man's sex, his alone?

I had stopped rebelling against my mother's condition. When I went to see her at the hospital, I stroked her hair, her hands. I no longer felt revulsion towards her body.

One afternoon in mid-June, just as we were entering the hotel, the man who was usually on duty rushed towards us with great gestures of denial, exclaiming that the hotel was full. Perhaps a police raid was in progress or had just ended. We took a taxi to the Père Lachaise

cemetery, with its shady paths. But in this open setting, with trees and birdsong, we were at a loss. All we did was caress each other furtively. In the heat, P's face was red. As the first time I saw him, I found that he looked tired, older than his age.

Another attempt to go to the Casanova, a few days later, met with the same result. P did not look for another hotel, nor did I want him to. It was at the Hôtel Casanova, during that hot spring and the beginning of my mother's illness that our story developed and took shape, from one orgasm to the next.

After that, we met every now and then at my home in the suburbs, when he had a few free hours in which to take the train. He visited reluctantly, left quickly, seemed uncomfortable in my apartment. I waited for him without desire and without imagination. Things had turned sober and normal. One time I asked myself, 'What is he doing here?' I no longer remember when we stopped seeing each other for good.

I have never gone back to the street the hotel is on, even though it is located in the heart of the Opéra district, albeit devoid of shops. Perhaps he was right to say that I only cared about his cock, for it's all I remember of the hours we spent together at the Hôtel Casanova. Yet I know that because of this man (whom I saw from a distance one day on the platform of the Opéra metro station – his hair was white), I felt the infinite and mysterious aspect of physical love, its dimension of compassion. And every gesture, every embrace afterwards, contained something of him and the Hôtel Casanova, like an invisible substance uniting men and women who will never meet again. ∎

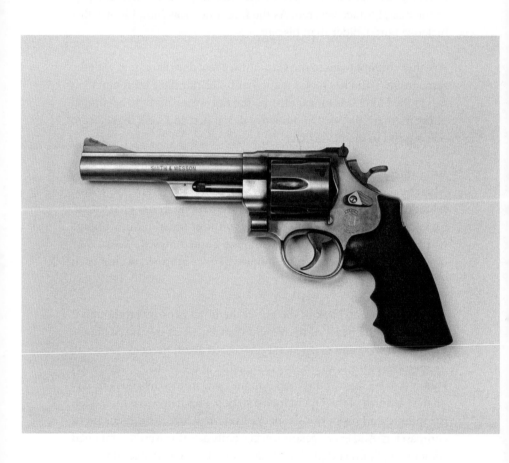

ZED NELSON
from *Gun Nation*, 1999

MISFORTUNE

André Alexis

1

At the age of six, Amara McNeil shot and killed her father. She had discovered a gun in the bottom drawer of a credenza, its silvery barrel gleaming, attractive because she wasn't sure what it was, though some part of her must have recognized it as belonging to the world of screens and make-believe. And her father had surprised her as she held the thing. Startled, she'd discharged it, the bullet catching him somewhere in the abdomen. There followed: a brief, eerie silence, his cries of pain, the wailing of her mother and sisters.

It was a moment Amara had been parsing for forty-one years, and although small details sometimes receded from memory, the vivid things were inescapable: the handle of the credenza's drawer (ivory), the gun barrel visible though most of the gun was covered by black velvet cloth, the recoil when the gun went off, the sudden quiet that was as terrifying, in retrospect, as the chaos that followed it.

She had adored her father, and forty-one years on, she still dreamed of him – not as he was when she shot him, or not always, but as he had been when tossing her up in the air and then catching her with a loud 'whoosh!' before setting her down so one of her sisters could have a turn.

Amara no longer believed her father's death was the worst of what the world had to offer. At forty-seven, she knew that there were deprivations and humiliations beyond her imagining. One read about them daily. And it wasn't as if she had built her life around guilt and sorrow. Rather, she'd done her best to come to terms with them.

But it did, at times, feel as if guilt and sorrow had secretly steered her circumstances. Was it really a coincidence that two of her closest friends had suffered childhood trauma that afflicted them as Amara's afflicted her? Or, again, why was she fascinated by novels and films that depicted the worst in human nature? She preferred to reread *Dracula* than to finish *The Wizard of Oz*, and would sit through *Funny Games* countless times before finishing *Annie Hall* or *Palm Beach Story*.

Her tendency towards darkness, which grew more pronounced as she approached adolescence, troubled her family. It was most troubling to her mother, who walked in on her one day as she was watching raw footage from accident sites – human body parts strewn about a roadway, a digital time code on the bottom right of the screen. It took her mother a moment to realize what Amara was watching, but when she did, she began to cry, which was when Amara, until that moment absorbed in trying to figure out just what body parts she was looking at, first clocked her mother's presence.

Thereafter, and for some time, her mother and sisters treated her with almost excessive compassion, inadvertently rewarding her for the path her psyche had chosen for its recovery. Or, it could be, deliberately encouraging this tendency of hers as something preferable to discussing the death of her father, a subject all of them had tacitly come to accept as *hors-jeu*, too fraught.

In either case, this suited Amara. Curiosity had done her no favours. And for years, playing up her role, Amara wore black clothes and black lipstick. She listened to Throbbing Gristle and Nurse with Wound. She cut herself, her arms mostly. And her friends were those of her contemporaries who shared not just her tastes but something of her psychic imbalance. A number of them tried to kill themselves, one succeeded.

Time in the city passed in the usual way: innumerable buildings were torn down to make way for newer buildings that would themselves be torn down, the face of the city changing so much that, were it not for Toronto's lake-adjacent fate, its mutations poised against an expanse of blue, the city might have grown unrecognizable.

That, in any case, is how Amara figured time's passing.

As for its effect on her: the years were kind and unkind in almost equal measure. She fell in love and was loved a number of times. But she fell out of love – or was pushed out – just as often. She took on work as an administrator at York University, but her career stalled and, in her forties, she found herself being nudged aside – gently, for now – by younger peers who, to her embarrassment, she found herself envying. She bought a small house on Cowan Avenue, but was forced to be frugal as she tended to its flaws. Friends and acquaintances began their migrations from friendship, called away from its pleasures by divorces, marriages, children and ageing parents.

Her forties, it seemed, were fated to uncertainty. And, to make matters more uncertain still, 2020 brought a pandemic, two years into which her mother died after a prolonged illness.

This death was in almost every sense more devastating than her father's had been. For one thing, although Amara was acquainted with the dark shadows and strange light of loss, the pain of this death was more distinct for its slow oncoming. She was used to speaking with her mother once or twice a week, and visited her in Petrolia, often. And she had come to dread the very thought of her mother's death, prefiguring the loss again and again over the years.

Then too, occurring as it did when much of the world was masked and wary, her grief was mixed with a different kind of anxiety. Meetings with her sisters – held to decide what to do about their mother's funeral – took place over videoconference, so that their anguish seemed theatrical, as if they were performing for each other. And the funeral itself: the four of them, and very few others, masked in a chapel with a masked prelate, a ritual observed by any who wanted, on closed circuit.

Following her mother's cremation and the distribution of the small porcelain vases containing her ashes, there was a reading of her mother's will. She had left property in Sarnia, to be divided equally among her daughters. Her personal possessions she left to the discretion of her oldest daughter, Warda. And the modest amount of money she'd saved up was given to her grandchildren. The will was succinct, sad and clear. And it was very like her mother, one who did not like to leave loose ends.

So, Amara was surprised when, a month after the reading of the will, her eldest sister called her privately to arrange a visit, a visit during which she would give Amara a letter their mother had left for her. More surprising still, Warda said this was something the two of them were to keep to themselves.

'Ward,' said Amara, 'you can visit whenever you want. I just finished repainting the spare bedroom. You can break it in. But what's all the mystery?'

'You'll see,' answered Warda. 'I'll come next Friday.'

Which she did, arriving in a cloud of Warda, her tall, no-nonsense self bringing childhood with it, bringing back a time when her older sister seemed mythic to Amara. And although, over the years, Amara had fallen out with her other sisters, she'd never had any disagreements with Warda, preferring – even if unconsciously – to be on her older sister's side.

There was something different about this Warda, though. She seemed hesitant, maybe even troubled. After they'd got current business out of the way – the virus, the dead and other causes for distress – Warda said:

'I'm sorry about the secrecy, Mara, but Mom made me swear to keep this to myself until Dr Olson died. You remember Dr Olson? He used to visit us, after Father died. His daughter June called me last week. He died around the same time Mom did, about a month ago. Covid, June said. So, here we are.'

She handed Amara a sealed envelope.

'This is for you,' said Warda.

'You don't know what it's about?' asked Amara.

'No, I don't. I've been holding on to that envelope for two years, now, but I promised not to look at it, so I didn't. If you want to tell me what it's about, that's great. But you don't have to. It's between you and Mom, as far as I'm concerned.'

'I see,' said Amara. 'Okay, I'll read it later. Come see the guest room. Did I tell you I painted it myself?'

2

Dear Mara,

I don't know where to start. I have wanted to tell you the things I'm about to write, every day since the afternoon your father died. You can't imagine how hard it's been to look on in silence as you suffered, unable to say anything as you lived through the worst that any child could live through.

I want you to know that I've suffered along with you, though I know my suffering was no help to you then and isn't likely to help you now.

First to begin, Mara, you did not kill your father. Your father didn't die from the flesh wound he got from the gunshot. He died because Dr Olson, our GP in Petrolia, saw to it that he died. I don't know exactly how he did this. He was afraid to implicate me. But Dr Olson, Brad, did this because we couldn't see any other way to stop your father from hurting us.

You were so young at the time, Mara, I don't know how much you remember about your father. Though he was good to you, he was sometimes very troubled. I imagine Warda remembers more than a few bad moments, but

some things must have faded for her too, except for when we couldn't keep your father's behaviour from others.

I don't like to speak ill of your father. I never have, because I know Gary had a terrible childhood, worse than any of us. And because he could be so loving and good, as he was with you. Was it wrong to believe that his love for you, Mara, was his real self and that his flaws were something we could all fix together?

I tried my best under difficult circumstances, and when your father died I was devastated. But I was grateful, too. Grateful to Brad above all. He did what he did because I asked him for help and because, over the years, he'd seen what we went through.

It's for his sake that I've kept silent, Mara. I swore to keep this secret to myself, for Brad's sake. My only regret is that you've had to carry this guilt with you for so long. If I could have done anything, short of breaking my word to Brad, I would have done. As it is, Mara, I've told no one any of this. Not even Warda, who is the only one of you girls old enough to really remember the troubles with your father.

I understand if you can't forgive me for my silence. I do wonder if I was right to promise that I'd tell no one. But what I want more than anything else is for you to know you are innocent.

You've done nothing wrong. You never did.

Your loving mother,

Ada

It would be difficult to exaggerate the confusion Amara felt on reading her mother's letter. 'You were so young', 'Brad did this', 'Warda remembers': perfectly understandable phrases, in any other setting, but not in this one. And the phrases became less clear as she tried to parse them. *What* did Warda remember? Had Dr Olson murdered her father? If so, why would her mother call him 'Brad' and agree to protect him? Was it that Dr Olson and her mother had been . . .

This last thought was one she could not complete before a wave of shame erased all thinking. It was as if she were trapped in a tawdry and unspeakable drama, the kind of human baseness that engulfs other people, other families. It filled her with revulsion to even consider the idea that her mother's lover had murdered her father. There had to be, given the mother she knew and loved, given her mother's probity, some better reason for 'Brad', for 'Grateful to Brad', for 'the troubles with your father'.

Dr Olson? She could barely remember him: pipe tobacco, though she never saw him smoke, dark glasses, white shirts, clean shoes, even in winter. There wasn't enough there for her to create a 'Brad'. Worse: her mother's mentions of Dr Olson felt like a betrayal of the long reticence that had been a part of her intimacy with her mother.

She had assumed that her mother's reticence about the whole 'misfortune' had been meant to shield her daughter, to protect her from 'the worst any child could live through'. What was she to make of that silence now?

The letter said both too little and too much. Amara forced herself to read the words and phrases over and over, though the shame and revulsion grew with each reading. The letter was a venomous spider, and it was not possible to dissociate its venom from the memory of her mother who had, by a seeming miscalculation, managed neither to assuage her daughter's guilt nor to bring any kind of resolution.

If anything, for some time after putting the letter aside, Amara relived the misery of her father's death but, now, with a sense of betrayal that had not previously been a part of her memory. The guilt she'd felt *before* reading her mother's letter now seemed purer, and almost virtuous.

3

W arda was not intrusive. It wasn't in her nature. When, Friday evening, Amara came downstairs after reading their mother's letter and pleaded a headache and sudden exhaustion, Warda expressed concern, but no curiosity.

Nor, the following morning, did she seem interested in the letter she'd been safekeeping. Warda, soul of discretion, a living echo of their mother, down to her very features and figure, seemed more interested in Parkdale, a neighbourhood she'd always liked for its 'unpretentious' feel.

As they walked along King Street heading to Liberty Village, Warda complained about the Longo's and PetSmart and Winners . . . so many new franchises in glossy buildings. It was only as they sat in a coffee shop – which, though new, met her approval – that Warda said:

'Have you read Mom's letter?'

The question came without undue emphasis, as if the letter were just another subject between them, no more urgent than houses, children or health. But it felt, to Amara, as if Warda knew something. And so, testing her, Amara said:

'Yes. She wanted me to know that she forgave me for shooting Dad.'

'Oh!' said Warda. 'Is that it? I wonder why she wanted to wait 'til Dr Olson died, then? I thought maybe she was protecting him.'

'Protect him why?' asked Amara.

'Well, I don't know. Why else wait for him to die, though?'

She was staring at Amara, now, an eyebrow slightly raised.

'I have no idea,' said Amara. 'There's nothing in the letter that mentions him. I think she blamed herself for what happened and she just wanted to apologize.'

'She definitely blamed herself, poor Mom. I mean, it's not like she could have stopped a six-year-old from being curious. And what was the point of keeping so many guns around the house anyway? Honestly, Dad was obsessed. After I had Michael and Edwige, I really

wondered how anyone could leave a loaded gun where kids could get to it. I suppose it was a different time. When men were men and women were nervous is how Doug says it. It's sad Mom carried this guilt with her all these years. But it was obviously an accident. You don't blame yourself, do you?'

'No, no,' said Amara. 'Not any more. A long time ago, maybe.'

'That's what I thought,' said Warda. 'And that's a good thing, too. I suppose the Dr Olson thing is just a mystery.'

Amara drank her coffee, nodding her head in agreement.

'It was hard for Mom,' said Warda, living in Petrolia. 'She used to complain that everybody knew her business or wanted to. She felt like we were in a fishbowl. Which is why we left, I guess.'

'What was Dad like?' asked Amara.

Warda looked at her directly – interested, all at once.

'I don't think you've ever asked me that,' she said. 'Just as well, because the thought of him is pretty painful. He wasn't a good person, Mara. Mom wouldn't let us say anything bad about him, but I wasn't sad when he died. None of us was, except you and Mom.'

Now, out of nowhere, Amara recalled the smell of their father's aftershave, and the way he would put shaving cream on his face and pretend he was rabid, growling like a dog. It was a good memory, leading as it did back to a time she'd always imagined as idyllic. The memory – the feel of it – in no way corresponded to what Warda had just said. Nor did Warda's words correspond to what Amara remembered of the grief that followed his death.

'I know I was only six,' she said pointedly, 'but I remember Dad's funeral. I remember *everyone* crying.'

'There's no point arguing about things that happened forty years ago,' answered Warda, 'but I think Fern and Ruth will agree with me. I'm not saying we didn't love Dad. It's just that it was different for us. He wasn't the Dad you had. With us, he could be a little . . . *impetuous*. And that's all I'll say about it. If you want to hear more, ask Fern, though I imagine she's buried as much as she can.'

Something in Amara was deeply aggrieved by these words.

Despite her usual deference to Warda, she was almost desperate to protect her father, a desperation made more painful by the fact that there seemed no one else to defend him. How bitter it was that the one who longed to speak on his behalf was the one who'd killed him!

She kept this desperation to herself. She drank from her coffee and bit the almond croissant she and Warda were sharing: powdered sugar, almond paste, a brittle shedding of flakes. The reason for her hiding her emotions: She was wedded to the clarity that accompanied the idea – the fact – that she had killed her father; even more so, now, having heard her sister's efforts to tear the man down, having endured the tawdriness of her mother's letter.

It seemed to Amara, as she bit into the croissant, that her mother and sister were both trying to make things better for her, trying to lessen her guilt. Perhaps they still remembered her as she had been at fourteen, susceptible to darkness. And they were frightened for her.

But they had failed to convince her, and she was buoyed by the relief that accompanied their failure.

4

In the days that followed, Amara tried to avoid the subject of her mother and father, but it was not easy. For one thing, she felt compelled to ask Warda if their father had done anything 'unforgivable'.

'It depends what you mean by unforgivable,' Warda answered. 'He never molested us, if that's what you mean. Did he touch you?'

'No,' said Amara at once.

And again the image of her father's 'rabid' face came to her, along with the sound of his voice calling their mother's name.

'Ada! Where's my coffee?'

'Ada! Where did you put my lunch?'

'Ada! What are you doing?'

Always the same asking or beseeching; on the edge of anger, if you will.

'No,' she repeated, 'he never touched me. Why would you ask that?'

'You're the one who brought it up,' said Warda.

But she then waved a hand, dismissing the subject.

'Let's go out somewhere for supper,' she said. 'My treat.'

And that was that.

That was more or less that, in fact, for the remainder of their time together. Neither sister directly alluded to their childhood during the last two days of Warda's visit. They spoke, instead, of Ruth and Fern, of children, of Toronto, of Center Island, of the state of democracy, etc. And when it came time for Warda to leave, Amara took the afternoon off, accompanying her sister to Union Station, waiting with her until her boarding call – Train 60, Track 17, east towards Ottawa, where her son lived.

Their parting was as poignant as it usually was. Amara's love for her sister was not the least changed by what had passed between them – their mother's letter, the pointed discussion about their father's personality. If anything, the fact that they had *not* talked about these things for two days was restorative – restorative of the silence her mother and sisters had always maintained around family matters. A careful silence, as it now seemed.

Amara felt relief as she walked out of the train station and decided, because the day was warm and the sky was blue, to walk home along the lake shore, hurrying through the mingle of exhaust and stale air, shadows and noise, jackhammers and music that afflicts pedestrians as they walk south on Bay Street.

After that, what else could it be but pleasure to see the lake, to feel it?

And as she walked along the shore she looked out at the water, which was not blue at all – as it invariably was in her imagination – but various and changing so that, in places, it was gunmetal or grey as a cloudy sky before rain. Here and there it was blue or bluish, while in the distance, touched by some errant light, it was bright green. And

it occurred to her that, contrary to her assumptions about the city's changes, the lake was more various and changeable than Toronto was. She had always thought of the city as 'ever-changing' but, obviously, it changed physically much less often than the lake beside it. More than that, when she thought of the city's inhabitants, it occurred to her that, from a certain angle, they were always the same: their faces different but their stories limited and drab.

Even her misfortune, when you considered it coldly, was more of the same human sadness. How many children had accidentally – or purposely, for that matter – shot a parent? Too many to count, no doubt. And although her story was vivid to her, wasn't it, in the end, more of the human noise that drifted across the water, dissipating long before it reached the middle of the lake?

At Spadina and Queen's Quay, she wondered how far the sound of a city actually travels over water. And turning to look at the lake she thought of her father, poor man, his story as tawdry as hers, the ways in which humans betrayed each other more limited and certainly more predictable than the evolutions of cloud cover and water colour beside her. This thought was as comforting as the discretion that had reasserted itself between her and her sister.

<div align="center">5</div>

That evening, Amara stayed in and ordered momos from Little Tibet. But otherwise, she returned to the life she had made for herself. She deliberately returned. She did not think about her sisters, did not think about her father and tried not to think about her mother.

She failed to avoid thinking about her mother, however, because as she turned on her computer to stream an episode of something vacuous, she happened to push aside the envelope containing her mother's letter. And how strange that a white, unaddressed envelope could cause such distress.

What was she supposed to do, now, about the envelope and its letter? She could not leave it on her desk. She did not want to think about it every time she sat down. But neither did she want to put it somewhere 'safe', somewhere someone else – one of her sisters, say, on a visit – might find it and read her mother's words.

For any number of reasons, she did not want to destroy her mother's letter, either. It was, for one thing, the only letter her mother had ever written to her, and there was something moving and intimate about this. It was, besides, two pages of her mother's handwriting and, as such, it held something of her mother's essence. It felt as if burning the letter would be a burning of her mother, a being she had, of course, adored.

And yet, burn the letter is what she did.

Taking it from its envelope and reading it again, it occurred to Amara at last that the letter was not true. It occurred to her that the letter was a touching effort by her mother to free her from guilt; touching and, for all that, slightly desperate. Because of course *she* had shot and killed her father. It was inconceivable that Dr Olson – of whom she had a sudden and vivid memory: the man tossing her up in the air, as her father had done – it was inconceivable that such a kind man had, what?, murdered her father and allowed her to take the blame? It was not possible, and there was no reason to think about it, no reason to give the idea oxygen.

Her mother had clearly had kindness in mind, not truth. Moreover, the kindness had been meant for her alone. Why else write the letter and then leave it with Warda – Warda, who would have died rather than break the promise to keep it to herself? No, there was no doubt that this kindness had been meant only for Amara.

It was in this spirit, imagining she was keeping a private mitzvah private, that she burned her mother's letter: setting fire to the envelope and letter by the flame of her gas stove, leaving the pages to burn in the nicked and yellowed porcelain of her kitchen sink.

6

In the weeks that followed, any number of variations of her situation occurred to Amara, most of them bringing their share of humiliation: that her mother had written the truth, that her mother and Dr Olson had been lovers and they had done her poor father in, that her father had been a violent man and Dr Olson's intervention had saved his survivors.

Along with these scenarios, there came an unwanted solidity to her memories of Dr Olson: the smell of him around the house after her father's death, the tone of his voice, troubling her, now, as he spoke her mother's name – Aydie, not Ada.

She put these versions resolutely aside, however, holding on to her own guilt, as if it were a thing that shielded her from the tawdriness of the world, as if it were both essential – a necessary part of her – and yet in need of protection.

This guilt was part of a peculiar mechanism, since it was only real when it caused her pain, and it caused her pain only when she imagined her father as she had known him: kind, funny, loving. Amara, of course, did not see her guilt this way, but she felt it: a paradox, her distress bringing her comfort.

That is, although it was painful, she clung to her guilt until, after a few months, she could once again begin her own story, when telling it to herself, as she always had before, with almost as much confidence: At the age of six, Amara McNeil shot and killed her father . . . ■

CBC
CURTIS BROWN CREATIVE

THE WRITING SCHOOL LED BY THE
MAJOR LITERARY & TALENT AGENCY

Raise your writing game this year

Inside Story
with Tessa Hadley

Writing Short Stories
with Cynan Jones

Writing Poetry
with Anthony Anaxagorou

Unleash your imagination and hone your writing craft on a five- or six-week online course

- Inspiring teaching videos with exclusive advice
- Tasks to help you develop new writing skills
- Personal feedback from an expert editor
- Work-sharing with a peer group of writers

£20 Off
with code
GRANTA20

Enrol today to discover your writing voice

www.curtisbrowncreative.co.uk

Grundig TK 1 tape recorder, Germany, 1960

THIS IS AS FAR
AS WE COME

Carlos Fonseca

TRANSLATED FROM THE SPANISH BY MEGAN MCDOWELL

Juvenal Suárez was the youngest of five brothers, and he had watched all four of his siblings fall prey to the fevers of measles. '*Mu unteva*,' he'd heard his last brother say, and watched him dissipate just like that, the way flowers or clouds fade away. At that time there were fewer than fifteen members of the Nataibo tribe and only Juvenal seemed to understand that the words held a sad prophecy. A few weeks earlier, an expedition of garimpeiros in search of gold had stumbled upon their Amazon village, and from that moment on the Native population had fallen ill at an alarming rate. '*Mu unteva*,' his brother had said, proud that none of the garimpeiros could understand what his words meant. They were words that Juvenal Suárez would translate two years later for Von Mühlfeld as 'this is as far as we come', speaking a brittle Spanish he had learned years before from the rubber tappers whose arrival had marked the beginning of the end for the Nataibo people. He'd been only twelve or thirteen years old then, and he had never seen a white man. He couldn't know, then, what the older people remembered: that those men were demons, thirsty for rubber and blood, capable of unspeakable atrocities. Much less could he know that during those years, on a distant continent, the world was laying its bets in a war that would destroy all but the heavens. Even the Nataibo, who had pursued

isolation and privacy with such zeal, were not safe from that vile war. It was 1942 or 1943, and, when the Japanese captured the Southeast Asian rubber plantations, the Allied forces had been obliged to return to the route that a century before had led thousands of men into the nightmare of an unprecedented hell. Hope and a lust for victory were returning then, and the Amazon's waters were witness to the return of a monster everyone thought had been defeated. That was when a lost expedition of rubber tappers came into contact with the tribe, and Juvenal Suárez first saw the pale and pinkish skin of white men. In those days his name was not Juvenal Suárez, and if not for the old folks' memories he wouldn't even have known that they were men. In the following months he would learn it the hard way, on those rubber plantations where slavery came wrapped in the whisper of a strange language. That would be where he first heard the Spanish language that later, over the course of his life, he would learn and then renounce.

All that would remain of those years was a handful of words and the memory of the great wave of malaria that washed over them a few weeks after the rubber tappers' arrival. That first epidemic, furtive and deadly, would take both his parents and one brother. Even more important, it took away the illusion of solitude and isolation that had insulated the tribe up to then. So when the white men exhausted all the rubber in the region and finally set them free, the Nataibo decided to set off upriver in search of the peace that had now become synonymous with survival. After four days, they found a spot at a bend in the Tigre River that seemed remote enough, and they decided that was where they would seek the tranquility the rubber tappers had stolen. And they found it, or at least they thought so.

The years that follow are serene ones during which Juvenal cautiously watches the passage of time, aware that death, disguised as civilisation, is always hiding just around the corner. And so, one afternoon like any other, a decade and a half later, the hum of an airplane interrupts his nap. Rubber has been replaced by oil, and a US company – repeating a gesture as ancient as it is perverse – has

decided that the only way to conquer the jungle is through evangelism. A week later they see the first missionaries arrive from Puerto Rico, Bibles in hand. The image brings back the traumas of the rubber exploitation, the memory of his sick mother, the violent murmur of that language he has forgotten but that he starts to remember, with terror and fascination, as one more trauma. Those men and women don't want rubber. They are after something more ethereal but fearsome: the conversion of souls. And that conversion starts with a name. On the second day the missionaries gather the tribe, put them in a line, and baptise them with Christian names. He is twenty-seven years old, and a short, round girl with a face that inspires affection and tenderness looks at him and says that from this day onward his name will be Juvenal Suárez. He comes to accept it, not so much by choice as by rote – after hearing the name so much he ends up recognising himself in it. Along with the name, the girl gives him another talisman: a Spanish-language Bible that he will translate to Nataibo in his free time, a process that will take years but will ultimately convince him that the white man's language is not necessarily the language of evil. This is a period of peaceful coexistence, of learning language and religion. It ends the day when, the missionaries gone, the Nataibo see an expedition of garimpeiros arriving in the distance and realise it's time to migrate again. The trip takes ten days. This time, they carry the weight of inherited Bibles and the awareness that the jungle is filling up with enemies and intruders. They also, unbeknown to them, carry the first outbreaks of the measles that will ultimately destroy them.

Later, Juvenal Suárez will summarise that time with a word my father will one day hear emerge from the tape recorder and copy into his diary: '*Na'teya.*' Paranoia. From that moment on the Nataibo's existence will be marked by awareness of their imminent disappearance. Still, fifty members of the tribe remain, and none are willing to give up without a fight. Prepared to battle it out to the end, the Nataibo prepare their settlement as an impenetrable fort, surrounding their village with traps and pits, even building a

tiered surveillance system to warn of any enemy landing. They can't imagine that the enemy is already inside, in the form of a virus that will eventually reduce them to a handful of men forgotten by history. Just a week later, a member of the tribe has a fever, and when the shaman sees the reddish rash that marks his face, he knows there is no chant or prayer that can save them. And just like that, Juvenal sees the rash take the members of his tribe one by one, with the mysterious logic of contagion he knows so well, and he is convinced that his turn will come any minute. He watches his oldest brother die and then his wife, he watches his son and his uncle die. But it's at that moment, beside the brother whose whispered last words he will translate for Von Mühlfeld as 'this is as far as we come', when he understands that perhaps his fate will be even worse than his family's. He intuits, as he looks at the dying face of his last living brother, that perhaps the gods have ordained for him the misfortune of being his culture's only survivor. '*Mu unteva*,' he repeats in anguish, and in the words he hears the stealthy echo of a private language.

Perhaps that was the echo my father heard again four years later, sitting before that Alpine landscape so far from the Amazon, when he heard Juvenal Suárez's recorded voice. It was a voice that held no traces of melancholy, no irony. Merely the objective diligence of one who knows his own fate and decides to accept it without complaint. Something in the timbre of his diction recalled the exactitude of a man merely going along with a pursuit that he may not believe in, but on which someone close to him has pinned all their dreams. 'Juvenal Suárez, Dictionary, 1965,' the voice had said, and my father could immediately divine what was at stake there: the hope for survival of the Nataibo language had been reduced to a couple of magnetic tapes where future generations would seek the vestiges of a culture that had long since ceased to exist. He also knew that Von Mühlfeld's shadow loomed over that project, and it was that story, so full of contagion and solitude, of purity and impurity, that held the keys to the paradox that had led the anthropologist into madness. Knowing my father, I can guarantee that he said nothing that day, merely listened to the

unfortunate adventure of Juvenal Suárez, accepted the responsibility that secret entailed, and promised that on the fifth day he would take the tapes with him and continue the project Von Mühlfeld had been unable to complete. Knowing my father, I'm sure that a certain reticence kept him silent, and only hours later, in the hotel, would he have dared to open his diary and write down the tale I'm retelling here. A story he would try to synthesise with a couple of phrases that as a child I read without understanding, but that today pursue me as the key to my own biography. Those phrases like fists that say:

'the theatre of a voice doing battle with history, the silences of a language doing battle with oblivion.' ■

WHAT IT PROMISED

Cian Oba-Smith

Introduction by Gary Younge

In his book *The Promised Land: The Great Black Migration and How It Changed America* (1991), Nicholas Lemann describes a Southern rural landscape pockmarked by abandoned shacks. The mechanisation of cotton picking made some sharecroppers redundant, and many were unceremoniously forced from their homes. Elsewhere African Americans fled the South's racial tyranny seeking better wages and more dignity in the North, often at night, taking only what they could carry and leaving the rest where it stood.

'The Delta today is dotted with nearly spectral sharecropper cabins,' writes Nicholas Lemann. 'Their doors and windows gone, their interior walls lined with newspapers from the 1930s and 1940s that once served as insulation.'

Cian Oba-Smith's photographs of Syracuse's 15th Ward convey an analogous racial landscape almost a century later. Haunting scenes of dereliction and desertion: charred shells of houses, boarded up places of business and worship, long grass and empty lots underpinned by almost total segregation. Only this time it wasn't people who left but capital, taking its jobs, infrastructure and opportunities with it and leaving those who remain to insist on their humanity and salvage

what they can of their community. Herein lies the resilience that stands in contrast to and defiance of the desolation: babies are born, flags are flown, ball is played. Life goes on.

These pictures capture a bleak historical symmetry because we can assume many of the people Oba-Smith portrays in this decaying urban environment are the descendants of the sharecroppers who escaped those spectral, rural cabins generations ago. As such they are living testimony to James Baldwin's assertion that the only difference between the North and the South was that '. . . the North promised more. And [there was only] this similarity: what it promised it did not give and what it gave, at length and grudgingly with one hand, it took back with the other.'

In 1950, when Syracuse was at its population peak of 221,000, just 2 per cent of its inhabitants were Black. As the city shrank, its Black population grew exponentially. Syracuse today has just two-thirds of the inhabitants it once had: some 146,103, almost a third of whom are African Americans. For much of that time they were primarily confined to the 15th Ward, thanks to Jim Crow's kissing-cousin redlining, whereby Black people were confined to certain areas of a city because banks refused to lend them the money so they could buy elsewhere.

For a while the presence of Black people and the presence of capital coincided, providing skilled work and the economic basis for a culture and community to thrive, albeit within its enforced racialised borders. As the economy declined African Americans became a larger part of a shrinking and impoverished city. The steel mills closed while heavy industry like Rockwell International, General Electric and the Carrier Corporation moved either to the American South or Asia, where labour was cheaper and unions were weaker.

Through Oba-Smith's lens we witness the lived consequences of the combined impact of liberalised global trade, deindustrialisation, the legacies of slavery, segregation and municipal racial codes: a separate and highly unequal reality for African Americans, denied the education, training, investment or infrastructure to meaningfully compete in the modern economy. Of America's hundred largest metropolitan areas Syracuse has the highest rate of extreme poverty

concentrated among Black and Hispanic residents, according to one Rutgers study, and the highest level of child poverty among cities of over 100,000 people. 'Within a large, diverse and highly mobile post-industrial society,' argue Douglas Massey and Nancy Denton in their landmark book, *American Apartheid: Segregation and the Making of the Underclass*, 'Blacks living in the heart of the ghetto are among the most isolated people on Earth.'

The isolation Oba-Smith depicts is primarily collective. The blur of cars on Interstate 81 takes people through and over past Ward 15, much of which was cleared to make way for the motorway, but not to it. The red lines were drawn not only to keep the Black community in, but also to keep resources and other people out. ■

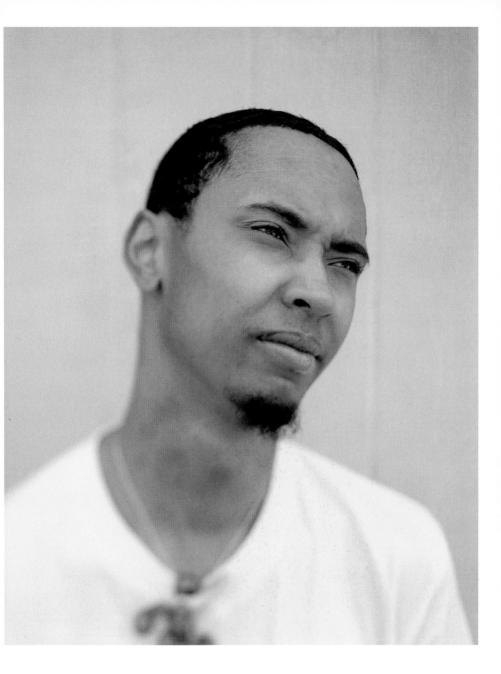

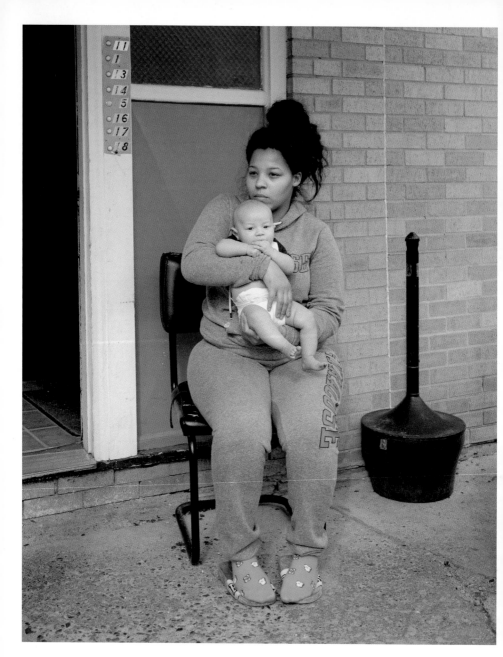

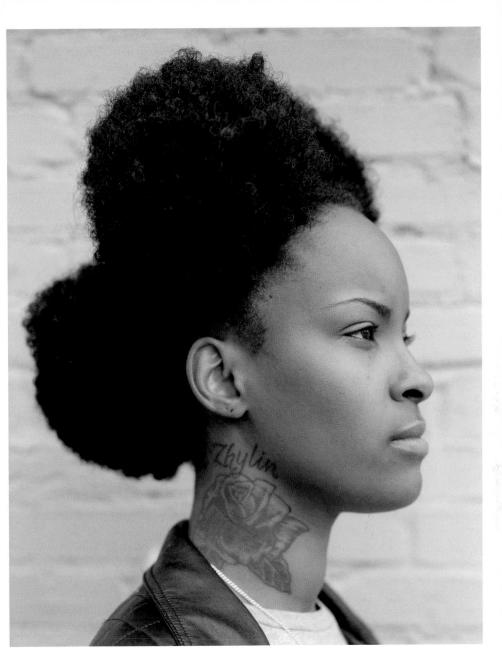

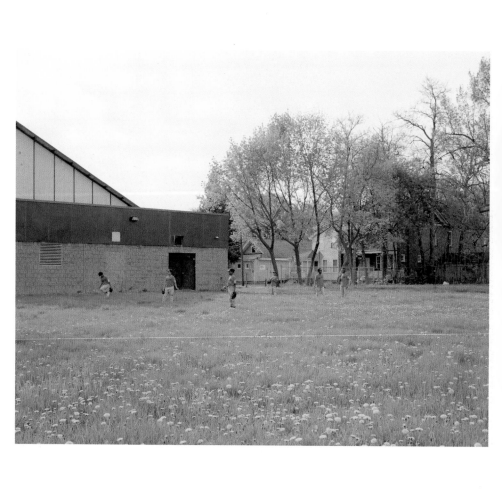

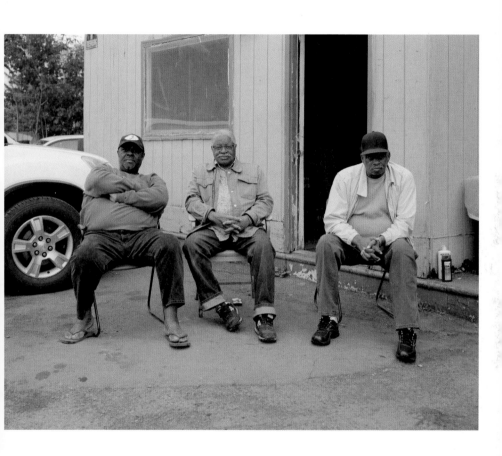

AMITAVA KUMAR
Hills of Kumarhatti, Solan, 2022

MANY WORDS FOR HEAT, MANY WORDS FOR HATE

Amitava Kumar

D elhi. Did Virginia Woolf write about the heat while she was
traveling in Italy, Greece and Turkey? I cannot remember. I
can remember nothing in this heat. There have been days where the
temperature was over eight degrees Celsius higher than normal. The
previous month was the hottest since India started keeping records
120 years ago. People dying from heatstroke; schools closing early
or simply shutting down; power outages. Before the heat here I was
at the British Library in London, looking at Woolf's notebooks from
her travels over 1906–1909. When I bought my own notebook at
Heathrow, I made a little calendar in plain imitation of how Woolf
had drawn her plan of travels during October 1906. Milan, Siena,
Perugia.

In Delhi the heat is chemical, something unworldly, a dry bandage or heating pad wrapped around the body. I sent a note to my friend Ravish, who was an anchor on NDTV's Hindi show *Prime Time*. I asked Ravish that if Inuit supposedly have more than fifty words for

snow (a *specific* word, for example, for snow used to make water), why don't we Indians have more words for heat? Ravish asked members of his audience to respond to this question. Words and phrases that Ravish and I didn't know, in a mix of Indian languages, came in from different cities and parts of the country, adding nuance and variety to what the newspapers were only calling a 'heatwave'. Ravish concluded his monologue by saying that if you forget the many words for heat in your own language, you will also forget the names of your neighbors or the fact that people of two different religions used to live peaceably together. You will also forget why you are beginning to forget.

My publisher provided a car for me to go to bookshops and sign copies of my books. At one point I passed a billboard that showed a fighter jet in the sky and above it these words: *Join IAF and give your career a flying start.* That Indian Air Force ad hadn't changed for forty years. I remember seeing it from bus windows in my late teens, and how, because I lacked any sense of direction, I would imagine myself in a jet, my head in the clouds.

There are new billboards too. A ubiquitous one is that of Arvind Kejriwal, Delhi's Chief Minister, sitting in a yoga pose on green grass. The ad promises that a yoga teacher will be in touch if you call the number provided. Nehruvian secularism, with its separation of state and religion, is now a thing of the past; more dangerously, religious identity, specifically a Hindu identity, is conflated with the national identity. To be Indian is to be Hindu. On the campaign trail, Kejriwal recited from Hindu prayers and sponsored government-paid pilgrimages for the elderly from Delhi, most egregiously to places like Ayodhya, where a sixteenth-century mosque was demolished by a Hindu mob in 1992 as a part of the ruling Bharatiya Janata Party's ascent to political power. No one, not even an opposition politician like Kejriwal, who should stand outside the ruling party's Hindutva fold, dares show a distance from what is fast becoming – no, what has already become – the culture of dominant majoritarianism. Hindutva, in its hard-edged form, is brazenly genocidal. As an ideology of ethnic

absolutism, it decrees that India is only for Hindus. During the riots in Delhi in 2020, one of the slogans was '*Hinduon ka Hindustan*' (India is for Hindus). In this scenario, yoga is only soft Hindutva. Let us focus on our inbreath and outbreath while the rest of our co-religionists lynch Muslims on the streets.

A journalist friend tells me that in his youth he watched Hindi films in which the hero, invariably an angry young man, wreaked havoc on his enemies. When the film ended, my friend would step out of the cinema hall feeling superhuman, his nerves tingling. He was telling me this story because, he said, *that* is the feeling now gripping Narendra Modi's followers. They imagine themselves as the protagonists in a powerful story about the destruction of their enemies. There was a Ram Navami procession in Delhi my friend watched, a traditional occasion celebrating the birth of Lord Rama, who has been adopted as the reigning deity of the Bharatiya Janata Party's campaign for a Hindu nation. The crowd in the procession was chanting obscene anti-Muslim slogans. My friend looked up from where he stood and saw two young women filming the procession on their mobile phones from a high balcony. It would be normal, my friend said, for these upper-middle-class women to feel uncomfortable when confronted with open displays of thuggish behavior. But not the two he saw on the balcony. Their faces shone with enthusiasm. Each one pumped a fist in the air. The women reminded my friend of what he was like as a teenager, his imagination fired by a delusional masculinist fantasy projected on a screen.

U mar Khalid is a scholar and activist who earned his doctorate from Delhi's Jawaharlal Nehru University. Khalid has been in prison since September 2020 under the notorious UAPA law (Unlawful Activities Prevention Act). Originally passed in 1963 to grant the government extra powers of detention, it was amended by the BJP in 2019 as a so-called 'anti-terror' law that allows an individual to be arrested and detained without trial. A huge number of the arrests made under UAPA in recent years have been of the

government's critics, journalists and activists. Khalid is accused of inciting riots in Delhi in February 2020, in which fifty-three people died, most of them at the hands of Hindu mobs. Kapil Mishra, the ruling party politician who openly called for violence against Muslims during that time – the man who allegedly instigated the riots – hasn't been named by the police in the case.

Today I wrote a letter to Khalid, which a friend forwarded to his lawyer. I had heard that Khalid had read more than a hundred books in prison. *Umar, can you tell me what you have been reading?*

M y wife's name is Mona Ali. Her uncle is a retired police officer. For decades, this uncle – whom she calls Chacha – has kept a daily diary. This is of interest to me as a writer and a diarist. I remember that I was present at Delhi Airport, back in 2001, when this gentle, old man first met my wife, his younger brother's daughter. He was meeting his twenty-six-year-old niece for the first time because they had always been separated by a border. Two decades ago, my wife was allowed a visa to visit India, and so she traveled from Pakistan to Delhi. At the airport, Mona and Chacha hugged and cried while I stood to the side and watched.

Today I asked Chacha to read me his diary entries from that December in 2001. He had accurately recorded my wife's arrival on the seventh, but the prose was emotionless. No mention of heartache, or the tears that I'd observed. I too made an appearance. Chacha's entry for the thirteenth of December reads: 'Terrorists attacked the Parliament. Waiting for Mona and her husband to visit us.'

Chacha's eldest sister left for Pakistan the year after the Partition. He didn't see this sister again till he retired from the police and was able to travel to Pakistan. In other words, Chacha wasn't able to see his Qamar Apa between the years of 1948 and 1992. How was their first meeting after that long separation? What did he write in his diary? While I was making my unsuccessful search among the stacks of his diaries for the one from 1992, Chacha told me that those who had lost their siblings during the riots that accompanied the Partition

were, perhaps, luckier than him. Their loss was final; his loss had lingered, tearing him apart as one year stretched into another, decade after decade.

I then looked at Chacha's diary from the year 1979. At that time he was a senior officer, a deputy inspector general of police, in an eastern Indian city named Shillong. He was helping build a police academy there. On the nineteenth of January he received a telegram from his brother in Pakistan, informing him that their father had died a few days earlier. Chacha's father lived in India, but he occasionally visited Karachi. (Such travel was possible at that time.) The news of his father's death left Chacha bereft, and he wanted to call his mother. When he booked a trunk call to Karachi at the local post office, he was asked what language he would be speaking in. He said it would be Urdu. A few minutes later, the operator called to say that no interpreter could be found. Each phone call to Pakistan had to be monitored, and no Urdu speaker was present in Shillong. As a result, Chacha wasn't able to talk to his mother. Speaking in English now, he told me that the irony was that at that time he was in charge of the entire border that India shared with Bangladesh and what was then still called Burma.

Chacha recorded in his diary the receipt of the telegram from his brother on the nineteenth. I went back to the page for the thirteenth of January. On the top he had written 'Holiday. Second Saturday.' And then, 'Listened to cricket commentary all day.' Underneath, in a clearly retrospective entry, he had drawn a rectangle and noted within that space the following words: 'Abba passed away today.' Often, I make the mistake of thinking that diaries reveal secrets; the truth is that as often they reveal silences. There was no mention in Chacha's diary of his failed attempt to offer condolences to his mother.

Patna. In the plane from Delhi, poor migrant workers are returning home for Eid from Saudi Arabia and other countries in the Gulf. Because I was speaking in Urdu, they assumed I was Muslim. How long had it been since I had come home? I said two

years and more. I was going to see my father, I said. One of them, the older one, said that my return would make this a special Eid for my father.

My father is eighty-six and, probably because of social isolation, he has aged terribly during the pandemic. I would try to talk to him on the phone, calling him from New York or London, and he appeared lethargic and uninterested. In early April, I bought two tickets to India. One for myself and one for my son. My son loves to talk to his grandfather; both of them possess a fantastic memory for trivia. But then my son's application for an entry visa to India was denied. We were told that the Ministry of Home Affairs would need at least four to six weeks to do a security check. This is because his mother, my wife, was born in Pakistan.

Like so many of my friends from school in Patna and Delhi, my father, who had always seemed liberal to me, has become a Modi supporter. What did he think of the Indian government regarding his twelve-year-old grandson with suspicion? When I got home from the airport in the late afternoon, my father was lying in bed. I touched his feet. He looked older, even shrunken, and vulnerable. He asked me about my children, what their plans were, and when they would be able to visit him. I didn't ask the question I had been framing on the flight. In fact, I knew that I wouldn't even bring up Modi's name. We were going to be together for only five days.

My father likes to take a twenty-minute walk each morning, but prefers to lie in bed for the rest of the day. I don't know exactly why this should be so. The other day, on the flight from London, I watched Anthony Hopkins in the film *The Father*. Hopkins plays a man suffering from dementia, his memories jumbled. He tells his nurse, 'I feel as if I'm losing all my leaves.' I put the movie on pause to note down the line in my notebook. There was a reason for the lump in my throat. My sister had informed me on the phone that recently my father, for the first time in his life, seemed disoriented at the bank. My father is someone who remembers everything, not

just phone numbers but also bank account numbers and registration plate numbers. He was now mixing up dates of birth.

This morning I told my father I was going to walk on the promenade beside the Ganga, and he said in response, quite correctly, that this was an auspicious day, Akshaya Tritiya, the day celebrated as the one when the River Ganga was said to have left the heavens and descended to Earth.

It was also Eid ul-Fitr. On the Ganga promenade there were young Muslim men strolling about in their new kurtas, mostly a blazing white but also yellow or pale blue. Although I had expected it to be hot, a fine breeze now lifted from the river. On occasion, my nose caught the smell of sewage and decay, but otherwise the air was pleasant. In news photographs of the promenade I had seen students cramming for exams, but there were very few of them now around. Young women posed for selfies at the water's edge. Four teens, two men and two women, were recording a TikTok video without any self-consciousness. My father had asked me to take a sip of the holy water, but I saw the debris and the filth and didn't dare.

For fifty rupees, boats took you to the opposite bank, where you could walk on the sand and buy tea at one of the shacks. I went. Sweet milky tea was served in clay cups. When dusk fell, the lights of the city began to glitter in the distance. And the glowing fires where dead bodies were being cremated. On the boat back to the promenade, a small group of young men took it upon themselves to raise the slogan *'Jai Shri Ram'*. This means loosely 'Victory to Lord Ram', and has been turned by the BJP into a battle cry in the war against minorities. In viral videos produced over the last few years, Muslim men are beaten or lynched and forced to chant *'Jai Shri Ram'*. Everyone on the boat watched the young men, but no one joined in. On the way back to my father's house, even before I had reached the open expanse of Gandhi Maidan, I looked up and saw, above the dusty haze of Ashok Rajpath, the thin and brilliant crescent of the Eid moon.

M otihari. My father agreed to come on a day trip to our village in Champaran. The family homestead is less than an hour away by car from the district headquarters in Motihari – where Gandhi launched his satyagraha. His protest against the British found its start there. I have dim memories of the smoke-blackened hut in which my father was born. When I was still a boy, a brick house was built where the hut had stood. There was no electricity in the village till I was already in college. No running water either. When I was growing up, this trip from Patna took a whole day, first crossing the Ganga by ferry, then a long journey by train or car, and, during the final stretch, a bullock cart. But now it is possible to drive here in under four hours. My father is very proud of these changes.

If you were to judge by the billboards on the drive from Patna to Muzaffarpur to Motihari, you would believe in the story of a nation under construction. Most advertisements are for cement, iron rods, tiles, pipes, paints. Another item that enjoys a similar ubiquity is coaching classes. Tuition for chemistry, math, biology. Assurances of high scores in the entrance exams to engineering colleges. And ads for men's underwear. Bollywood actors wearing vests or briefs. Even in the hinterland, or particularly in the hinterland, is a sense of hectic expansion, and a desperation to make it in a transforming market, even if mobility seems limited only to male consumers, confidently armored in a uniform of crisp white cotton.

On the way to the village we visited George Orwell's birthplace. Orwell's father, Richard Blair, was a sub-deputy opium agent for the British. While he was still an infant, Orwell was taken by his mother to England. The house where he was born is now gone, but a small building has been built at the site in Orwell's memory. There are no books or pictures in the two-room structure erected in Orwell's memory. A hundred yards away stand the skeletal ruins of the warehouse where the British stored opium before sending it on to China.

From Motihari we resumed our journey to the village. All through my childhood, this last leg of the trip would leave us covered in dust. Our clothes, faces, even our eyebrows would be coated in this gray

dust that I had seen nowhere else. But now there is a narrow tar road leading right into the village. That wasn't the biggest change. The most striking sight for me was two women riding scooters. And even more promising, girls in school uniforms on pink bicycles. The bicycles were provided for free by the government in a bid to raise female literacy. My sense is that the policy is revolutionary: the free bicycles have brought women out of their homes in a rural, rigidly patriarchal society.

Jadopur. Our village home was clean but derelict, its rooms locked. Parts of the house had collapsed, a heap of bricks. I have a novel coming out next year in which I have put parts of this house – the prayer room where I imagined my grandmother's death; she died while I was in grad school in America, and I wasn't there to witness it – and looking at those empty spaces I felt that I had stolen the soul of the place for my story. Feeling uncomfortable, I quickly stepped out. A few of the villagers had stopped by. They had seen me on Ravish's show, and wanted to send him messages.

A quiet man whom I had never met before also wanted to talk to me. He had been appointed as part of a government scheme for rural upliftment. His work was extremely local – he had his roots in the area; his official designation was *vikas mitr* or 'development friend'. He had come to talk to me because he wanted me to write an op-ed asking for clinics in those parts of the villages where the primary inhabitants were people from the lower castes. There are no provisions for hygienic living in these poorer parts, and people regularly fall ill due to the heat. Food spoils easily on hot days and causes diarrhea and food poisoning. Meningitis is another killer. As the lower-caste inhabitants in our village were mostly manual workers, they lived hand-to-mouth. Given the absence of any nearby medical facility, they were forced to go to nearby towns in search of treatment, which could lead to debts of up to fifty thousand rupees. When these workers fell ill their children were left defenseless in their huts. I was struck by the *vikas mitr*'s undemonstrative, earnest tone.

Only fifty yards away was the small hospital that my father had built in his mother's memory. I pointed at it. The *vikas mitr* didn't want to say anything that would offend me, and so he didn't respond. Another man, now with a beard that had gone white, although I remembered him from earlier days when we had played in the village pond together, said that there was a hospital, sure, but there was no doctor and no access. He said, 'A fan is rotating inside, there is a bottle of water on the table, but there is a large lock hanging on the gate.'

Patna. I heard on TV that the World Health Organization has estimated that more than 4.7 million have died from Covid in India, ten times more than the figure provided by the government. I stayed in today because my stomach was upset. From time to time, I came out of my room to work on a drawing in my sister's kitchen. I was drawing the street below the kitchen window. The young woman who is the cook made space for me, and thereby earned the right to comment on my efforts. She was happy that I had put in the drawing the black dog she always saw outside, but the truth is that there are at least half-a-dozen street dogs, all black, that congregate below. The one I had chosen to draw had an injured left hind leg. In the evening, Naresh Kumar, a young Patna artist, brought me coconut water. He said it was the best cure for diarrhea. We spoke about the Covid deaths. Back in November last year, he had a show in town at Gandhi Museum. It was an outdoor exhibition called *Hometown Anatomy*. One of the main installations that Naresh had set up was a coffin made of mirror-glass, with the coffin placed atop a rickshaw cart. In our home town, Naresh had seen all kinds of things being transported on such carts: fruit, vegetables, timber, tools, even a fridge. But during the second wave of Covid, each cart was loaded with a corpse. These carts lined the road where his old art school was located; this road leads to the cremation ghat, and there were so many corpses that each cart had to wait long for its turn. Naresh walked past the carts and all he could see were the feet of the dead protruding from under their thin coverings.

AMITAVA KUMAR
Below my sister's kitchen, Patna, 2022

The week before I arrived, there were accounts in the news, and especially on social media, of bulldozers being used to demolish Muslim homes in Delhi and elsewhere. The visiting British prime minister, Boris Johnson, appeared on my timeline, because he had jumped aboard a new JCB bulldozer factory in Gujarat. The JCB bulldozers were the ones being used in the demolitions. Did he not know that people's homes were being destroyed?

In more recent news, a feminist activist named Kavita Krishnan tweeted about a Hindu man being publicly killed in Hyderabad for marrying a Muslim woman. The BJP was using this incident to further spread anti-Muslim hate. The activist responded, pointing out that Modi's *bhakts* had done the same thing, celebrating the killing of a Muslim man, Dilshad, who had married a Hindu woman.

I mentioned the above tweets at a small gathering of my extended family in Patna. We were just sitting around drinking lemon tea. Someone said that a nephew of mine had been having an affair with a Muslim girl from Kashmir. The boy's mother interrupted to say that she had been relieved when they broke up. She had been scared that he'd be killed by the girl's family. Then I was asked if I remembered an incident from my boyhood. We were in our ancestral village at that time because it was winter break. Did I remember a distant relative of ours, a young woman, who had died because her infected appendix had burst inside her? I didn't remember. It didn't matter. The truth was now being revealed to me. There was no burst appendix. The girl had been killed by her own family. She had made the mistake of getting involved with a Muslim classmate. The relative who was telling me this story learned this years later when she was at medical school. A fellow student told her that his best friend had been that girl's lover. He didn't know how the girl had been murdered, but he had seen what her family had done to the boy's body. Try as they might, his friends couldn't find enough pieces to make a decent corpse.

Patna. I was invited to speak at a college that I used to pass every day on my way to school as a boy. At that time, I understood that this particular institution was a breeding ground for goons, but my father informed me that the college was now among the best rated in Bihar. When asked to choose a topic, I said I would talk about keeping a diary. I wanted the students to write down what they saw around them, and to record what was happening to them. (Was I thinking about the students? Not so much. I was thinking about who I was when I used to live close to the college. I wrote nothing then. My days were never connected in a story I could use to narrate what was happening in my world.) The organizers had been good enough to follow my request and give everyone in the audience a sheet of paper. There were three prompts from my side. 1. 'Yesterday it rained and today . . .' 2. 'During the pandemic . . .' and 3. 'I want to tell the writer . . .'

I should perhaps pause and first tell you that unlike any lecture or reading I have done before, there was a complicated ritual I had to follow at this college. The organizers asked me to remove my shoes and then place rose petals near the portrait of the politician after whom the college had been named. Next, flowers were presented to me, and a beautiful silk shawl draped around my shoulders as a gift. When this had been done, and duly applauded, I was given a lit candle and asked to light a lamp. While I was doing this, the men and one woman who were onstage with me placed their fingers lightly on my arms, so that we were all symbolically linked as we lit one wick after another. It was like a Hindu prayer ceremony, and it was remarkable to me that this wasn't seen in any way as being out of the ordinary at a secular educational institution. Lengthy introductions followed. It was only later revealed to me that the founder of the college, the principal, all the heads of various departments at the college, and indeed, also the day's honored speaker, belonged to the same upper caste. We hadn't yet made the great leap forward into modernity.

When I arrived back at my father's house, I was curious to see what the students had written. In response to the first prompt, many had

noted the renewed heat of the day. To the second, many wrote about the suffering and deprivation experienced during the pandemic, particularly by Bihari migrant workers. The responses to the third prompt were puzzling. Most students left that part blank. The first two prompts had asked for concrete responses, and they were easily provided; the third prompt was open-ended, and required a more abstract and maybe even an *imaginative* response. It was difficult not to conclude that the students for the most part had nothing to say to the visiting writer.

But a few did. I had read to them a passage about a human rights lawyer who, speaking in Delhi to those protesting against unjust citizenship laws targeting minorities, advised everyone to keep a particular kind of diary: 'Keep a record. Don't trust the state. Don't expect the police to document the violence it is raining on your head. You have to do this yourself. Note it down.' Several students at this college wanted me to know ('I want to tell the writer . . .') that the protesters in Delhi were engaged in an *illegal* activity. In other words, while most students had nothing to tell the writer, those who did only wanted him to know that to protest against the Modi government was not only anti-national, as the BJP leadership claims, but also unlawful.

Delhi. I returned to the city to participate in two book events before catching my flight out to New York. During the day I had several meetings with journalists, editors and publishers. One reputable editor, who asked me not to name him, told me during lunch that his role was a narrow one. In a country 'where writers are semi-skilled, where reviewers are semi-skilled, where readers are semi-skilled', his task was to bring in technique where there was no technique. He had a near-nationalist pride in Indian publishing which, he believed, is no longer beholden to the Western market. At the same time, he was critical of the ruling dispensation. Every year that the present leadership remained in power, India was regressing ten years. The nation's pluralist ethos was in tatters. Writers ought to share the blame for this. There was a time when writers had clout – he

used the French word *éclat* – but now they merely inhabited an echo chamber of irrelevance. He didn't blame the poor either. 'If you are a lower-caste rickshaw driver,' he asked, 'why would you vote for anyone other than Modi? To them, he is one of us.' The editor pointed at my plate and drink. 'Your tribe is eating linguine and drinking New Zealand white.'

Another friend bought me dinner after my book event at the India International Centre in Delhi. Then he showed me the handwritten reply that Umar Khalid had sent to my letter, in which I asked him about the books he had been reading in prison. In tight handwriting, Khalid neatly provided a list of nearly thirty titles. He had divided the list into two: fiction and non-fiction. Kafka's *The Trial* and George Orwell's *Nineteen Eighty-Four* were among those on the first list; Ngũgĩ wa Thiong'o's prison memoir and Trevor Noah's account of having been born a mixed-race child in apartheid South Africa were on the latter.

Hours before my flight to London, I visited Arundhati Roy at her flat. The heat was nearly unbearable. In the early evening, the road was lit up with the yellow flowers of the Amaltas, which made me think of Arundhati's unforgettable descriptions in *The Ministry of Utmost Happiness* of the brilliant yellow flowers defiantly saying 'fuck you' to the hot brown sky. Arundhati had just prepared cold nimbu paani, and I drank a glass quickly. The questions I hadn't been able to ask my father – the name that I didn't utter in his presence – I could now put to Arundhati. What is common life in India like in the time of Modi?

A few days earlier, Arundhati had spoken at an event where G.N. Saibaba's book of poems – a kind of prison diary – had been released. The author himself wasn't present. This is because Saibaba, a professor of literature and human rights activist, lost both his job and his freedom after being detained under UAPA, the same law under which Umar Khalid has been kept in prison. In the case of Saibaba,

the conditions of his incarceration are particularly horrific. He is kept in solitary confinement despite being 90 per cent physically disabled. On the day I met Arundhati, Saibaba had decided to go on a hunger strike because the authorities were not even allowing him to keep a plastic bottle for water, paying no heed to the incredible heat.

Arundhati recounted to me, as a way of answering my question, what she had told the audience at the Saibaba book event. In the 1960s, she said, revolutionary movements in India talked about the redistribution of land and wealth. In the nineties, things had been reduced to campaigns against the displacement of the poor in places like Narmada Valley, during the construction of big dams. From redistribution to 'Let us please hold on to what little we have.' In the 2000s, it came down to the National Rural Employment Guarantee Act, which assured the poor one hundred days of unskilled manual work every year. Even that was considered by some to be unviable or unnecessary. Today, people were being forced either to fight for their very citizenship, or to rejoice at being given five kilos of flour and one bag of salt with Modi's picture on the front. India was like a plane flying backwards with all its parts falling off.

Were the prison doors going to open for jailed human rights activists like G.N. Saibaba and Umar Khalid? Arundhati replied that it was difficult to know if it was more likely for them to come out and join the people outside, or for those waiting for them outside to join them within the prison walls. 'I don't want to scare you,' she said, 'but all these people in prison have sat at this table. Whether it is Gautam Navlakha, Sudha Bharadwaj, Varavara Rao, Rona Wilson ... It is so chilling when you speak at press conferences in Delhi, because all the people who used to speak on such occasions are not there anymore. What we are seeing more and more is prisons being filled with journalists, lawyers, academics, intellectuals, activists, students. And Muslims, Muslims, Muslims. For Muslims in this country today to be murdered is a crime. Cases are filed against your corpse.'

Arundhati had one last point to make before I left. She wanted me to know that India wasn't controlled by an individual, it was

controlled by the militant party to which that individual belonged. 'This is not Modi's India. This is RSS's India,' Arundhati said. The Rashtriya Swayamsevak Sangh is the right-wing party whose leaders were inspired by Hitler. They hold on to a dream of an undivided India ruled by Hindus. Modi began his political career as a grassroots preacher for the RSS. According to Arundhati, the RSS has hundreds of thousands of members, a paramilitary wing, armed cadres, women's organizations, schools in which millions of children study, farmers' and workers' unions. It has penetrated every single institution in India. She told me, 'The RSS is a nation within a nation waiting to take its place on the world stage, possibly in 2025, which will mark its hundredth year.'

2025. On my flight home I thought of this date often – for it is also the year the World Meteorological Organization predicts that the world will break a crucial heat barrier, making it nearly impossible to achieve what the Paris Climate Agreement had set as a goal, to limit global warming to 1.5 degrees Celsius by 2100. It's a dire prediction, and one that is not difficult to imagine coming true. If the slide into hate is just as irreversible in India, life, for a lot of people, is likely to become hell. ■

The British Museum

Give the gift of Membership

Set someone special on a journey through human history. They'll enjoy 12 months of extraordinary exhibitions as well as an exclusive programme of Membership events.

Buy now

Ways to buy
britishmuseum.org/membership
+44 (0)20 7323 8195

The British Museum Friends is a registered charity and company limited by guarantee which exists to support the British Museum.

Registered charity number 1086080
Company registration number 04133346

Large vase, tin-glazed earthenware (maiolica), from the workshop of Orazio Fontana, made in Urbino, Italy, about 1565–1571, with gilt-metal mounts made in Paris, France, about 1765. Part of the Waddesdon Bequest.

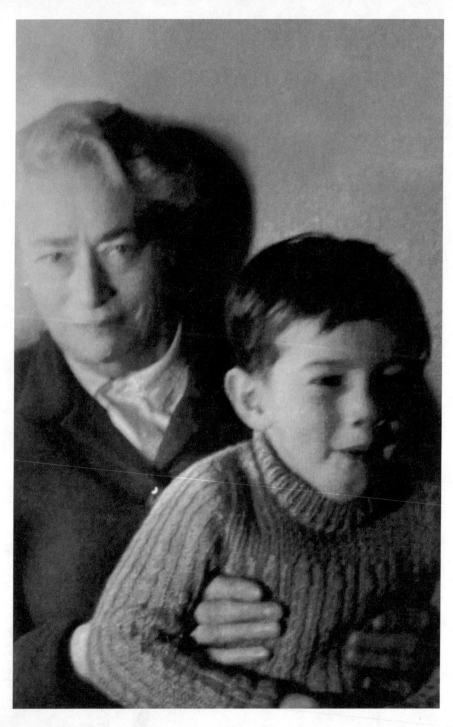

The author as a boy with his grandmother, Luise Rath, Cambridge, 1958
Courtesy of the author

AUSLÄNDER

Michael Moritz

The principal character of W.G. Sebald's novel *Austerlitz*, for whom
the book is named, recalls how he was brought as a four-year-old
from Prague on a Kindertransport train to Liverpool Street station
where he was met by an austere couple, a vicar and his wife from North
Wales. The boy was renamed Dafydd Elias, and subsequently raised
in a small village. As an adult, having reverted to his original name,
Austerlitz made his way back to the Czech Republic and, unable to
detect the borders between the distortions of memory and fact, relived
his life as a child. As I reread *Austerlitz*, I came across the following
passage recounting the memory of Dafydd Elias's boyhood in Wales:

> I had never heard of an Austerlitz before, and from the
> first I was convinced that no one else bore that name,
> no one in Wales, or in the Isles, or anywhere else in the
> world. And since I began investigating my own history
> some years ago, I have never in fact come upon another
> Austerlitz, not in the telephone books of London or Paris,
> Amsterdam or Antwerp.

As a boy in Wales, like the fictional Austerlitz, I had never heard of
a Moritz outside of my uncle's family in Manchester. There were

none that I knew of in Cardiff and none that I had heard of in Wales. Once a year, when a new telephone directory landed on our doorstep, I immediately flipped the pages to the 'M' section, hoping that we would not be alone, that there would be another Moritz listed, that we would have company.

I did eventually come across many people named Moritz in a telephone book, but only much later in my life. I found them in an online archive of the directories for Munich from the 1930s, which listed six people of our name, including a doctor, an innkeeper, a graduate student and a piano teacher. My grandfather was there listed as Maximilian Moritz, and his telephone number was given as 37 23 47. The telephone had been installed to help my grandparents follow what my father once described as 'the latest developments'. The same number was repeated in the directories for 1938 and 1939. In 1940 there was no longer a listing.

W hen the First Minister of Wales asked, 'What's a nice Jewish boy like you doing in Silicon Valley?' my skin shrivelled and all my feelings about being Jewish in Wales in the 1960s came flooding back. It was 2001. He posed the question as a lunchtime conversation opener in a restaurant in San Jose, where I had met him and other members of a Welsh delegation sent to uncover the mysteries of Silicon Valley. Later, he used pauses in the conversation to ask me why there were no great Jewish rugby players and why I, as the eldest son of Jews, had not become a doctor. Later, dwelling on his questions, I couldn't help but wonder whether part of the reason a nice Jewish boy like me was in Silicon Valley was that, while I was growing up, my schoolmates, their parents, my teachers, the shopkeepers, the man who hired me to deliver newspapers, our dentist and doctor and the people my parents had hired – once they had sufficient money to do so – to hang wallpaper, or tend to the garden, or replace the roof tiles, or repair their cars, had all been asking themselves (for, on the whole, they were too diplomatic, too restrained, and too tactful to say it out loud), one of two questions: 'What's a nice Jewish boy like

you doing in Wales?' or, 'Moritz. What sort of a name is that then?'

These people were, for the most part, Anglican, Protestant, Methodist or Presbyterian in a country that, at the time, was far from multicultural. A few people, and they were also considered oddities (but not as odd as the Jews), were Catholics or Quakers. In Britain in the 1960s a 'first' name was known as a 'Christian' name. My schoolmates were called Ian, Rosemary, Catherine, Evan, Hugh, Harry, Rhys, Gareth, Morgan, Robert, Hywel, Sandra, Felicity, Sian and Dewi. They were certainly never known as Mordecai ben Aharon ha Levi – which is what my own name is in Hebrew. Moritz was so much of a marker that I sometimes used to say that my family came from Switzerland since, at the time, there was only one thing worse than being Jewish in Wales, and that was being German in Wales.

The local shopkeepers also had thoroughly Welsh names. The tobacconist's belonged to Miss Morgan (its interior was guarded by a stuffed black bear clutching a collection box for the Salvation Army between his ossified paws). Two of the nearby shops (one with a small post office counter and the other a general store) were each operated by a Mr Williams – one known as Mr Williams the Top and the other, Mr Williams the Bottom. And in between Mr Williams the Top and Mr Williams the Bottom were the greengrocer, Mr Bowen, and the chemist, Mr Thomas. Years later, I was at a dinner with an editor of an American business magazine whose wife, to my surprise, was born in Pontypridd, about twelve miles from where I grew up. After moving to Wales, her father, whose last name had been Rabinowitz, decided it would help him assimilate if it was changed to Jones. Thereafter he was known as 'Jones the Jew'.

The distance between being a Jew in Wales and an Anglican, Protestant, Methodist, Presbyterian, Catholic or Quaker in Wales was illustrated by a wooden panel, topped with a small electric light that was always illuminated, in the chamber of the synagogue, a bomb-damaged former chapel, to which my parents belonged. Tidy gilt lettering marched across this panel, listing the names and

home towns of the relatives of the congregants murdered during the Shoah: Bortstieber, Cohn, Epstein, Folkmann, Gottschalk, Gross, Gunz, Hersch, Hornung, Kamerase, Karpf, Kotlan, Magid, Mandler, Mayer, Pinkus, Polak, Riemer, Rosenthal, Schindler, Seidner, Silberschatz, Stach, Steidler, Stoger, Ullmann, Weil, Wiznitzer, Wurm and Zander. They were from many of the places from which the Nazis had deported Jews: Brod, Vienna, Brussels, Breslau, Brno, Prague, Žilina, Berlin, Fischach, Frankfurt am Main, Munich, Ingolstadt, Hamburg, Enschede, Jarosław, Brunswick, Bleijerheide, Tarnów, Stříbro, Klatovy, Weiden, Nuremberg, Aachen, Brotzen, Cologne and Trebnitz.

A few of the Jews in this converted chapel had changed their names. An optician named Rosenberg had become Mr Montrose. Mr Grunebaum, who ran a men's clothing shop for his father-in-law, became Mr Greenwood. As if, with their foreign accents that no form of anglicised name would ever conceal, they, or any of us, were going to deceive the people in Cardiff about who we were or where we came from. We were Jews. My family even advertised the fact that we were the only Jews on the block by the mezuzah pinned to the right-hand side of our front door. We were Jews and we were living in plain sight. My friends did not have grannies and grandpas with names like Josef, Mendel, Fritz, Fanny, Sigmund, Emil, Gertrude, Siegfried, Gustav, Pavel, Zdenka, Erna, Lieselotte, Karoline, Mariska, Judis, Regina, Herz, Moshe, Heinrich, Elas, Leopold, Bona, Grete. They called their grandmothers Gran or Nan and their grandfathers Gramps. Not Oma. Not Opa. And definitely none of them had an Opa whose name, when spoken, seemed like a girl's – Salli.

The First Minister's question transported me across the ocean and the decades. Being a Jew in Wales where every slight, though small or unintended or inconsequential and rarely delivered with real malice, nonetheless reverberated within me. Finding a swastika carved on the inside of the lid of my wooden school desk while I was in elementary school. Or the high school English class

where, when we were made to read from *The Merchant of Venice*, the teacher amused himself by assigning me to play the part of Shylock and the other Jewish boy the role of Tubal.

The experiences that lodged the deepest were the Church of England services which marked the start of each school day. That was when the handful of Jewish students, sequestered during the prayers in a nearby room, could hear the full-throated renditions of 'Christ Triumphant, Ever Reigning'. After the singing stopped, we did not sidle into the back of the hall. We were paraded down the aisle to take our seats in the front as if the head teacher was saying to the other boys, 'Here come the circumcised.'

In my last year at high school, after I had been appointed head boy – one of those positions that doesn't exist in American high schools – I had to stand on the stage during these assemblies alongside the senior teachers. As the hymns rang forth and as the prayers were read, I found myself looking at the school organist who was seated directly beneath us. He was a Welsh speaker who taught English, lived with his mother, and was completely incapable of quieting the classroom titters as he struggled to explain the mysteries and beauty of *Paradise Lost*. Despite his diffidence, as his feet skittered across the organ's pedals playing the melodies that he knew by heart he would fasten me with his gaze, as if to say, 'You're a Jew and I know it.'

Decades later, when I came across this stanza from 'Refugees' by Louis MacNeice, I immediately thought of that Welsh-speaking English teacher: 'With prune-dark eyes, thick lips, jostling each other / These, disinterred from Europe, throng the deck . . .' I found myself humming – as if to retaliate – the tune of 'Onward Christian Soldiers'. ■

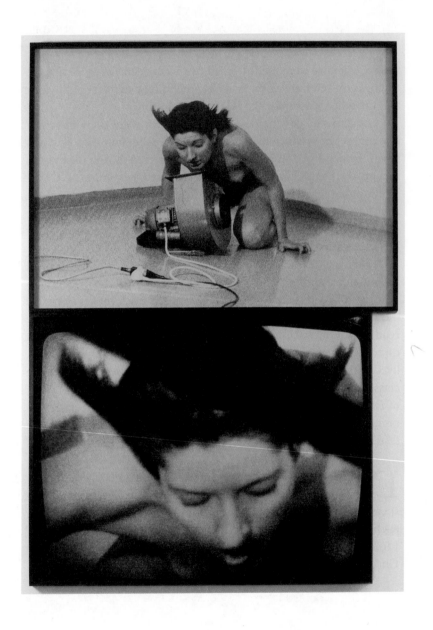

MARINA ABRAMOVIĆ
Rhythm 4, 1973
Photograph by Ken Adlard
Courtesy of the Lisson Gallery

BIOGRAPHY OF X

Catherine Lacey

The first winter she was dead it seemed every day for months on end was damp and bright – it had always just rained, but I could never remember the rain – and I took the train down to the city a few days a week, searching (it seemed) for a building I might enter and fall from, a task about which I could never quite determine my own sincerity, as it seemed to me the seriousness of anyone looking for such a thing could not be understood until a body needed to be scraped from the sidewalk. With all the recent attacks, of course, security had tightened everywhere, and you had to have permission or an invitation to enter any building, and I never had such things, as I was no one in particular who was needed nowhere in particular. One and a half people kill themselves in the city each day, and I looked for them – the one person or the half person – but I never saw the one and I never saw the half, no matter how much I looked and waited, patiently, so patiently, and after some time I wondered if I could not find them because I was one of them, either the one or the half.

One evening, still alive at Penn Station to catch an upstate train, I asked a serious-looking man if he had the time. He had the time, he said, but not the place, as he'd been exiled from Istanbul years earlier but never had the nerve to change his watch, and looking into this

stranger's face I saw my own eyes staring back at me, as I, too, could not un-locate myself from the site of my banishment. We parted immediately, but I have never forgotten him.

It wasn't a will to live that kept me alive then, but rather a curiosity about who else might come forward with a story about my wife. Who else might call to tell me something almost unfathomable? And might I – despite how much I had deified and worshipped X and believed her to be pure genius – might I now accept the truth of her terrible, raw anger and boundless cruelty? It was the ongoing death of a story, dozens of second deaths, the death of all those delicate stories I lived in with her.

Or maybe what kept me alive was all the secretarial work I had to do, as I'd become X's secretary by necessity – she kept firing the others. I sometimes found a strange energy to shuffle through her mail in the middle of the night – signing contracts I barely understood, reviewing the amendments made 'in the event of the artist's death', filing away royalty statements in the manner that X had instructed, and shredding the aggravating amount of interview requests addressed to me, the widow. The Brennan Foundation had invited me to come receive the Lifetime Achievement Award on X's behalf, not knowing that she'd planned to boycott the ceremony in resentment for how long it had taken them to recognize her. There was also an appeal from a museum that had been eagerly anticipating X's contractual obligation to make one of her rare public appearances at the opening of her retrospective that spring; by overnighted letter, they asked whether I, as a representative of whatever was left of her, might fly over to London in her stead? I sent back my regrets – *I am currently unable to explain how unable I am to undertake such a task.*

Tom called, despite a thirty-year silence between us. He'd learned of my wife's death in the papers and wanted to tell me that he had been thinking about me lately, about our strained and ugly childhood as siblings. His own wife, he said (it was news to me that he'd married),

had been given another few months to live, maybe less. His daughter (also news to me) was fourteen now, and there was a part of him that wished she were younger, that believed she might be less damaged by grief if she were protected by the abstraction of early childhood. *What an awful thing,* he said, *to wish my daughter could have known her mother for fewer years.*

But I did not find this so awful. Grief has a warring logic; it always wants something impossible, something worse and something better.

When Tom was fourteen and I was seven we lived in a clapboard house on a dead end with our mother and assorted others, and that summer as we were eating spaghetti in the kitchen Tom stopped moving, and sat there with his mouth open and the noodles unraveling from his poised fork as he stared into nothing, everything gone from his eyes, and he kept staring, unblinking and frozen as our mother shouted, *Tom! Stop it! Tom!* His eyes kept draining, nothing and nothing, then even less than nothing as Mother shouted for him to stop, to stop this horrible prank, until she finally slapped him hard in the face, which still did not bring him back but freed his fork from his hand and sent it into my lap. That night, slowly, he did start to come back, and later a neurologist was excited to diagnose him with a rare kind of epilepsy, which was treated with a huge pink pill, daily, and for months after my wife died I'd often find myself in some abject, frozen state – sitting naked in a hallway or leaning against a doorframe or standing in the garage, staring at the truck, unsure of how long I'd been there – and I wished someone could have brought me such a pill, something to prevent me from pouring out of myself, at odds with everything.

Tom and I were living in different griefs now – his imminent, mine entrenched – but I wondered if the treatment might still be the same, and I asked him if there was any kind of pill for this, some pill like that pill they used to give him all those years ago, but Tom felt sure there wasn't, or if there was he didn't know about it, and anyway, it probably wouldn't work.

CATHERINE LACEY

After two years of ignoring his letters, I took a meeting with
Theodore Smith, at X's request, to put an end to his nonsense.

'I can't believe it's really you,' he said, 'I can't believe it. X's
wife – incredible.'[1]

Though it was 1992, I was unaccustomed to such fawning, as
she and I avoided the places where such people lingered. The sole
purpose of this meeting, which I recorded for legal purposes, was
to inform Mr Smith that X would not cooperate with his supposed
biography; she would not authorize it, would give no interviews,
and would allow no access to her archives. As my wife's messenger,
I encouraged Mr Smith to abandon the project immediately, for
he would suffer greatly trying to write a book that was ultimately
impossible.

'If you truly want to write a biography,' I told him, 'you must first
select a subject who is willing to comply, advisably a ghost.'

Mr Smith sat there blinking as I explained, in slow detail, our
total disapproval of this endeavor. The estate would not license any
reproductions of any of X's work, nor would he be allowed to use
any of the portraits of X to which we held the copyright. We would
not give permission for him to quote her lyrics, essays, scripts, or
books, and of course X had no time to answer any of his questions,
as she had no interest in his interest, nor any respect for anyone who
intended to exploit her work in this way.

'It is her explicit wish not to be captured in a biography, not now
and not after she's gone,' I reminded him, my tone absolutely cordial,
or at least judicial. 'She asks that you respect this wish.'

But Mr Smith refused to believe that X would choose to be
forgotten, to which I explained that X had no such intention and
already had plans for what would happen to her archives in the event
of her death; all I knew of those plans at the time was that access
would require forfeiture of the right to biographical research.

'Her life will not become a historical object,' I explained, as X had
explained again and again to me. 'Only her work will remain.'

[1] Theodore Smith, conversation with the author, June 18, 1992, Café Vesper, New York.

'But she's a public figure,' Mr Smith said, smiling in a sad, absent way. (How odd to remember the face of someone I hate, when so much else is lost to the mess of memory.) He slipped a page in a plastic sleeve from his briefcase. I glanced down – it was unmistakably her handwriting, dated March 2, 1990, and addressed to *My Darling*, and though I should have been that darling, given the year, I had a way of overlooking certain details back then.

'I have several others,' he said. 'The dealers always call me when they come across one, though they're rare, of course, and quite expensive.'

'A forgery,' I said. 'Someone has ripped you off.'

'It's been authenticated. They've all been authenticated,' he said.

I thought I knew what he was doing – dangling false artifacts to entrap me and compel my cooperation – but I would not budge. The letters must have been (or so I wanted to believe) all fakes, and even if X *had* written such a letter to someone else, which she most likely had not, she would've never associated with anyone treacherous enough to sell her out. This pathetic boy – no biographer, not even a writer – was simply one of X's deranged fans. I don't know why she attracted so many mad people, but she did, all the time: stalkers, obsessives, people who fainted at the sight of her. A skilled plagiarist had merely recognized a good opportunity and taken it, as people besotted with such delusion hold their wallets loosely.

'You must understand that my wife is extremely busy,' I said as I stood to leave. 'She has decades of work ahead of her and no time for your little project. I must insist you move on.'

'She won't always be alive, you know.'

I did not believe myself to be such a fool, but I was, of course, that most mundane fool who feels that though everyone on earth, without exception, will die, the woman she loves simply cannot, will never.

'Whether she wants there to be a biography or not,' Mr Smith went on, 'there *will* be one, likely several, after she's gone.'

I told Mr Smith, again, to cease all attempts to contact us, that we would file a restraining order if necessary, that I did not want to ever

see or hear from him again; I was certain that would be the end of it.

Four years later, on November 11, 1996, X died.

I'd always thought of myself as a rational person, but the moment she was gone I ceased to be whomever I thought I was. For weeks all I could do was commit myself to completely and methodically reading every word of the daily newspaper, which was filled with articles about the Reunification of the Northern and Southern Territories, a story so vast that I felt then (and still feel now) that we might never reach the end of it. I gave my full focus to reports of the recently dismantled ST bureaucracies, the widespread distrust of the new electricity grids in the South, and all the sensational stories from inside the bordered territory – details of the mass suicides, beheadings, regular bombings – and even though my personal loss was nothing in comparison to the decades of tyrannical theocracy, I still identified intensely with this long and brutal story, as I, too, had been ripped apart and was having trouble coming back together.

Reading the paper gave a shape to my boneless days: each morning I walked the length of the gravel driveway, retrieved the paper, walked back, and read it section by section in search of something I'd never find – sense, reasons, life itself. Immersed in the news, I felt I was still in the world, still alive, while I remained somewhat protected from the resounding silence she'd left behind.

In early December of that year, I read something in the arts section that I could not, at first, comprehend. Theodore Smith had sold his biography of my wife to a publisher for an obscene advance.[2] It was scheduled to be published in September of the coming year. For a few days I succeeded in putting it all out of mind. I thought, No – no, it is simply not possible, it will fail, they'll realize the letters are frauds, that it is a work of obsession, not of fact, and when I, executor of X's estate, deny them all the photo and excerpt rights, that will be the end of it. How could there be a biography without any primary sources?

As it happened, the editor who'd purchased the book was

[2] Elinor Snow, 'Recent Publishing News', the *New York Times*, December 2, 1996.

someone with whom I shared a close friend. She called me that
winter – 'a courtesy', she said, as she was under no obligation to gain
my approval. She insisted the research was impeccable. *Scrupulous
but respectful*, she said, whatever that means. She assured me that Mr
Smith truly revered and understood X as an artist, as a woman, and
that he had so many wonderful insights about her work, but of course,
some would find the book a little controversial, wouldn't they?

Your wife never shied away from controversy, the editor said.

Is that so?

The editor suggested I come to her office to meet with Mr Smith
while there was still time to correct the text, that I might want to
dispel some rumors he'd been unable to detangle, and though I'd
been sure I'd never see Mr Smith again, by the time I'd hung up I'd
agreed to the meeting.

Two days later I was sitting in a conference room with Mr Smith,
his editor, and two or three lawyers. The cinder block of a manuscript
sat on the table, practically radiant with inanity. I asked for a few
moments with our author, and once alone, I asked him how he'd
done it.

Oh, just, you know, day by day, he said, the false modesty so
pungent it could have tranquilized a horse.

*But what could you have had to say about her? What could you have
possibly known?*

He insisted he still had plenty to go on without the archive, as
she'd given thousands of interviews since the 1970s, that she rarely
repeated herself, and of course there were the ex-wives, ex-lovers,
the collaborators, others. They all had plenty to tell him, and lots of
original letters to share. It had all gone quite well, he said, except for
his interactions with me, of course, and the fact that he'd never been
able to speak with X herself – a miscarriage he still regretted. But I
did not care what he wanted from me and only wanted to know who
had given him interviews. He listed a few inconsequential names –
hangers-on and self-important acquaintances – then, surprisingly,
Oleg Hall.

Mr Smith must have known about the enmity I'd long been locked in with Oleg. The only comfort in X's death was that I'd never have to see him again, her closest friend though I could never understand why. I'd disliked everything about Oleg, but I thought the very least I could expect of him was that he'd protect X's privacy.

You must have been so glad she died, I accused Mr Smith. *And so suddenly! A nice dramatic end. I'm sure you were thrilled to hear the news.*

Mr Smith squirmed in his chair as I berated him, calling him (apparently) 'a groveling fraud, a useless little leech with no talent', an insult he later quoted in his book, and though I don't remember saying those words, I do approve of the characterization.[3] However, I am sure I did not, as Mr Smith alleged, accuse him of killing my wife. I was indeed grief-wild, but I've never been a conspiracist, and it's clear Mr Smith lacks the fortitude to accomplish a murder from afar, undetectable by autopsy.

I'm trying my best to include you, he pleaded.

I do not wish to be included.

Then why did you come here?

I could have said that I was attempting to wake up from this nightmare, that I came to somehow stop his book from existing, to ensure it was never published, to spit in his face, but I didn't say anything. Why did I go anywhere? I had no idea anymore, now that she was gone, where to go or how to live or why I did anything. I started to slip out, leaving the manuscript behind, ignoring the clamor around me, refusing the editor's assurance that X would be remembered '*so fondly*' – I could give a shit for anyone's fondness – but when she made the suggestion that the biography would likely inflate the market value of X's work, I do recall telling her to fuck off as soon as possible and never contact me again. It was my fault, I'll admit, for hoping any of those people could be reasoned away from profit.

The night after my first meeting with Mr Smith in 1992, as I was falling asleep beside X, she sat up, turned on the lamp, and asked,

[3] Theodore Smith, *A Woman Without a History* (New York: Brace & Sons, 1997), 3.

What did the warning mean?

X was a nocturnal woman, but also a diurnal one – in fact, it seemed she never grew tired, or jet-lagged, not even weary on a warm afternoon – while I've always just been a regular person, tired at certain intervals.

What warning?

We warned Mr Smith to cease his research, she said, *but what did we warn him with? What was the threat?*

Of course I hadn't threatened him in any specific way. She was neither surprised nor content with this answer and suggested we could send someone to his apartment to intimidate him, or to mess it up while he was out. I laughed, but she continued – we might as well get right to it and have someone break his legs, or maybe just one leg or, better yet, a hand. Did I notice whether he was left- or right-handed? I felt then, as I often felt, that I was a mobster's wife, better off looking the other way.

Well, it's something to think about, she concluded, *if he tries to contact us again.*

From the very start, I knew that X possessed an uncommon brutality, something she used in both defense and vengeance. She was only a little taller than me, but her physical power was so outsize that over the years I'd seen her level several men much larger than she was, sometimes for justifiable reasons but also in misplaced rage. The longer we were together, the more I understood that I, too, was at risk of being the object of her anger, that there was always the possibility, however remote, that she might turn against me, if not physically, then emotionally or intellectually, that she could destroy me totally should the whim ever arrive.

I fear I am the sort of person who needs to feel some measure of fear in order to love someone. My first love had been – privately, embarrassingly – God itself, something that made me, something that could destroy me; every mortal relation that came after, until her, had always fallen short of the total metaphysical satisfaction I'd felt in prayer.

But I never needed to fear X's strength. Other things, yes, but never her strength.

Months after that disastrous afternoon in that office, I received an advance copy of Smith's book accompanied by a terse note explaining that the 'scene' I'd made had been included in the newly added prologue. I left the book on the floor of the garage beside the trash bin until one morning – something must have been extremely wrong with me – I went to the garage and, instead of the daily paper, brought in that book and did not stop reading until I reached the last page.

Though I had failed to prevent this book from coming into existence, Mr Smith's horrific prose and lightless perspective seemed to be the more atrocious error. His writing is – both aesthetically and in substance – page by page, line by line, without interruption, worthless. The only thing impressive about it was that he managed to take a subject flush with intrigue and grind it down into something so boring, so absolutely pedantic and without glamour, that I often laughed aloud, alone, so sure it would fail, that the book's primary weakness was not the estate's lack of cooperation, but that it simply wasn't any good.

I slept easily that night, certain I'd reached the end of this entire charade.

I am not bitter that Theodore Smith's *A Woman Without a History* was met with such acclaim – let him drown in his spurious success – but I am surprised that such a dull book has captured the attention of so many. I am not even appalled by his depiction of me – unflattering to be sure, but I have no interest in the flattery of a fool. What bothers me about it is that his lies have been held up as the definitive account of X's life, that his work speaks the final word about her groundbreaking, multi-hyphenate career and its impact, that every reader and critic seems to believe that Mr Smith successfully navigated the labyrinth of secrets X kept around herself, and that he illuminated some true core of her life. This is far from the case.

It is no secret that my wife layered fictions within her life as a kind of performance or, at times, a shield. Mr Smith described this as 'a pathological problem' and called her 'a compulsive liar, crippled by self-doubt, a woman doomed to fortify herself with falsehoods'.[4] Though it is true that not even I always knew where the line was between the facts of her life and the stories she constructed around herself, my wife was no liar. Anyone who was ever fortunate enough to be a part of X's life had to accept this hazard – she lived in a play without intermission in which she'd cast herself in every role.

That was the first reason X refused to authorize a biography: it would necessarily be false, and this work of falsehood could only serve to enrich whatever writer was shallow enough to capitalize on her infamy. And yes, I realize I am that writer now, but over the course of this work, my reasons and aims for it have shifted as the story around X shifted; Mr Smith wished to warm his cold hands on her heat, while I have been scorched by it.

X believed that making fiction was sacred – she said this to me many times, and mentioned it in her letters and journals and essays repeatedly – and she wanted to live in that sanctity, not to be fooled by the flimsiness of perceived reality, which was nothing more than a story that had fooled most of the world. She chose, instead, to live a life in which nothing was fixed, nothing was a given – that her name might change from day to day, moment to moment, and the same was true for her beliefs, her memories, her manner of dress, her manner of speech, what she knew, what she wanted. All of it was always being called into question. All of it was costume and none of it was solid. Not even her past was a settled matter, and though anything else around her might fluctuate, that unsettled core – her history – was to remain unsettled.[5]

'A biography,' she wrote in a letter to her first wife, 'would be an insult

[4] Theodore Smith, *A Woman Without a History*, 92, 209.
[5] 'List of Self-Attributes', April 10, 1981, box 15, item 2, The X Archive, Jafa Museum Special Archives Annex, New York. (This collection is cited hereafter as TXA.)

to the way I have chosen to live. It's not that I am a private person; I am not a person at all.'[6]

I've since discovered another, more specific reason that X did not want anyone to fact-check her past prior to 1972, the year it seemed she had materialized out of nothing, without a past, without a beginning. Of Mr Smith's many egregious errors, his misidentification of her parents and birthplace is perhaps the most fundamental, though it is true that X made uncovering that fact nearly impossible, as she obfuscated every detail, planted false narratives and never came clean.

In fact, until I set about doing my own research, even I did not know where she'd been born. She once told me she had no memory of her life before she was eighteen, and another time she said she could not legally reveal the identity of her parents, but occasionally she claimed that they were dead, tragically dead, or that they'd kicked her out, or that she hated them so much she couldn't remember their names. She sometimes said she was born in Kentucky or Montana or in some wilderness, raised by various animals, or that she'd been born illegitimately – an ambassador and his maid, teacher and pupil, nun and priest, some doomed union. There was one allusion to an orphanage, or a childhood on the run, or no childhood at all. 'It depends on how you look at it,' she said in one interview. 'It only seems to be a simple question – *Where are you from?* It can never be sufficiently answered.'[7]

There were rumors she'd been rescued from a sex trafficking ring somewhere in the West, or had escaped the Southern Territory, or that she was a spy from the Soviet Union, but I had long assumed that the truth was more likely quite simple and sad. She seemed to me to have the face of someone who had been given up by her mother and had spent the rest of her life refusing that initial refusal, as if her own mother should have been able to recognize the enormous capacities

[6] X to Marion Parker, undated carbon copy, item 134a. TXA.
[7] Penny Saltz, '23 Minutes with X', the *Underworld Magazine*, June 1982.

that burned inside that soft infant, and now the whole world would be punished for it.

After she became better known, fans and strangers alike claimed to be her long-lost parents or siblings, calling up reporters and insisting they were her true mother or brother or husband, finally willing to tell the story of their daughter, their sister, their wife. When contacted to verify or dispel these new stories, X said they were true, all of it was true – that she'd been born a thousand times, that she was the child, the sister, the anything of anyone who said she was such. It confused people until it amused them, amused them until it bored them. The interest in her past would subside for some years before returning again, always unfinished.

When I read the chapter in Mr Smith's book about X having been born in Kentucky to Harold and Lenore Eagle, I knew this to be one of her objectively false stories: Harold and Lenore were actors whom X had hired many years earlier. Though it was just one of the many details Mr Smith got wrong, the birthplace error bothered me more than any other.

I never intended to write a corrective biography – if that is what this book is. All I wanted at first was to find out where my wife had been born, and I imagined I might publish my findings as an essay, an article, or perhaps a lawsuit, something to quickly discredit Mr Smith. I did not know that by beginning this research I had doomed myself in a thousand ways, that once the box had been opened, it would refuse to be shut.

Perhaps it doesn't make sense to marry someone when you don't know some of the most basic things about them, but how can I explain that those details did not seem relevant to how I felt about her, the sort of buzzing sensation I had in her presence, as if I'd just been plugged in? Early on, I sometimes asked about her past, but I soon accepted she would be both the center of my life and its central mystery, excused from standard expectations. Love had done that, maybe – love or something more dangerous – but now that Mr

Smith's false narrative was out there and I was in our cabin alone, I had nothing to do but avenge him and his lies, to avenge reality itself, to avenge everything.

The title of this book – as titles so often are – is a lie. This is not a biography, but rather a wrong turn taken and followed, the document of a woman learning what she should have let lie in ignorance. Perhaps that's what all books are, the end of someone's trouble, someone putting their trouble into a pleasing order so that someone else will look at it.

Early on, certain people kindly and less kindly advised me to give up my research or, if I could not give it up, at least avoid trying to make sense of it. I certainly shouldn't attempt to publish it in any form, they said. Some believed that I was jealous of Mr Smith's success or that I was being a self-destructive fool. X's gallerist told me I was delusional, that X's biography had already been published and I should accept it and move on. Others thought I was not in my right mind, that I was grieving inappropriately, that I should be patient, let another year or two pass, that I should back away from grief as if evading a large animal – go slowly, be patient, make no sudden movements. On one occasion I did put the manuscript aside, briefly believing it to be hopeless. That afternoon I set out for a long hike in the woods, but as the hours passed I felt increasingly hurried, as if I were running late to meet someone, only I didn't know whom.

And obviously X would have vehemently objected to this work, and still I am waiting for her to find a way to argue with me about it from the other side. If she ever does, I know I will lose that argument, no matter who was wrong or right. I can imagine her disapproving of this endeavor just as I can imagine her disapproving of anything, pacing in the kitchen and telling me all the ways in which I (or someone, or something) was wrong. No two ways around it: No. Absolutely wrong.

A passage from her journal, 1983:

There is no such thing as privacy. There is no experience or quality or thought or pain that has not been felt by all the billions of living and dead.[8]

But even if I had quoted her own words in my defense, she would have continued making her case against this book, blistering me with accusations. A derangement of nostalgia, an indulgence, a wallowing. Every time I shuddered at the news of a friend's death, she insisted I never mourn the dead, as 'they know what they're doing', but I remain unconvinced.

Some days it seems she is only away in the next room, and when I go to that room she has fled to another room, and when I reach that one she is in yet another. So often I am sure I hear her voice on the other side of a wall or door, but she never stops moving – lecturing, arguing, laughing, making and remaking her case, always – insistent, scouring, spiraling, clear. Even now, with all these years gone and all these stories stacked up irrevocably against her, I keep hearing her footsteps come steadily down the stairs, and I swear some afternoons I can hear her taking off her boots at the back door and padding up the hallway after an afternoon hike. In anger, in longing, in both, despite myself, I strain to hear those steps. ■

[8] X, journal entry, June 9, 1983, box 4, notebook 46, TXA.

Peter Gizzi

Ecstatic Joy and Its Variants

as surely as this is about seeing you dance naked

it is also about the sky and Mahler in the wan distance
heard by a child

as surely as the sadness never leaves and that music
heals the night with its deeps and neon

as surely as the glow of the radiator at 3 a.m.,
a line of inquiry, souvenirs, a signature for the sun

o bed of stray barrettes, discourse, and water
bed of laughter, hot takes, dried blood
bed of cedar bows, pinhole light, thing music

surely this is about water jetting from a spring,
a languid rafting with no particular destination

as the old arguments, humans, how they rhyme,
stutter, get lost

this is also about conversations with the dead,
the only honest definition of silence

surely you are not listening to the words I am singing

about the last day of my life, the gift of blood,
the perfect text

are not all the sounds on my lyre about you,
like a seam through the sky, glitter, sometime youth

surely this is about the one thing you do to me,
places not even music has touched

and in my outrage, I am immortal
because I love, I am here

Johnnie Ray at the London Palladium, 1954

THE PUBLIC AND PRIVATE PERFORMANCE OF THE DEAF BODY

Raymond Antrobus

The audiologist who fitted my new hearing aids was surprised when he took my hearing test. He said he's around people with my level of deafness who struggle more visibly with it. A common saying about deaf people is that what we lack in hearing is compensated for with another sense, like a superpower.

My superpower has become lip-reading and perfecting my listening face, so it looks like I'm fluidly following speech, nodding, relaxing my shoulders, loosening my jaw. I've found that if you physically express your listening then people open up and talk more which gives me more time to get used to the voice and speech patterns of a person. These internal gymnastics mean piecing together the things I hear with the missing parts.

But I was born with my deafness and most of a private audiologist's patients are late deafened so it's different. 'Physicians in particular tend to underestimate the quality of life of disabled people, compared with our own assessment of our own lives,' writes Harriet McBryde Johnson.

But look, I'm not trying to speak to other people's deafness, even though hearing people are constantly speaking to what they think it is.

On Hunter Street in Central London, I once passed a broken sign above a shop THE I ING OF FALAFEL. The broken parts of the letter 'K' that became an 'I' reminded me of the parts of words I don't hear and

have to be mentally filled in. The I'ing of Falafel matched my internal deaf dilemma and externalised the language of that internal space, the part of me that is wondering if I heard something correctly and the part of me that is wondering if I've found a poem to perform.

I started to think that a deaf person asserting their relationship to their specific deafness is a necessary kind of performativity. How we perform seems to depend on the audience we're performing for. As a deaf poet, I avoided writing about my deafness at first, for fear of being simplified and pigeon holed. Deafness is one part of my identity but the themes I write into aim to have wider appeal. Now, I feel that what's equally a sign of wide acclaim and success (as performing for hearing mainstream audiences) is knowing who we are as deaf people among ourselves, who we are when we turn away from the hearing mainstream gaze altogether, who might we be if we lived in a world of understanding ourselves first, what music could we be making instead, what beats have we been missing, what beats have we been taking, what could we give and take from our most authentic performances?

*

I wanted to start writing something about the public and private performance of the deaf body, starting in the early 50s with a skinny, sensitive, bisexual deaf boy from the suburbs who grew up to become the brief spotlit white face of black American music.

America heard Johnnie Ray croon for the first time through the radio in the autumn of 1951 and no one tuned in like the misunderstood misfits did, the ones who felt strange and awkward in their complicated bodies. Ray's singing swung with so much feeling, was so alive and aligned with such pleading sorrow that myths blossomed all around him.

At first they mistook his voice for a black woman and music executives and critics alike grimaced, said that she lacked smoothness and precision in her phrasing. When they found out that Ray wasn't a black woman, that he was a white deaf man from Dallas, Oregon,

they changed their tune and dubbed him 'The Prince of Wails'.

Johnnie Ray was touched by black sound since he was a teenager. He heard Billie Holiday and whatever wave hit him never left. But that wasn't the only thing that struck me when I first watched the grainy black-and-white footage of Ray crooning in the spotlight – it was also his un-concealable boxy hearing aid.

*

One of the first things I watched after the audiologist fitted my new high-tech hearing aids was Deaf British actress Rose Ayling-Ellis and Italian dancer Giovanni Pernice making it to the semi-finals in the British show *Strictly Come Dancing* in 2021.

These new hearing aids were the neatest I'd ever had, lucid in sound and smaller than the brown NHS devices I'd worn since my school years. The microphone was clearer and the Bluetooth software synced up with my computer and my phone making my virtual world sharper.

I don't watch much television, but I was told about Rose and Giovanni's 'silent dance' while being interviewed on *Saturday Live* on BBC Radio 4 by Nikki Bedi and Richard Coles. They wanted my opinion on Rose but I hadn't seen the dance, so I just said that it was always great when a talented deaf person is able to thrive in the spotlight.

*

At seventeen I auditioned for the lead role in a play at Hoxton Hall Theatre called *Perfect Species*. At the audition I deliberately didn't wear hearing aids. It felt logical that I had more chance to be cast in the play without bearing what I knew would be perceived as a vulnerability, something that made me imperfect.

I landed the role and for two weeks I rehearsed unaided, learning the lines of everyone I shared a scene with. It worked until the actual performance. I lost my nerve and could barely hold any of my scenes together, fumbling lines and missing cues as the panic in the eyes of

the fellow actors triggered me into guilt and shame. I couldn't move.

I had got the part but the piece of me missing on that stage was forcibly hidden and nothing announced it louder than the end of the first scene, where I stood on the edge of the stage, arms splayed out in front of me, my chest bared to the audience. The cue for me to step forward was the sound of a bell, a sound I could not and will never be able to hear. I was left standing where I stood, alone and glaring out at the spotlight.

<p style="text-align:center">*</p>

In 1948, before Ray's first performance in the Flame, (the lavish liberal downtown Detroit venue where he would be discovered), Ray was told, 'The louder you sing boy, the better', and believe me, Ray brought his volume beyond the stage. He took his microphone from the stand and strolled into the audience, his boxy hearing aid device so heavily amplified that every ear must have felt the static and spit. The Flame presented the biggest black names of music at the time, from Billie Holiday to Dinah Washington. It was the Midwest's leading live showcase for jazz, R&B and black variety artists. Patronised by both the black working class and high-class white liberals, its 500-seat capacity was reached nightly.

'Flame Showbar' was spelled out in huge neon letters on either side of a diagonal corner marquee and entrance. Its interior was lavishly appointed with a long bar and a sunken nightclub floor, and dozens of tables crowded in a semicircle around the stage. On each table there were gavel-like wooden knockers that audience members could beat to approve an act.

Despite the Flame announcing black line-ups, Ray was the white exception; although some say he was so caked in make-up under the light that he looked like a black man or an Italian. The visible presence of his hearing aid meant he got away with not being on beat. His band helped him along. If Ray fell away from the tempo they pumped their horns and drums louder and sometimes held back to wait for Ray to find himself again in the rhythm.

The singer LaVern Baker was also in the audience that night and said that Ray's deafness meant 'he could get away with murder', musically. But tonight Ray is a lanky, liberated androgynous-looking twenty-two-year-old bearing a hearing aid and when he arrives at the climax of his performance, wailing lung-bursting blues at such high decibels that the whole stage vibrates below his feet, his sweat-soaked shirt bared to the audience, his wide trembling arms, his slight convulsing hands and his voice, wild and flexed with such visceral inner energy that no ear or eye could hold together, no one moves, nothing except whatever released Ray from his stiff and awkward constraints was now bared and glowing in the spotlight.

*

The spotlight is already lit for Rose Ayling-Ellis as she stares into the camera, composed and radiant, wearing a silky white-and-purple dress like Wendy from *Peter Pan*. She strolls onto the floor barefoot. The thin dress waves dramatically in the light behind her. Giovanni walks barefoot into the shot in silky light pyjamas. A showy piano melody trickles its notes. Giovanni places a cupped palm over Rose's ear like a seashell. She beams as if hearing something new, takes his hand and brings it to his chest, which sets her off in a twirling motion.

As Rose is spun onto the other side of the stage, Giovanni runs to her side. He lifts his arm above his shoulder as the piano lifts louder. A woman's voice starts to sing, the tone brightening as the beat drops and purple-pink fireworks erupt and rain down behind the stage. Now Rose and Giovanni bounce on cue to the keys that pump harder and higher, twirling and spinning each other, a springy lightness in their feet. Slowly the music begins to strip itself of pump and bass but no music is missed in the rhythm of their steps. Gradually all sound falls away and everything is bared to silence.

Now the couple are almost entwined, chest to chest, their light is shared, almost sealed. Their eye contact is a tight invisible rope they don't lose hold of, even as Giovanni lassos Rose around the stage.

Their movement in shared silence lasts ten seconds and even though the lack of sound almost overwhelms the measured meaning of everything, each step finds a new ground to grace, every twirl and spin and lift and prance and smile is pure, blissful ballroom elevation.

*

I was walking through Soho, Johnnie Ray's 'How Long Blues' tinkling in my hearing aids when I saw Lotus again. Lotus didn't see me. He was sitting in the window of the Caffè Nero with his hair in cane rows and his same soft soil eyes. A lamp beamed above his head like a small golden spotlight.

I thought back to one sunlit afternoon in my childhood when Lotus and I wrestled on the glowing grass by the basketball court between our blocks. The sun was high and the sound of the birds in the one tree made it feel like a forest. I took my hearing aids out and nestled them in our pile of shirts. We wore vests and our skin was smoother than a quiet river.

Holy . . .

Slim. Dark.

Holy . . .

Two brown black boys wrestling in the sun.

Holy . . .

He had me pinned to the ground, we grunted over each other, our bodies almost stuck together as we rumbled. Wanting the other to submit, to surrender, to hurt but not scar or draw blood. We didn't break eye contact, it assured us that we were safe in each other's grip, we were in control as we held each other on the warm grass through each improvised movement.

Holy . . .

An older boy, darker than Lotus and me, walked onto the basketball court in blue baggy shorts, saw us grappling on the ground. Man, you have no idea how gay you look. Lotus stood up, straightened his vest. I stayed on the ground. Man, fuck you, Lotus said, and the grass stopped glowing.

*

What gets me when I watch Rose and Giovanni dance through the silence is their eye contact, the determined refusal to look away, their tightened gaze holds them through each movement, and oh man, the trust it takes to be carried through a silence like that, one that lifts you off the ground and catches you wherever you land.

*

Johnnie Ray found himself onstage in the Flame Showbar where his future manager and lover, Bill Franklin, sat in his pressed smooth blue suit and white shirt, saw a frail boyish-looking stick figure stand in the spotlight snapping his long long fingers to a beat that hadn't yet begun.

You can't believe everything that went down in a smoky midnight downtown Detroit bar but I can believe that everything hushed as Ray poured his whiskey and gin voice, I can believe that the air changed colour as Ray crooned into the darkness. Later, Bill would say that Ray was never more himself than his early days performing here, in 'black and tan joints' where he was 'a much wilder, bolder, much more secure performer'.

Some music critics called Ray melodramatic on the stage. They hated how he held himself, how he pretended to faint, tumbling theatrically over the body of the piano, hated how he picked up his music stand and pounded it into the ground as if some colourful current had shot up in his suit and he imploded with it. Later in his career beyond the Flame Showbar, his booking agents saw Ray's hearing aid as a hindrance, something that boxed him into a gimmicky novelty act, a 'handicapped honky', a 'vehicle for self-pity', but Ray soon proved that his talent had staying power, life beyond the dimension of novelty or caricature when he began consistently selling out respected clubs across America and acquainting himself with respected Hollywood stars from Marlon Brando and Sammy Davis Jr to Marilyn Monroe and Fred Astaire. Before he started

stepping onto more mainstream stages like New York's Copacabana, he would be forced to perform without his hearing aid which led to stiffer performances on those stages. Ray could barely hold himself in time, staying put between the piano and the drummer, relying on the vibration and eye contact with the band.

There was always cynicism about Ray being a deaf novelty act. A *New York Times* critic even said, 'His performance is the anatomy of self-pity.' But listen, Ray deserved to be understood and among a lot of things that broke out of his performance, there was a man and a child barely holding himself together . . . and in the end nothing and nobody hurt or beat Ray up more than himself.

*

Lotus had grown into himself. He looked solid, not the sixteen-year-old boy I remembered with braces and a clunky backpack, who walked like a giant foot in the wrong shoe. Back then he wore trousers tight on his waist and thick fitted jumpers even in summer. I hadn't seen him since leaving secondary school. He was part of the state hearing school and I was part of the state deaf school attached to it, located in the shadow of the hearing school, semi-hidden behind hedges and trees. We shared some classes. I liked him.

Lotus's voice was slightly nasal but it had depth. And he was well spoken so he was easy to lip-read. This combined with his mild manner led to the other boys calling him a 'coconut', the slang term for a person who is 'black on the outside but white on the inside'. I look less distinctively black – Lotus thought I was Italian when we met – but I was nicknamed 'dumb boy', pronounced more like 'Dumbo', because of my hearing aids or perhaps more creatively 'bush boy' because I grew my hair out so it would cover my ears.

I stared at adult Lotus for a few minutes, and then I stared at the hairs that had grown over the scars on my hand. These scars were formed from fights, scabs that became scars after I peeled them off too quickly, eager for healing.

Lotus didn't look up. His eyes were deep in conversation with a man sat next to him. They were both stylish in ripped jeans, white trainers and black jackets; casual city professionals. Lotus's face was still smooth, slim and dark. I remember the version of myself that was once familiar to him. The skinny deaf boy, hooded in sports tracksuits. We were the kind of boys who wrestled for hours after watching *WrestleMania*, grappling each other with the moves of our favourite muscled men, sleeper holds and clotheslines, falling flat on our backs together. We were the kind of boys who saw any wide-open space and turned it into a ring.

*

After Ray's 1951 performance in the Flame, he came offstage, wiped the sweat and tears from his face with a handkerchief (an idiosyncrasy of Ray's that would inspire his first branded merchandise, the 'Cry-Kerchief') and walked a few blocks to the Stone Theatre Burlesque House. He dangled his long arm over Bill Franklin, the man in the pressed smooth blue suit and white shirt and kissed him on the lips. Soon after Ray disappeared down the street and nothing smashed except a heart or two. Believe me and you'll believe anything that is twisted, scrunched up and thrown into mist and smoke . . .

*

Once, Lotus invited me to his house after school. We stayed in his room listening to music. He made hip-hop beats on his computer and was playing them to me. Mid head-nod I pointed at the handkerchiefs by his bed and laughed. You don't have a cold, bitch, I said, then jumped on him and put him into a sleeper hold. His room was in his parents' attic, concealed white walls and wooden window frames, like a stylish tree house. It smelt of leaves and washing powder. It got late and he said I should stay over. I slept on a mattress on the floor next to his bed.

*

The Stone Theatre Burlesque House was one of Ray's regular haunts. One night he breezed into the restroom and saw an olive-skinned moustached man with a slim, square jaw leaning against a cubicle with a cigarette between his fingers, the top button of his shirt undone. At 1.45 a.m. Moustache Man greeted Ray, 'Hi.' 'Hi . . . hot isn't it?' replied Ray. 'Sure is,' said Moustache Man, removing the cigarette from his lips. 'I know where it's real cool,' said Ray, 'real cool.' 'Where might that be?' asked Moustache Man. 'The Park Avenue Hotel, room 310.' 'What could we do at your place?' asked Moustache Man, leaning closer. 'We'd get cool man, real cool,' grinned Ray, as he turned away from Moustache Man to wet his hands under the running tap. 'We could open a bottle and have a couple blasts.' Ray was looking in the mirror at Moustache Man. Moustache Man smiled, Ray turned back to him, pulled Moustache Man towards his body from his belt and cupped his groin. He then twirled Moustache Man on the tiled floor, their hard polished shoes squeaking below them as they locked into each other. A determined dance, refusing to look away, the tightened gaze held them through each movement. Almost anyone could have walked into that men's room and witnessed what erupted in their hands but it all happened behind closed doors and oh man, the trust it takes to be carried through moments like that, moments that lift you off the ground and catch you wherever you land.

*

Hours after falling asleep in Lotus's room with my hearing aids under my pillow, I woke without opening my eyes, lying on my back. I felt a hand on my groin moving towards my shaft. The hand undid one of the buttons on my boxers. I lay still a moment, needing to be sure what was happening; I could hear blood pulsing in my head. I felt the hand try to pull my shaft out but I shot up in the bed and briefly saw the dark outline of Lotus, leaning over me. He flew backwards

like a shadow had slammed his body onto his mattress. He lay still, pretending he was asleep in his bed, quiet as land by a lake. I could smell leaves. I lay there listening to the blood in my head until my mouth was cold and dry from my heavy breath, then I hurried, dressed, grabbed my hearing aids from under my pillow and without putting them in and making no effort to be quiet, I rustled and thumped and screeched through the house and left.

*

In that restroom of the Stone Theatre in downtown Detroit, Moustache Man, who was about to have sex with Johnnie Ray, was in fact working undercover for the Detroit Vice Squad. The whole pleasure for Moustache Man was in criminalising men like Ray. Ray had barely whipped his belt off when Moustache Man slung his cuffs from behind him and pushed Ray face first against the door, bruising his jaw. Ray fought back but any blow that landed on his hearing aid amplified lightning bolts of pain which squeaked and squealed through his skull. Ray kept trying to turn it off as he fought back but he was ripped away from the restroom door, kicking, screaming, hearing aid squealing . . .

*

On my way home from Lotus's house I kept checking my watch as I waited for the night bus. 4.12 a.m. It felt like a new time zone. My mind split from my body, I kept thinking over and over what happened. It rewinded and played, rewinded, played and then became a *WrestleMania* action replay, actions I wished I'd taken grew in violence; a knee in his nose, a fist in his eye, a chair over his head.

At school I told Emanuel, a mutual friend of ours, what he did, expecting wise words from him. He was the only boy who could grow a full beard. But his projected wisdom failed me; he was just a boy like any of us. He would stir and shit talk for pure entertainment and each time he told someone about what had happened the rumour would

slowly slant into new angles like a picture frame vibrating on a wall in a house party.

*

After Ray was arrested for soliciting sex in the Stone Theatre Burlesque House he was charged under Section 448 of the Penal Code of the state of Michigan, Soliciting and Accosting: 'Any person who shall accost, solicit or invite another in any public place, or in or from any building or vehicle, by word, gesture or any other means to commit prostitution or to do any other lewd or immoral act, shall be guilty of a misdemeanor' .

Ray turned his hearing aid off, not putting it back in meant he could just glare, nod, smile passively if needed without having to take all the weight of the interaction with police officers. He glared at the mugshot camera, 'looking feral, scared and angry' described his biographer, who went on, 'He kept his hearing aid off, a typical Ray move when a situation worked against him.'

Ray made a quick court appearance, paid a twenty-five-dollar fine and left Detroit. He went to Ohio to return to the nightclub circuit, his career-defining performances still ahead of him.

Even as a child Ray knew that he wanted his name, his body in lights, he wanted the dazzling big-time noise. He left high school and darted for the theatre crowds and was hired to sing 'Look for the Silver Lining' at a burlesque house (Portland's four-star theatre), He lied to his parents about the job, said he was having dinner with friends when he was working. Ray's mother wanted her son to become a minister or a baseball player and would have died knowing he was sharing stages with erotic performers. Ray said, 'I was the kid they goosed to get laughs', the boy with the hearing aid singing about finding a silver lining in a downtown burlesque show, laughter was too easy and the joke got old fast.

Jonny Whiteside wrote in Ray's 1994 biography *Cry* that 'Popular music relies on gauging and defining an audience's self image and

desires, the unspoken urges that lie at the soul's core. By speaking to and gratifying the needs of its audience, pop music goes beyond entertainment to offer spiritual glamour.' But there was nothing glamorous, spiritual or liberating about deaf, bisexual Ray being forced into double hiddenness because of what was and wasn't marketable in the pop music industry of the 1950s, a world that wanted anything that wasn't white, straight, rich, able-bodied and preferably male to be squeezed out of the picture. Even Hollywood told Ray he'd never make it if he bared his hearing aid onscreen. Ray was never given the opportunity to present who he was to the wider culture, who he was when he performed on underground stages like the Flame Showbar.

In one interview from 1952, Ray referred to himself as a 'freak'. 'They come to see what the freak is like! They want to know what this cat has got. I know what this cat has got. I make them feel. I disturb them. I exhaust them. I bring one or another of their buried controlled emotions to the surface.' Even the readers in the 1950s sensed that there was something about Ray, something between the lines . . .

Ray's later manager and partner, Bill Franklin knew that when Ray referred to himself as a freak, he wasn't signalling his defiance as a deaf bisexual while striving for mainstream success! Ray wasn't trying to dim his own flame, Ray wanted mainstream success whatever it took, he knew that the kind of success he dreamt of meant hiding, leaning away from the parts of himself that made him a throbbing heart. But that's the thing about the spotlight – it can swallow you whole because it relies on what it hides as much as what it shows.

*

Thinking back to my performance at Hoxton Hall Theatre when I was fifteen, staring out into the spotlight, I think of my failure to signal my deafness to any of my fellow actors or hearing collaborators. It meant that I couldn't assert myself within any performance. If I had had the *confidence*, I could have performed some aspect of my deafness, bringing it into the space. Instead I kept myself mentally

stuck and shamed in that spotlight for years, turning away from public performance altogether.

I didn't write poetry or perform anything publically about my deafness for years because I didn't think there was poetry in it. Deafness was something I was trying to look away from, something that stained my humanity. It didn't deserve language, it didn't belong in the 'Perfect Species' or the story I was trying to tell about myself. I didn't know it could be written or asserted on the stage, and if it did, wouldn't it be a self-pitying ploy? A novelty? How would I centre something about myself that I was actively resisting?

*

'I didn't want to believe the rumours,' said burlesque 'Queen of exotic dancers' Tempest Storm after meeting Ray at a party. Storm was a glamorous red-haired woman with a similar background to Ray – she was country, she was working class – 'Ray made a pass at me, I could have fallen in love with him very easily, but because of the rumours I just didn't want to go there.'

Ray responded directly and swiftly, 'I've heard all those stories that I'm queer . . . I pay 'em no mind and keep on singin'.'

Later a gossip magazine ran the front-page headline: 'Johnnie Ray arrested on homosexual charge'. The words 'homo' and homosexual are used eighteen times.

Privately, these things didn't matter to most people on the inside. 'Someone told me that Johnnie Ray was homosexual, but I didn't place any weight in that,' said a Hollywood agent remembering Ray years later, 'because most of your top talent attractions are homosexual.'

But Ray needed to find a woman that would marry him to quell the gay rumours. Marilyn Morrison, the woman who married Ray in 1952, said she'd 'straighten it out'. She knew about Ray's police record, that he slept with men, she knew that the whole marriage affair was partly a showbiz ploy, that Ray used to perform in her father's nightclubs and knowing what they all knew, that her father would

push back against the marriage, but still, Ray walked Marilyn down the aisle in his favourite midnight blue suit, he spun and shimmered in the lights of the wedding reception. His wife-to-be wore a pale lilac taffeta cocktail suit with full accordion-pleated calf-length skirt and satin shoes, her tulle hat and the baby orchids and lilies of the valley that she carried in her hands were all matching lilac-white. When they stood at the end of the aisle no one in the room heard Ray's 'I do', but then as the pastor sentenced them to a life of health, contentment and happiness, he barely let the pastor finish before taking his new wife in his arms for a kiss that lasted two full-bodied minutes . . .

*

I didn't do that bro, said my friend, Lotus, who'd used all his breath that day defending himself to our other friends, and then to the strangers from other year groups who had started calling him Lotus Pokus. My friend yelled, pointing at me, He's the gay boy! He touched me!

Swear down, said Ben, an older boy outside the science block with a basketball under his arm. If my mate touched me in my sleep he'd be fucking dead. You best put some serious bruises on him.

No one in our world believed back then that boys like me who are easily talked into violence are part of a problem. Boys with something to prove will do one mindless thing that could harden their entire life. Throw it away, even.

Here's the thing, I didn't know any other stories that could help or speak to what was happening in my life but they must have been out there, there must have been stories about boys like us, deaf, queer, whatever, but where were they? How could I find them? How could I stitch them together and make a kind of sense, even when they contradict each other, how could they sing, dance, square up? ∎

LONG, TOO LONG AMERICA

Aaron Schuman

Introduction by Sigrid Rausing

In 1999, then-unknown photographer Aaron Schuman set off on a road trip with his girlfriend, driving west in a Chrysler minivan. Most of the photographs he took on that trip were put away, and are published here for the first time.

The sequence begins with an image of a South Dakota national park, the territory the Lakota people called the *mako sica*, the badlands. It was a ceremonial sacred site for the Oglala Sioux and was designated Sioux land in an 1868 treaty. Within a few years the treaty was broken, and in 1877 the territory was confiscated by the US government and eventually made into the Badlands National Park. Turn over the page, and there is the Lorraine Motel in Memphis, Tennessee. This is where Martin Luther King Jr was murdered by white supremacist James Earl Ray. On the same page is a photograph of the Lincoln Memorial Reflecting Pool, where King gave his famous 'I have a dream' speech. The last image in the series shows a family in one of the Amana colonies in Iowa; a father, daughter and the daughter's husband on

a green lawn. The Amana Colonies were founded by nineteenth-century Pietists from Germany, and remained self-sufficient until 1932. This, too, is an aspect of America: religious communities offered the freedom to practise without, for better and for worse, much state intervention. Some deteriorate into patriarchal cults; others, like the Amanians, assimilate into the surrounding community. The old villages had become tourist destinations by the time Schuman took this photograph. The Lorraine Motel, too, is a heritage centre, as is the Badlands National Park and the Reflecting Pool in Washington: these are all memorial sites. But what are we meant to remember?

'Long, too long America', the title of this photo essay, is taken from the first line of a Walt Whitman poem about the ravages of the Civil War (1861–1865). The last two lines read somewhat ambiguously now, a repeated call to conceive and show the world what the children of America 'really are'. Is that what Schuman is showing us here? A remnant of Sioux land, a broken treaty. A motel, the site of racist murder. A pool of water to reflect on the state of the nation. Descendants of Amanians on a green lawn. The conundrum of America: on the one hand, violence and repression; on the other, freedom and social justice.

But I find myself wary of conclusions these days. In Swedish schools of the early 1970s, our textbooks in history, geography and civics each ended with a chapter on the Soviet Union and a chapter on America. These books were, I suppose, part of the effort to maintain neutrality in the Cold War, but there was no balance in tone or content of the chapters. The US was presented as a country riven with poverty and racialised polarisation, whereas the Soviet Union was shown as quite poor, perhaps, and, yes, lacking in free speech and other human rights, but also as progressive and cosily communal. It was a political smokescreen, of course – Sweden's ongoing information exchange with NATO was kept secret (finally revealed last summer); the security police registers of communists in workplaces, ditto – but I suspect that the difference in tone also stemmed from the fact that the language for critical thinking was missing in the Soviet Union. Beyond Solzhenitsyn and a handful of other samizdat writers precariously pushing against the limits of

censorship was a multitude of ironic jokes and an ocean of political slogans and propaganda. The lack of interrogative social sciences and a free press made the vocabulary to criticise communism a little elusive – it existed, of course, but in neutral Sweden it didn't quite trip off the tongue in the same way as the critique of the US.

Some causes come with preconceived language. It is easier to criticise the US than, say, Myanmar or Turkmenistan because the language and positions are readily available. We praise originality more in art than in politics.

Perhaps – I am not sure – Schuman asks us to pay attention to what we don't know rather than to what we know. Mowing a green lawn. A bed, a wallpaper. A car park, a gun shop, a singer at a family reunion. Roller skaters, tourists and park ranger. A stuffed wolf, a TV. Ordinary beauty: incidental and anarchic. ∎

Find what you

National
Art Pass___

weren't
looking for.

Get endless inspiration with free entry
to hundreds of museums, galleries and
historic places across the UK. Search
National Art Pass or visit artfund.org

The more you see,
the more you see.

Art Fund_

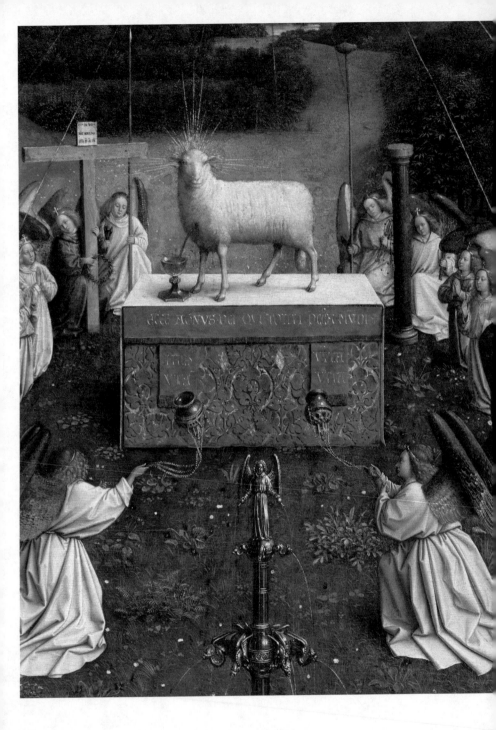

Hubert and Jan van Eyck, detail from *The Ghent Altarpiece: Adoration of the Mystic Lamb*, 1432

THE SCHEDULE OF LOSS

Emily LaBarge

Pierre says I should lie in exactly the same position, just like how it happened, for as long as it happened, and for as long as it takes until the pain comes out of me, otherwise it will never leave. It will be stuck inside, forever, and it will do bad things. I picture myself lying first on my front, face down, neck bent sideways; then on my left side, hip twisted at an awkward angle; then on my right side, curled into a foetal position. It is possible that my body did other things during the time that it was lying on the ground, but I cannot remember. I would have to do this for seven hours? I ask. Maybe longer, Pierre says. You mean, I think, it could take forever? You can do it anywhere, he says. Choose a place you feel safe and will not be interrupted. But you have to do it.

I imagine myself lying down – prostrate, a chalk outline, a dead man's float – and then, after some blank period of time, a sticky, tar-like substance oozing out of me in a viscous pool that spreads thickly, coagulates, peels itself off the ground, pulses, contorts and vanishes into thin air with a dark, creaking moan, after which I am, all of a sudden, free. Unfortunately, this does not happen, and I do not even attempt to do as Pierre suggests. I now regret this. Perhaps It is stuck inside forever, most certainly It does bad things. Though I remain unconvinced that It would have been so easy to get rid of, just like that, all in one go.

/

When the six men with their masks and their guns and their knives and machetes and screaming and terror arrive, we are about ten minutes into watching *Mrs Doubtfire*, the good-natured 1993 family comedy about a divorcé who impersonates a no-nonsense Scottish nanny so he can spend time with his family. I see a flash and movement in the corner of my vision and suddenly the men are there. I did not hear them coming. Maybe I heard them coming. I did. I did not. The film continues to play in the background as they ransack the house, force us to the ground, put blankets and pillowcases over our heads, hold guns to the back of our skulls, whisper in our ears – *we don't want to hurt you, but we will* – grope our bodies, tie my father's hands, hit him with the end of something blunt, his back, his head. After three of the six men leave, leave us cowering on the ground, leave the other three men 'in charge', the film continues, continues to play. I hear familiar lines, *It was a run-by fruiting!* and *Frank, make me a woman!* and the chorus of Aerosmith's 'Dude Looks Like a Lady' and Robin Williams as Daniel Hillard, the divorced father desperate to see his children, *Did you ever wish you could sometimes freeze-frame a moment in your day, look at it and say 'this is not my life'?* As it happens, Daniel, I do. But I do not know that one of the men now 'in charge' is sitting on the couch watching the film until I hear him laughing at one of the most famous trailer gags in which Mrs Doubtfire, trying to learn how to cook, accidentally lights her blouse on fire: *My first day as a woman, and I'm getting hot flashes!* The man laughs, hard, and dangles his machete idly over the arm of the couch. I watch him through a small hole in the crocheted blanket that has been hooded over my head.

Once the movie is finished, after it is stuck on the Menu for what seems like an eternity, the looped soundtrack for which is a cartoon bird voiced by Williams singing 'Figaro', one of the men turns the television off and begins to fumble through the small selection of CDs – Christmas music – we have brought with us. He doesn't want anyone to be able to hear us, I realise, when we XXX or XXXX or XXXXX or X. He chooses *Agnus Dei*, a compilation of classical

religious choral music performed by Edward Higginbottom and the Oxford New College Choir, boys with voices high and pure, like angels. The subtitle of the album is 'music to soothe the soul', but it is filled with songs that are actually imploring cries of anguish: *Lord, have mercy* and *Hear my prayer, O Lord* and *Have mercy on me, O God*, in English, Latin, German, ancient Greek. There are Beatitudes, Ave Marias, psalms, hymns, several variations of Ave Verum Corpus (*Hail, true body*) and Agnus Dei (*Lamb of God*), which are both liturgical chants. The most beautiful are the most ominous, from Gabriel Fauré's *Requiem* – a Mass for the dead, whose text variously begs for delivery and absolution, for mercy upon the deceased at the Last Judgement.

This music plays and plays until the men leave. Every time the CD finishes, one of them walks over and plays it again, and again, again, again. I begin to use the number of repetitions to count time, to keep track of how many hours they have been here, we have been here, when will it end. The music plays so many times, so many requiems, that I begin to think and then vividly hallucinate that I am witnessing my own death Mass. Could this have something to do with the Christmas a few years ago when my parents sat us down and told us, with a strange sense of ceremony, they did not believe in God any more? Not a surprise to us, already never-believers, but somehow a momentous thing, they believed, to announce. To be Godless. A family decision. A family requiem. A family death Mass. The End.

The End.

Once I think this, I cannot not think this, cannot not imagine it and what it will involve, the family death Mass, The End, cannot not recall the fear, heart-pounding, unbelievable, and appearing at unexpected times for years after.

Francisco de Zurbarán's *Agnus Dei* (1635–1640), which hangs in the Prado, is said to be one of five versions the painter did of the subject. In it, the titular lamb lies slumped on its right side, neck softly extended forward, across a charcoal-grey surface surrounded by dark shadows that seem to both emanate from and enclose the brightly front-lit figure. The lamb's gentle hooves are crossed over each other

and trussed to form an X that extends towards the viewer. Painter and writer Antonio Palomino wrote in 1724 of an art lover in Seville who 'has a lamb by this maker's hand, painted from life, which he says he values more than one hundred living rams'. Other of the five paintings contain iconographic elements, such as sacred inscriptions about the lamb's holy character, or a halo around its head. But the Prado's *Agnus Dei* fuses the religious with the still life, carefully rendering the manner of the lamb in the latter – an isolated study of a subject against a neutral backdrop, with a focus on texture, detail, volume. Although the lamb's face is passive, resigned even, it is not possible to tell whether he is yet dead. Maybe he is just lying there, waiting.

In Ghent, almost a decade later, on a study trip with my students, looking at the central panel of the famous Van Eyck altarpiece, *Adoration of the Mystic Lamb* (c.1420–32) under restoration, I hear one of the British students describing the painting to a student from India, who has asked about the iconography. The lamb is evil, he says, it has the devil in it, so it has to be sacrificed, but first they let its blood so that everyone can drink it and be purified. So you can see, right there, he points, where the blood is spouting into the cup, that's getting rid of the sin. Everyone here has come to watch and celebrate. He says nothing of the angels, the processions of dignitaries, the scholars in prayer and worship, the lamb's radiant crown of light, more light from above, the scene shot through with gold. I wonder how to intervene, to gently correct, or if I should just leave them with their own symbolic readings, since Catholicism is abstruse and superstitious enough. The teacher in me says no, the writer in me says yes, why not. Transubstantiation would then dictate that congregants are drinking not the blood of Christ, but the blood of a satanic lamb; and the liturgical chant, what would it conjure? The Lamb of God no longer God's innocent child, but God's great, dissembling foe. A daemon in merino wool? Sure. Weirder inversions have certainly occurred.

Earlier this year, restorers found that the lamb's face had been painted over sometime during the sixteenth century. Stripping away the overpaint revealed the lamb's 'intense gaze' and 'large frontal

eyes'. The *Smithsonian Magazine* described the lamb as having an 'alarmingly humanoid face' with 'penetrating, close-set eyes, full pink lips and flared nostrils', features that are 'eye-catching, if not alarmingly anthropomorphic'. Yes, shocking to see a human face where it seems not to belong, but what is it that tips the anthropomorphic – itself a purposeful misattribution – into the alarming? Another version of this question might be: what is too alien to consider human?

In Ghent, all those years later, I will remember the songs of Agnus Dei, and I will still hear them ringing in my ears again and again, their force, however, lessened, now almost beautiful. But I do not know any of this, lying on the floor a few days before Christmas in 2009, as they play on repeat, and I think about J.D. Salinger's Franny, who repeats the 'Jesus Prayer' from *The Way of a Pilgrim* – 'Lord Jesus Christ have mercy on me' – as if it might allow her to leave her body, leave it behind, the words themselves almost incidental to the practice of repetition. 'Alone, Franny lay quite still, looking up at the ceiling. Her lips began to move, forming soundless words, and they continued to move.'

T is for touch, as in do not, as in *noli me tangere*, do not touch me, as Jesus is said to have told Mary Magdalene when she recognised him in the garden, just after his resurrection. Do not touch me, do not hold me here, in this place I must leave, I think he meant – we are now worlds apart, with a vast chasm between us, I think he meant, and I am no longer human: I am changed.

T is a body with arms outstretched, *noli me tangere*, splayed to the sides, if lying down, if standing, held up to the sky, or drooping with fatigue. T is a posture of gravity, eternity, endurance. T might have been taller – a cross! – until the head bowed or was lopped off.

Noli me tangere is another way of saying I am marked – the touch remains – *ça me blesse, ça me perce* – it wounds and punctures, like the 'punctum' Barthes writes of in *Camera Lucida*. The touch, the mark, is the detail that leaps out of an image, piercing its viewer like an arrow: *cette blessure, cette piqûre, cette marque faite par un instrument pointu* – this wound, this prick, this mark made by a sharp instrument.

Barthes is writing of photographs, but I begin to believe this is also how any moment or sequence in time works, how memory works: the mind is touched, marked, pierced, wounded, and the *piqûre*, the puncture remains, maybe multiple, a nebulae, draws the eye, the heart, the soul, draws everything into it like a vortex. And what to do then, all turned inside out?

Noli me tangere is another way of saying *trauma*, losses that have no shape or face, too immaterial for the rituals of mourning we have available. Something we cannot hold, some hole the darkness shines and shines through.

A rthur shows up I don't know when. Arthur shows up at maybe, it must be, around 3 a.m., maybe later. What time is it, time is over, The End. Did the police call him, the police must have called him. Arthur is the partner of the woman who owns the house we have rented on the low-lying coral island in the Atlantic Ocean where the waters are cyan, turquoise, azure blue and the sand is the finest pink-flecked white. The woman is extremely upset that this has happened, he says, she is bereft, he says, she has been unwell, he says, she cannot attend. Arthur has brought an enormous spotlight with him and a bag with some heavy tools in it including a gun. Does he not know the men have gone. Does he think they will come back. Arthur says his father was a tracker who passed down the knowledge to him, and he will find human tracks if there are any. He runs outside to the steps that wind down to the beach through thick green brush, the spotlight bobbing blinding bright before him, a circle in the dark. They did not come from that way I want to say but actually who cares I can't feel anything, The End.

The police are not surprised when Arthur shows up, they all know each other, did they call him, they seem happy for him to walk around the house that is now being called 'the crime scene'. How many police are there. Three or four or maybe only two. I don't know. The house is no longer a house, it is like nothing I have ever seen, it has been raided, trashed, turned over, like in a film, down to details that strike solely as

THE SCHEDULE OF LOSS

absurd, like slashed-open mattresses and couch cushions, as if – in a slightly run-down rental house – something valuable must certainly be elaborately hidden within. There is smashed glass everywhere, chocolate cake smeared on the walls, empty bottles of rum and cans of Diet Coke, a roasted chicken wrapped in an undershirt, not ours, and thrown in the bushes outside. It is horrible, but what is really horrible is how ordinary it is. The violence has not endowed the house with any spectacular or unusual qualities. It is exactly the same as before, just ruined. Arthur says he is shocked, appalled that this has happened but his face does not look that way.

The woman from the huge house next door who wouldn't let us use their phone to call the police comes over to apologise. My sister knocked and knocked and implored and maybe begged, I think, since we were panicked that the men might be about to return at any moment, but we don't talk about this. *We have children*, the woman says, *I thought it might be too dangerous to open the door.* I don't remember what else anyone says, I just stare at her, her coral nail polish, her dark tan, her white flip-flops, her jean shorts, her pinched face and wringing hands. We're so sorry, she says, we're leaving, we say, Merry Christmas, we say, and all that.

Arthur drives us to a hotel. The police drive us to a hotel. Someone drives us to a hotel. Where is our car, did they steal the car. The hotel is a hotel the room is a room I think the bedspreads are olive-coloured and I take the one in the corner. They tell us to get some sleep and we will be picked up in the morning to go back to the house and get whatever remains of our things, then go to the police station to give statements and have other dealings with 'officials'. What does that mean. It must be 5 a.m. by now, maybe later, or earlier, the hotel room is freezing and I am quite sure I will never sleep again. I am petrified to assume any of the positions I held on the floor all those hours, lest they somehow suck me back in, like my body is a traitor, a deep hole to somewhere else, not mine, so I lie flat on my back, like a slab of stone. I sleep in my clothes a few hours of leaden, faithless sleep.

Nothing until we are in a car with I don't know who driving to the police station. Sleeping, showering, breakfast, nothing, what am I wearing, where are my parents. Hazy memory that Arthur arrives early at the hotel with a group of young men who have been out with him in the early hours of the morning searching. They say that people live in the bushes. They say there is an open border with Haiti and the Dominican Republic, people come over on boats and join gangs. They are furious, they say, they are ashamed – the people who do this, this is why people think we are poor and criminal and it's not safe to come here, to our home, to the beautiful island, crystal blue water, grilled conch, johnnycake, schools of shining fish, so much coral, land that licks and arcs through the ocean like a poem, like an arabesque – no, they say, this is not our country. Arthur calls me poor baby and touches my arm, strokes it lightly with the back of his hand, where the shattered glass made a cross-hatch of fine cuts. His face still does not look surprised. But I am surprised, surprised to be touched by this man I do not know. Poor baby poor baby. I am twenty-five. I battle feelings of gratefulness, oh so grateful that these angry men are here to help us because not all angry men are the same is that true. The place at the base of my skull where they pressed the gun throbs gently.

Arthur takes my parents to the Governor's Office, because the island is a British Overseas Territory, to see what to do about our missing passports, how to get home without them, also official procedures about what will happen and what the Governor is going to do about – anything. Why are we special we're not. We are just from another British colony, albeit one that was granted its freedom long ago, one not so 'foreign', which means white, one with wealth and infrastructure, which also means white.

No, Arthur has already taken my parents to the Governor. The group of men arrives separately? How would we have known who they were. Maybe they all came at once and these ones waited for us to be ready because we were all meeting at the police station at the same time later on.

In the car the two no three men have a strange energy about them and so do we, we recount things quickly and then fall silent, like waves of fever filling the car. They shake their heads and tsk in sympathy, sometimes pound their fists in outrage, but we do not say much because you learn quickly that all anyone wants is the bare bones, no details, please, and anyway as you speak the story becomes something else and the reality falls away to a place more horrible, less utterable and stays there as you rehearse what becomes a version of the good story, the short version that doesn't make anyone feel too uncomfortable, bad, complicit. This is another version of that story. You can stop reading any time you want. I look at my sister and barely recognise her, her face stained with bewilderment. I know I must be a mirror reflection but for some reason we both grit our teeth and smile dutifully, as we have been trained, I feel my mouth forming words but I do not know what I am saying. I think I make a joke, maybe two. Ha ha. I look down at my pale legs and think I am fat and feel ashamed of the blue sky that presses against the windows the green that rushes past as we drive over hills and through low shrubland, ashamed of the heat of the wind in my hair of something invisible of everything.

The main police station is out by the airport so that as we approach it we seem to be driving directly alongside taxiing planes. It is so loud we all stop speaking. The station is a low, flat building that looks more like a strip mall, run-down, squat. The sound of the planes overhead is deafening. Suddenly my parents are there too and we are walking through a hallway at the end of which is an actual jail that could be from another era, a bad stage set – a grim concrete door with a window of bars – a man shoves his face through it and shrieks at us, makes a grotesque visage, waggles his wiry arms. My mother gives him the finger? What are you doing, I ask her. That was one of *them*, she says, I *recognise* him. I don't, but her fury is so hot, so radiating, wouldn't yours be, mother, that I say nothing.

Nothing again until I am in a room alone with a woman who will take my statement, which seems laborious for her. She sighs a lot and clicks her nails, annoyed that the acrylics are interfering with her

handwriting. Every once in a while, when I am mid-sentence, she picks up her phone to read and send text messages. A couple of times she answers phone calls about if she wants to come for lunch and what she will order. A salad. With chicken. And mandarin oranges. Sigh, sigh, and then what happened, yes, yes, and then what happened. Then XXX then XXXXXX then XX then X and XXXX. I know that it is not right, but I feel embarrassed, like this is all our fault, like why are we here anyway, we are interlopers, fools, like I am wasting her time, like my terror, my abjection, my dehumanisation, my body is of – like I am of no consequence. No. She makes me feel that way. No. It is our fault. No. People keep walking past in the hallway, pretending to casually look in out of interest, but actually look right at me, as if memorising something. I watch the woman's round writing form letters, another version of the good story. She keeps spelling 'yelling' as 'yalling'. Will the police think I can't spell. I don't want them to think I can't spell. That doesn't make sense I didn't write it. What if they think I can't spell. I don't want to disappoint anyone. When we are finished, she sighs again and half rolls her eyes and says slowly and unconvincingly, 'I'm sorry you had this experience,' then gets up and walks away leaving me alone in the room.

Nothing again, again, until I am outside sitting in the parking lot with my sister and the two no three men, sitting on the hot concrete curb watching the planes fly so low, so loud in the wide bluest sky. They tell us they will find the men, they have a plan. I believe them more than I believe the police, who lamely offer that they heard there was going to be 'a siege' on one of the houses in the area we were staying, offer 'a siege' in casual tones, what is that, offer no explanation for lack of vigilance but that it's too big an area – five kilometres, a ten minute drive – for them to patrol. Sorry. Sorry, and we do hope you'll come back to visit again.

Some of this makes more sense later, when I find out one of the men involved was the teenaged son of a police officer. My sister says that the two men who took her statement locked the door of the small room they were in. As they loomed over her, a man in the hallway

outside started banging on it open this door he said OPEN THIS DOOR. They opened it why did they lock it why.

Sorry. Sorry, and we do hope you'll come back to visit again.

This is said by the many officials, all of them, time and again, but my only consolation – the moment I am waiting for – is when I can leave this low-lying coral island in the Atlantic Ocean where the waters are cyan, turquoise, azure blue and the sand is the finest pink-flecked white and never return. I think that I will leave It behind. I am wrong.

A t the hotel we talk fast and hysterical our voices shrill and high like we cannot stop. It's like electricity is coursing through our bodies, our eyes brighten, we sit up straight, the words come thick and wild, building on each other, interrupting each other, until we remember what we are talking about and fall silent. The trauma – the experience of it, its strange details and recollections, the bizarre dealings with officials – is like a current we are drawn to, like an incandescent voltage, like moths to a bulb, like sucking on it. It is unpleasant and yet deeply difficult to speak about anything else, so particulars are hashed over again and again – but only the weird, almost comical, parodic ones, not the life-threatening, not the deep marrow-fear scarring ones. Not my dad lying on his chest for hours, hands tied, only a year after quadruple bypass heart surgery. Not how we yelled he is going to DIE if you don't let him move. Not how they did let him move. Were they good after all. No. Only relatively speaking. Many awful things seem just fine if ultimately you are not raped and murdered. It is over, I think, it is over. But it doesn't seem to matter that the worst didn't happen, because it feels like it is all still happening all of the time, on some sort of horrible subterranean level, like something cold and awful is wrapped around my oesophagus, pulling it down, pulling it out. Like my brain is burning along its neuronal pathways, like it is screaming SCREAMSCREAMSCR but my face is blank, pliable, doesn't forget manners. My mind will get used to this, but my nerves will not.

Dinner is a wild oscillation between talking about It, not talking about It, trying not to talk about It and failing, sucking on It, feeling guilty and possessed, and various people coming up to the table to apologise for It, to ask us about It, yes, strangers, and to invite us back next Christmas because It would never happen again, they all promise. I remember a busy restaurant, I remember candlelight, a white tablecloth, our faces flickering, laughing, remembering, uncomprehending, brittle, no longer fearful, just furious. My mother insists that we should stay for the rest of the two weeks as planned, but at the hotel, so that we are not also 'robbed' of our holiday, since we have run away from Christmas and our lack of extended family for so long that there is nothing to return to, only snow. Everything feels like a poorly scripted satire I am watching from outside of myself. We leave the next morning.

B ack in Ottawa, you are tasked with creating the Schedule of Loss. This is the official title for what must be given to an insurance company or any kind of court or tribunal issued with loss compensation. Laptop, clothes, jewellery, dignity, mind. You also come to think of it as the required repetition of the good story over and over again to friends, family, more officials.

In some cases, the Schedule of Loss is required – passport replacement, health card replacement, driver's licence replacement, UK visa replacement, all of which are difficult to get when you don't have a single piece of identification remaining. A birth certificate is not enough. But I *am* myself, you have to keep reiterating, told many times, at this bureau and that, that you do not, unfortunately, have enough evidence to prove that you are you. At the Ontario Health Care Office, the desk clerk rips up your application form, she seems to think you are trying to commit health insurance fraud. You burst into inconsolable tears for the first time since It happened, petty bureaucracy truly the last dehumanising straw.

In some cases, the Schedule of Loss is voluntary – you do not want to tell people, but it is too weird to not tell people, which would

feel like an injunction of some sort. Make a list of who can be trusted with the Schedule of Loss. Some people shake their heads in disbelief. Many people say 'it sounds like a movie!', with a strange mix of horror and glee. Some people say, and reiterate later, that they are traumatised by what happened to you. I can't believe it, they say, I will never feel safe again, they say. Some people cry!! Some people don't answer your messages for days. Some people say, a few times, I can't talk right now I'm talking to my boyfriend. Some people, you get the distinct impression, ask obliquely about specific details of the event because they want to know if you were a victim of sexual violence – if there was Rape, the Worst Thing they can imagine, and which holds within it all the other Worst Things that have no clear designation. Imagine asking someone, casually, as if it were the ultimate salacious detail. They think it is their business, that it is information they are entitled to. Like what happens to women's bodies is for public consumption, though the public generally chooses to do nothing about it. But maybe you have offered this licence by telling the good story at all: it is no longer entirely yours, it is open to the world of Trauma Stories and all of the ways in which these are rehearsed and narrated and constructed and peddled and normalised in so many spheres of contemporary culture.

But the Schedule of Loss, the good story, is just that: a rehearsal – socially acceptable – with a narrative arc – just enough details to perturb, to hint at but never say what cannot actually be turned into a story with any serviceable point other than randomness, cruelty, and utterly speechless fear. The real Schedule of Loss is its other side, boundless, an endless tally, what you cannot find words for, what you are too afraid to say – as if it might conjure something awful – what feels like a dark hole in your heart beating through your throat or tar pouring out of your eyes. You do not, actually, think that there is anything language cannot do, just things it will not do, because language is representational but it is also relational. The Schedule of Loss is what can be heard, what can be tolerated, what can be borne by both teller and told.

The Schedule of Loss henceforth goes by many names, used by many different speakers including yourself, such as the good story, It, That Awful Thing That Happened, That Christmas, The Incident, What Your Family Went Through, The Thing, The Home Invasion, sometimes – though rarely, and latterly, as it seems too explicit, sometimes embarrassing, as victimhood, because it is helpless, often feels – The Trauma. Perhaps the greatest euphemism of all of them, since it implies something singular and enclosed, which is precisely the opposite of its effects, no matter how you try to contain it. ∎

FOYER

An independent magazine celebrating literary fiction, poetry, reportage, memoir, artwork and photographic essays from individuals of mixed-culture, second-generation and third-culture kid backgrounds

Explore the cultural threads that connect us all

ISSUE 01

FOYER

CONNECT

Stories: foyermagazine.co.uk | Updates: @foyer_mag

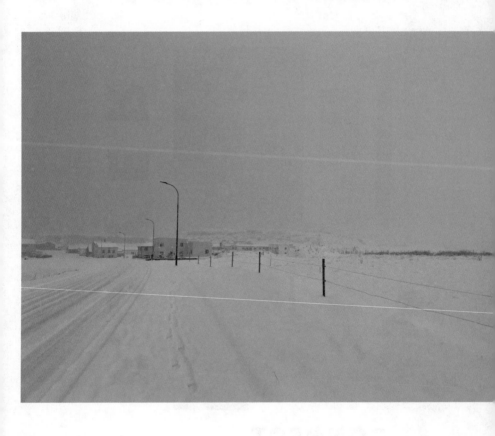

Courtesy of the author

TO THAT SILENCE, I TOLD EVERYTHING

Xiao Yue Shan

There are supposedly four hundred people living in the northern village of Skagaströnd, Iceland, but if all I had to go on was my own knowing, the number would dwindle to a finger-count. Along the coastline, the dice-toss of homes ranged silent and secretive. There were lamps in windows and linens ghosting on washing lines, hinting at bodies that read by yellow light or slept in navy cotton – but I hardly ever came across them. Though the lines and pathways that had brought me here required a great number of convergences and intersections, it was parallels that greeted me upon my arrival. The distance between the Iceland Sea and the mountain Spákonufell, the way the road mirrored perfectly the winding turns and curves of the earth, how the silence of the people never even touched the immense voices of the landscape. Day after day I walked the fifteen minutes between a kingfisher-blue house and a library that seemed to rest at the end of the world, along whistling water and dark rocks, past the diminutive structures, the upwards sweep of land behind them, the solid weather.

The library was coated seashell white, rimmed red. From one window there could be nothing but blue, then from the opposite nothing but black. When I unlocked the doors in the afternoon, the only evidence of other comings and goings were footprints on the

tiles, and when I locked them once again at night, I turned to face a tremendous silence. It wasn't the end of the world, of course. Local fishing boats docked at irregular hours, skimming back and forth with their catch of Atlantic cod. Fresh lilies and carnations appeared daily, somehow miraculously, in the only supermarket. Armoured tyres carved tracks along the single two-lane road. The darkness, the seclusion, the nothingness – it was only frightening because I was in someone else's home, furnished with symbols and inheritances I could not read. I had to move within it slowly, making my way through a labyrinth of invisible facts, invisible company, invisible testimonies of living.

All throughout the ungiving frost of March I repeated the same routine, entering the library in the late afternoon and leaving long after all the other lights in the town muted low. I had taken a month-long writing residency, continuing an ongoing project of writing poems that follow the logic and narratives of coastlines. Having lived most of my life on islands, their precarious, stranded geography has always moved me: the fluid nature of human life in constant negotiation with water. Iceland was a further elaboration of this project, after Hong Kong, Vancouver Island and Japan – and because it was the last, it became a place where all those previously disparate points coalesced. In drafts and carbons, I traced a path backwards through the red bridges and porous torii gates of Iwaki; skeletons of tsunami-swallowed structures in Fukushima; the patterned flanks of Aomori horses, spruce and cedar along Strathcona inlets; the greening islets of Kyuquot Sound. And when I raised my head from the paper, I looked out the window at a familiar tableau – the blue broadside, the finer line of blue in the distance, the black. Eternal division of land and sea. But that remembered image in the window soon recedes, as if a camera is pulling back, and I am left in the library, surrounded by books I cannot read. The sea-lines of my life demur, paling to the enormous gulf that surges underfoot.

Gradually, as the landmarks of journey diluted into the familiar physical patterns of commute, the days began to feel softer with wear.

The black stones became footholds, the windows became facades, and the silence – well, one never gets used to it. But after a week or so, the flow of that silence, which swept up every footstep, every whistle in its appetite, laid down against the landscape. By then, it was not simply that I was walking down silent streets, opening silent doors, walking down silent hallways to enter silent rooms, but that I was being carried through silence itself.

Inside the silence were cases and cases of books, from Marxist texts to poetry pamphlets and immense, cloth-bound volumes of the Icelandic sagas. Historical records lay behind glass shelves that held the worn residues of inheritance. There would be twenty-six horses one summer, and thirty the next. Kilos of soap and crates of potatoes were detailed in stilted pencil-marks so faint a single breath could've snuffed them out. This was a past that foresaw a future where memory would be needed. Life was patient, and because it did not move it became somehow longer, brimming with halfway moments – books open, unwrapped packs of chocolate cookies, notes scrawled on scraps. In this untouchable time of objects and souvenirs, I walked from window to window, shifting the hours between my hands, excerpting them from their lineage and into my own knowing.

Because of the drastically different hours we kept, the people that populated the library in my absence remained a mystery. They were parents perhaps, as deduced from the sudden appearances of child-drawings. They were purveyors of the morning, they drank tea and liaised with marine biologists, their handwriting had a barely legible elegance. All the while the season was changing, and stones muffled under soft cotton rounds of snow overnight would resurface glistening granite in the morning. It was as though winter and spring were completely unaware of one another as they passed each other by, at dawn and dusk. The soil faintly greening then silvering, the light pearled with frost, then honey.

W hen we moved to Canada, I was struck by how children in the West traded a sing-song anecdote between them – that if you made a hole and kept on digging, you would eventually find your way to China. Growing up in the Dongying farmlands, I never thought about digging a hole to seek the exotic; that mystery had been long solved by my grandfather's hands, the crescents of fingernailed soil, and the seeds, once so small and hard and dark, that would turn leaf and sprig. Had I wondered about the other side – what it hid from us, what it asked of us – I would have asked my grandfather to take me along the waters of Xiaoqing River, past the parcels of greening rice dividing Qinghe and the neat geometry of Yangkouzhen's skyscrapers, until we reached the shores of the Yellow Sea. There, where a barely distinguishable line portioned water from sky, is where I would begin my questions.

Growing up, my mother always warned me against falling asleep in the car. *Your soul will wander off in your dreams,* she said, *and it won't know the way home.* It was this glare of consciousness, sparking off the surfaces of the surrounding world, that guarded us after the loss of our first country. One always had to be brightly aware of seeing as a weapon, and being seen as either a source of strength or weakness. To survive, difference was something that had to be mastered.

M y seclusion in the library lured me into thinking that no one lived in Skagaströnd. The town seemed populated by ghosts. I talked to them in the way the living have always attempted to communicate with the silent: intuitions, desperations, tapping every brick in the wall to find the one that shifts. Yet, by the definition of anyone else, I was the ghost. I was the ephemeral thing that moved in the night, standing just to the left or to the right of the periphery, stealing into the written archive to mold it into source material. From my side of the divide, I wanted to mend the now with the beyond, to knit together the two worlds that progressed without any mutual acknowledgement, to describe myself in absentia. Yet no one who entered that library would ever know what I looked like, where I had

Courtesy of the author

been, what I did. They would look at the empty chair, crooked from the table in the angle of my body, and they would think – who?

That constant lesson of my upbringing, *don't fall asleep in the car*, has always meant to me: make sure that wherever you go, you're all there. The consequence of migration is that you are often elevated to being representative of a nation, a people, a way of living – and you must present your existence knowing that you are telling a great myth of place. To explain a life, to justify a life, you first speak the name of your homeland, then you feed the flicker with the kindling and flotsam of what you have lived through, with legends and anecdotes and tastes and sounds, describing photographs and landscapes and the memories of memories, until everyone sitting around the blaze is cast in its glow. But in the library at the end of the world, there was no surface to strike the match against. No one ever asked: *What brought you here?*

When I go to my mother's hometown of Harbin, I visit my uncle, who has watched the city be built up and torn down around him across the decades, who has witnessed that evolution, that trajectory of time. *It's changed*, is usually all he'll say. Then he'll sit back, light a cigarette, and we would sit in silence. This was the steady assuredness of staying. There was no need for him to explain his life to me; the fact of him having lived it was enough.

After staring into the black for a long time, shapes emerge. Black figures start to flow within the black texture, black shimmers of movement shake free from the black static. In the library, between the redacted scenes of life just outside of my reach, I searched the black and found domestic shapes of cooking and bed-making, exchanges of ardor and carnality, celebrations and mourning, curiosity and boredom. All for colouring in the black lines of absence, to create a portraiture that did not resemble a factual reality, but that interpreted reality's image in prisms. This is the wonderful thing about being a ghost: you walk through walls.

In breaching the borders of Iceland, I dragged into its perimeter the Pacific coast, the Yellow River silt, cabbage greens and egret calls.

In the imperceptible vastness that is human history, I held in my hands a chronicle of firsts: the first in my far-ranging ancestry to romance the English language; the first to do, as a daughter, what had always been done by sons; the first to step onto this raw, vacillating country they call 冰岛 – the island of ice. All of this I carried with me into that library, the library which had its own continuity of time and shadow, its own rhythms and evolutions, and there, I lived alone, I lived in silence. Before my arrival, there was no doorway between this world and mine, no interchange between my memories and the memories recorded in this archive. It was only when I was there, having long ago learned the value of language, that I could speak – not only the out-loud language of people, but the expansive, illusory language of place.

In the library at the end of the world, I listened repeatedly to a recording of my mother, taken a month prior in the living room of my home in Victoria, a city perched similarly on suboceanic fire. I heard her voice obliterate distance, searching a room she had never entered, her words braiding with a foreign silence. And the more she spoke, the more vividly I felt that she would never be here, in these quiet offices of oblivion. What I had carried here were only images, imitations, surviving remnants. Nothing was with me, but everything lived, in the free ranges of absence.

You think you're in an empty room. You think you're the only one between the sea and the mountains. You think all that white snow erases everything to oblivion. But then, again, no. ■

MAX MEICHOWSKI
Antigua, 2020

THE ANTIGUA JOURNALS
(WHAT IS A HOMELAND)

Chanelle Benz

I am about a week away from seeing my father for the first time in thirty-six years. I have almost no memory of him, so it will be a bit like meeting for the first time. How strange to see someone who remembers me much more than I remember them. When I think about this trip, I can't think about the trip – only the edges of my brain remain functional. I want to immerse myself in a possible itinerary of Antigua but it's hard to believe that this is happening. Because it's also a return to a homeland I've never seen.

Found out that my great-grandfather, Harold, was an overseer in the 1930s. Post-slavery, but not post-colonialism or oppression. The 1930s were a time of intense poverty in Antigua. I wonder what kind of man he was, what his job entailed, and which class he would have been considered a part of. He was Black and of mixed heritage. One of his wives, my grandfather's mother, Rebecca, was white, though I believe she would have been called Mauche, maybe a derogatory term for poor Europeans.

*

I am getting an abortion tomorrow. How terrifying to write it, to commit to that word I have hypothetically supported for everybody,

but maybe not for me, who was supposed to never need it. These are secret thoughts I have been keeping from myself. I am looking for a poem but I cannot find it unless I write it myself and I am no poet. I am making the reality decision and everyone I tell agrees except for my breasts, already fuller and more tender, having been here three times (this being the fourth), like a needle finding the groove in a record that's been played before. I am no longer tortured by the pros and the cons of a child I can't imagine, but when I read about the medical procedure my conviction slips because I don't want to do it and I don't want to have it, not in the reality of the life I actually have and can already barely hold.

*

Like a witch, I get a stye the morning after my abortion. At least it's in my right eye, the left would feel more significant. I took the pills in the evening and the pain was mild compared to my miscarriage before the boys, which had felt like mini labor. I'm not sure I deserved such little pain. I was fine in the doctor's office until the ultrasound, when they asked me if I wanted to know how far along I was and if it were twins. The embryo was six weeks. That knowledge pushed the button in the middle of me reserved for grief. I couldn't stop the tears: my body was screaming at my life. My mind stepped in to assert itself, to make a point, to advocate for its right to flourish. The physician assistant was patient and left me alone so that I could be certain before I took the first pill, which had taken on a science-fictional quality. You take the first pill to stop the pregnancy from growing, and the second to empty your uterus. You have to take the first pill in the office, meaning the decision had to be made now. Usually my body betrays me, but this time I felt like I had gotten the drop on my body. I was wringing my hands like I were in a Chekhov play, some Tolstoy drama, next I would faint and be swallowed by the inky folds of my mourning dress. Except I was under fluorescent lights, sitting on wrinkling white paper, the PA watching me behind her glasses

and mask, measuring whether to offer comfort or medical advice, and there was no answer other than I am not certain, which in this moment of my life I was not allowed to be, being the adult, the body in question, the only one who could in reality make the decision and so the only one in reality who could carry the weight of it.

*

The days that follow my abortion are not days of thinking, no thinking about my self is done. I work, read, catch up, feeding and dressing and fetching and putting children to bed, mostly the little one who I need to hold close to me now more than ever. I love the high baby voice of two; the mispronunciations, the joy and denouncements: Good idee, Mommy! Go away, Mommy! Mommy, I come with you! The urgency, the soft apple cheeks, the sucking on my knuckle because he finally lost his pacifier. The older one, my little chaos agent, has either been serenading us obsessively with his ukulele or lying on the floor in some howling fit, both of which I have come to expect of him. I have nothing to say for myself. I am packing and planning and preparing. I am having erotic dystopian Shakespearean jungle dreams. I am wondering what happened the last time I saw my father, if I were five or six, and if either of us knew it would be the last time.

I'm hoping the trip to Antigua will be a little boring.

*

On the east side of the island there are winds from Africa that beat the palm trees all day. Tonight I can hear the hollow roar under the DJ's drums down by the beach. To get here we passed through Freetown where my grandfather grew up. Where or how he lived I do not know. Family knowledge here is a collage – a photo here, a wrong name righted there, a story told two ways three times – there's a town named after my Wilkins forebear, a cousin's name on a billboard for the opposition party, another cousin who works at the airport,

the discovery of a new uncle that my grandfather had with another woman who lives in England.

*

The graveyards are dusty in Antigua, plots piled high with dirt and rocks, the walls tangled with bright pink bougainvillea. The most beautiful churches are Anglican. I don't know where my grandfather is buried and I keep forgetting to ask. He was a big man: tall, broad, very kind, though he had to leave Antigua for England in the 1950s when he was nineteen because he kept getting into fights. When he was five years old he woke up and his mother Rebecca was lying dead next to him in the bed. Why she died I don't know. These are the kinds of one-sentence stories floating around my family. A lot of the stories about my grandmother Marie are about her beating my dad and his brothers, especially my dad, the mischievous middle child. Like when she moved him and his brothers back to Antigua and after exactly one day at their new school, in which my dad failed to answer a question from his teacher whose accent he could not understand, he was ruthlessly caned. Thanks to the British, education and caning for minor infractions went hand in hand. After school, my father and his brothers met in the yard and decided they would never go back. No matter how much they were hit or what was said, the three would not go, and so were reluctantly allowed to stay home. Soon after, his grandmother, his mother's mother, asked my dad to do something and not only did he refuse but he was rude. When he got home that day, every adult in the family was waiting and each took a turn beating him. My father recounts these stories over Prosecco, readily laughing with my uncle, made radiant by conjuring a time when this family was alive. I smile but don't laugh, because how terrifying for a child, and what does it teach but that violence is how you get people to behave the way you want?

My grandmother was often ill – medically or mentally I do not know which. My dad and uncle speak of 'nervous breakdowns', an

antiquated term I think they are too young to use. It implies a one-time event, a build-up with a clear cause, and perhaps the first time it happened, after her third and youngest son was born, this may have seemed true. If she had been back in Antigua among her ten brothers and sisters – on our small island with her extended family where it is about eighty degrees almost every single day – whatever she was suffering from may have been softened, but instead she was in the cold, biting damp of London, with its tides of anti-Black sentiment.

She had always wanted to be a nurse, my dad said, but then she had three children, and was too sick herself. She was divorced from my grandfather by the time she died from a heart attack following a hysterectomy at forty-nine. How that happened is a mystery too.

For four days we stay at my uncle's house with my father. My father calls my uncle Junior, which I'd always thought meant his real name was Hugh, but his name is actually Julian, the name of my oldest little boy. At Julian's, nobody could be kinder, everyone eager, tiptoeing around what I want, what I like, what I permit – the only real tension is coming from me. All the big questions I have had about my father and me are now too unwieldy to be attempted and I am suddenly rather incurious on their behalf. Here on this island, my father is my patient guide and what I want, really want, is the map of our family that marks where my blood has been.

Not sure anyone in Antigua really gets what I do for a living, but no one cares. It wouldn't change their warmth towards me. Perhaps it would be more correct to say that everyone has their own idea. My uncle asks me if I'm thinking of having a third child. I don't tell him about my abortion because I know he has converted to Catholicism and fear it would offend him, though I feel that he would as quickly forgive me. I go through a few of my reasons not to, ending with, and only half saying, that it would hurt my career. By which I mean I'm a Black woman in academia, a woman whose body is in its early forties, a woman who sent in final revisions of her first book at 3 a.m. holding a one-month-old baby, a woman who did a reading when her next

book came out two weeks before her second baby was born, a woman who toured (often alone) with that two-/three-/four-month-old baby, breastfeeding between panels and interviews, achy and eyes sweating from no sleep. I'm a woman who did all I could do during this time as a writer and professor and still there was so much I didn't do and put on hold and said no to or said yes to when I shouldn't have, and if I want help as the woman that I am then I will almost always pay for it. This is not said, but then I am not profound in Antigua, I am not reflective, I'm just here sitting in the sun.

*

I had a tumultuous early childhood. And trauma doesn't clean up after itself when it leaves. From time to time things go off in my spine, a response to scenes I'll never remember. (But none of it could be as bad as the worst thing that happened to me, that would come much later.) My father lost custody when I was six and I left London for the United States just before I turned seven. As the child of teenage parents, we sometimes lived with grandparents. I was babysat by aunts and uncles (barely more than teenagers themselves), and I was taught to read by my great-aunt. I felt myself at the center of this lopsided constellation: I had my place in their light. Then we left.

This is my first time in Antigua but I don't feel like here's where I belong forever, or that this is my home now. I've never been anywhere more beautiful but I couldn't live here for a long period of time. It's too rural and slow and I need my little bougie luxuries. But my uncle and my cousins and my dad, they are all happy to see me, as if everything about me makes sense to them, as if I couldn't and shouldn't be any other way than as I am.

*

When I had my second son, something strange happened. While getting an epidural, the anesthesiologist's needle hit a nerve in my

spine. I became nails on a chalkboard, teeth breaking on a curb. No pain has ever reached my brain faster. The thing was that the injection had gone in crooked, numbing only half of my body. They upped the dose, they rolled me onto my side: nothing worked. One thigh was practically dead to the world and the other remained very much alive. The anesthesiologist said he could try again. I did not want him to try anything with my body. (Later, when it felt like someone was stabbing my left hip with a steel knitting needle, I may have reconsidered.) The result was that the left side of my body felt every cramp and contraction, while the right felt a faint sense of pressure, something big distantly taking place below. Perhaps these are my two modes of moving through the world.

*

We can't drink the water at my uncle's house. It's not government water but from a cistern. I heed my uncle's warning; I have always been a good student, scared to get in trouble. I have to bring a bottle of water into the bathroom to brush my teeth. Though there doesn't seem to be recycling in Antigua. The first time we went to the beach here it was night. Our plane had been delayed but the six-year-old was desperate to swim so we took him to Dickenson Beach, reached through the lobby of a resort. There's a law here that says that no Antiguans can be denied access to any beach; there are so few just things in this world. We got drinks at the bar and took turns watching the six-year-old in the water, but my little one, the two-year-old, started bawling, calling to his brother: Come back! It get you! Come back!

No matter what we told him, he would not stop crying and clawing up my chest to hide in my neck, he would not believe the ocean wasn't here to take us. It took days before he would let the waves touch him without screaming. That night we laughed because it was so adorable, but also incredibly sad – his real terror and anticipation of loss, the huge baby elephant tears down his cheeks. That first night I clung to him too because I was afraid to be alone with my dad. I felt like

the oldest person on the beach, at the bar, like they'd rolled me out from my nursing home and everybody was watching to see that I had a good time, like I couldn't hear well and everything I said and did was a step behind. As my six-year-old frolicked in the black waves, his little boy body becoming shadow, telling us this was paradise underneath a fingernail of moon, my last baby clung to my neck, his hands telling me you are my harbor, you are my nest.

*

My great-great-grandmother Mary-Ann was once Nene (Nanin?). My father says she was from Ghana, but most of my West African genes come from Nigeria and Mali, and I suspect my great-great-grandfather from Wales that Mary-Ann 'married' was Scottish not Welsh, because my tiny bit of Welsh DNA isn't from my dad. I further suspect that Mary-Ann wasn't from Ghana but kidnapped, brutalized and brought to a ship docked there, or else that she was born on Antigua in the island's hot, dry, hilly interior on a sugar plantation in one of the wattle-and-daub homes (which continued to exist into the 1940s) and told that her parents came from Ghana because by my imperfect calculations she could have been a very small child when slavery in Antigua was abolished in 1834, and the last recorded slave ships docked in 1820 and 1815, French ships – the *Belle*, the *Hermone*, the *Louise á Normandie* – which were then confiscated by the British. I've been searching slave manifests to look for her name, but all I've found are the names of the enslavers who received compensation from the British government after emancipation, compensation which British taxpayers finished paying off in 2015.

I can't find Mary-Ann. I can't find Philip (Filip?), I can't find Oliver or Rachelle. I can barely find my grandfather Hugh in the historical record except for his registering for the election in West Ham in London in 1965. Beyond that, Hugh is a very tall shadow with skin lighter than mine, and his mother, Rebecca, has a surname

often found in St Kitts. Rebecca, who my great-aunt says was 'fair' and wore a long black plait over her shoulder when she rode behind my great-grandfather on his horse. The same great-aunt who told me that my grandfather Hugh would hold my hand as I made him skip down the road to the sweet shop. He loved me, you see, but that's another thing I don't remember.

When I was four but close to five, I decided that four was my Golden Year. I didn't know that the phrase actually referred to one's retirement, but playing alone out in the fickle English sun, I didn't think it would get much better than this. This before we left England, before my father lost custody, before I never saw my grandfather again. I am very far from that golden year, standing with my uncle on his porch in Antigua watching my baby holding his pink binoculars upside down. The degree to which we have delighted in him this week is writing in the sand before the coming waves.

*

People ask me how the trip is, what seeing Antigua is like, about reuniting with my father, and what I want to say is that I am terrified of my mother. That by spending time with the man who caused her so much pain, I feel I am betraying her. That I am upset that I didn't get to come to Antigua much earlier, meet my great-aunts and -uncles, spend time with my grandfather before he died. What I want to say is that despite England needing to reconcile with the legacy of slavery and its imperialist anti-Black policies, and despite three white guys jumping my teenage father in London when they saw him with my white teenage mother and knocking out his front teeth, I didn't know until I came to the States that I was Black or that Black was a bad thing, but I sure got the message. In the US, I would not be Black enough or white enough but stuck-up and uppity and ugly and exotic and spat on and my hair pulled out and what are you and why do you talk that way and you don't look like them is that your family and you're not urban enough and we don't know what to do with you

and you're more marketable professional attractive when your hair is straight. I am used to not belonging; it is, you could say, my brand.

Coming to Antigua, I am nothing special. My father's daughter, a mother and a niece. I belong here in this house at Blue Waters where my father was a child, I belong here in my uncle's spare room, I belong driving through Freetown, All Saints, where my family once lived. That's my elusive great-uncle who lives by the docks, and these are my children who everyone picks up and coddles and teases, everything is okay, even when the children bump heads and the hospital is far away down skinny potholed roads that have us driving on the wrong side, everything is okay and I'm seeing my father in the airport for the first time in thirty-six years as his face breaks with excitement, everything is okay my mother said when one of her children was concussed and couldn't speak and was being lifted into a helicopter and went up without her into the sky, everything is okay: I am your mother and I love you. ∎

NASA
Cover of the Golden Record

THE GOLDEN RECORD

Caspar Henderson

O ut beyond the edge of the solar system, two spacecraft are heading away from the sun at more than ten miles per second. On board, they carry sounds of Earth, engrooved on old-style long-play records made of gold-plated copper and engineered to last more than a billion years.

NASA launched the craft, Voyager 1 and Voyager 2, in 1977 to study Jupiter and Saturn. Taking advantage of a favourable alignment of the outer planets, Voyager 2 also flew close by Uranus and Neptune, the only probe ever to have done so, and beamed back additional images and data. Meanwhile, Voyager 1, which had already flown out beyond the orbit of Neptune, turned its camera round, and in 1990 took a photograph in which the earth appears as a single pixel – famously described by the astronomer Carl Sagan as a pale blue dot.

Slingshotted outwards by the gravitational fields of the planets they passed, both craft will continue towards the stars indefinitely. In about 296,000 years Voyager 2 will pass within 4.6 light years of Sirius, the brightest star in the night sky. At the time of writing both Voyagers are still sending data home, but by the mid 2020s they will finally run out of power and fall silent. After that they will only 'speak' again in the astronomically unlikely event that an intelligent

entity finds one or both and plays the records they carry. All other things shall change, but they remain the same, till heaven's changes have their course, and time hath lost his name.

The sounds on the records, chosen by a small group convened by Sagan, include surf on a beach, wind and thunder, the songs of birds and whales, greetings in fifty-five languages and electrical signals from the brain of a woman in love. There are also images encoded on the records: printed messages from US President Carter and UN Secretary General Waldheim, and photographs of ordinary people going about activities that were normal in the 1970s such as gurning in supermarkets. There are landscapes, plants and animals and the human body – although detailed depictions of genitals and the belly of a pregnant woman were not considered acceptable by NASA. A diagram on the cover of the records locates the Sun in relation to the different rhythmical beat of fourteen nearby pulsars – stars that emit rotating beams of electromagnetic radiation that sweep out across space like the signals from lighthouses.

One of the greatest treasures on the discs is proclaimed in words etched into them by hand: 'To the makers of music – all worlds, all times.' The twenty-seven tracks range from Bach to Chuck Berry, and are so varied in origin and kind that they escape a quick summary. One of the things that stands out in many of them, however, is the human singing voice in all its brilliance and directness. This is particularly so in tracks such as 'Tchakrulo', a three-part harmonisation for male voices from Georgia, and the Bulgarian 'Izlel je Delyo Hagdutin', in which pipes accompany a female voice that is both sweet and awesomely powerful.

Among the final four tracks are three that suggest that something of what is most essential in the human spirit is better expressed in music without words. The first of the last three is 'Flowing Streams', a Chinese classic composed more than two thousand years ago. Performed by Guan Pinghu on an unaccompanied *guqin*, or seven-stringed zither, the music is meditative and in some respects quite simple. As well as depicting the river, which the ancients believed

to be the blood of the world, 'Flowing Water' is said to tell of a great friendship between its composer, Bo Ya, and a woodsman named Zhong Ziqi. It is said that when Ziqi died, Bo Ya broke the strings of his instrument and vowed never to play the piece again. Succeeding generations have continued to regard the music as a memorial to friendship as well as the beauty of life.

Ann Druyan, who was creative director for the project, identified 'Flowing Water' with the help of an American musicologist very near to the deadline for production and dispatch of the discs. Excitedly, she left a message on Sagan's answering machine, describing her discovery. The two had been having an affair, and when Sagan called back he asked her to marry him. She accepted. This romance then found its way into the Golden Record as it was electrical signals from Druyan's brain that featured on the recording of 'a young woman passionately in love'. In 2017, the folk singer Jim Moray put this story at the centre of his song 'Sounds of Earth'.

The last track but one on the Golden Record is 'Dark Was the Night, Cold Was the Ground' by Blind Willie Johnson. Recorded in 1927, the sound is scratchy – the auditory equivalent of an old-time movie or a fading photograph. The guitar comes first: a bottleneck, metallic slide through blue notes in an introductory phrase before picking out the tune. Johnson begins to sing about half a minute in. He hums and aahs but never quite articulates the desolate words of the song ('Dark was the night, and cold the ground / On which the Lord was laid; / His sweat like drops of blood ran down; / In agony he prayed . . .'). But in a little over three minutes, the track helped define blues and slide guitar for generations to come. Pier Paolo Pasolini used the recording in his 1964 film *The Gospel According to St Matthew*, and in 1984 Ry Cooder based the title track for *Paris, Texas* on what he called 'the most soulful, transcendent piece in all American music'.

The final track on the Golden Record is the cavatina from Beethoven's String Quartet No. 13. A cavatina is a short, simple song, and Beethoven has composed just that: a tender theme in two

parts that he asks to be played *adagio molto espressivo* – slowly and very expressively. The simplicity of the piece is all the more striking given the context, for the thirteenth quartet is one of the longest and most ambitious of the late quartets, and Beethoven intended the cavatina to be played before the fiendishly complex and frenetic Grosse Fuge, or Great Fugue. It's a little like passing through a forest glade dappled in sunlight before ascending a mountain range.

People hear different things in the cavatina, observes the musicologist Philip Radcliffe. 'Some have felt it to be a profoundly tragic piece of music, while others have stressed its serenity, or its religious fervour.' Ann Druyan reports that when she first heard it she felt the cavatina captured a kind of 'human longing and even human hopefulness in the face of great sadness and great fear' that moved her profoundly. The Golden Record became her 'big chance to pay Beethoven back'. Later, Druyan discovered two things that amazed her. First, the composer had actually thought about the possibility of his music going into space, writing on the margin of one of his pieces: 'What will they think of my music on the star of Urania?' (a reference to the planet Uranus, which had been discovered when Beethoven was a boy). Second, on the manuscript for the quartet containing the cavatina he wrote *Sehnsucht* – the German word for longing. 'That affected me deeply,' says Druyan, 'because that was at the heart of the Voyager record: longing for peace and longing to make contact with the cosmos.'

The two copies of the Golden Record were shot into space nearly fifty years ago. Today, an electronic device could store vastly more information – although it would be unlikely to endure for so long. There has been no end of talk as to which music and images would go on a new mission. The comedian Steve Martin joked that aliens had already been in touch to say 'send more Chuck Berry'. The composer Philip Glass has suggested Bach's cello suites. Bach, whose music already accounts for more than a tenth of all the music on the Golden Record, 'takes you by the hand . . . and walks you into states of being that you didn't even know existed'. He also suggested music from

Africa, throat singing and flute-playing from South India. But the writer Mireille Juchau argues a satisfactory set of choices could be beyond reach: 'The longer I consider it, the less possible it seems to capture the simultaneous unfolding of beauty and ruin in our present moment.' ∎

NASA
The Golden Record

TAS50
Discovery Hut, Antarctica, near McMurdo Station, 2008
Erected in 1901 by Robert Falcon Scott's Discovery Expedition

ORDINARY PEOPLE

Richard Eyre

You don't choose your parents and they didn't choose theirs. I never met Charles Royds, my maternal grandfather, who died when my mother was a child. What remains of him is memorabilia from the defining years of his life – from 1901 to 1904 – when, at the age of twenty-five, he was first lieutenant on Captain Scott's first Antarctic expedition.

As a child I became familiar with his tales of exhaustion, frostbite, cramp and snow blindness from his journals and sledging diaries. I was fascinated by his wooden goggles with narrow cross-like slits – still lying on my desk – which failed to prevent his eyes streaming with frozen tears as the sun stabbed his eyes, while he and his team dragged heavy sledges for up to a hundred miles – comparatively easy when the weather was good and the terrain flat, but, in storms, racked by the wind and crippled by cracking ice crust, their progress became a blind stumble.

When I look down a stairwell I feel mild vertigo, yet I never tire of the mystery of why men should push their bodies to exhaustion and beyond and then go back for more. 'Because it's there.' Is there any answer less adequate than this and is there any more sufficient? I admire what I am unable to do, and my grandfather's descriptions of camping in blizzards made me whimper with vicarious dread.

Pitching his tent, he thrashes against the gale like a drunk, fumbles sightlessly for poles, pegs and groundsheet. Once inside he gets cramp in his legs while he changes into his dry clothes. As he takes off his mitts to undo leggings that have become pipes of ice, his fingers grow numb and inflexible. He takes hay from inside his ski boots and puts it in his shirt to keep warm for the morning, and puts on his human hair night-socks. His pipe is frozen, his matches are damp, his tobacco is sodden and, even though he's kept it under his shirt, his flask of water is frozen solid. He wraps himself in fur, climbs into his sleeping bag, longs for something to eat besides biscuit and, as summer night seeps seamlessly into summer day, he's too cold and too exhausted to sleep.

Back at base, when he reads an earlier account of an Antarctic expedition, he spits indignantly at the descriptions of brooding over loneliness, weeping over sweethearts and being too tired to cut one's hair. He doesn't present himself or his colleagues as men without fear or without a sense of danger. For him, the wonder – if there is wonder – is in their ordinariness:

> -63°F What I call pretty chilly!!! One can't help laughing when one thinks of a sore throat and cold in England and thinking how one doesn't dare show one's nose out of doors . . . The winter cannot be all joy and comfort, & no one could expect it, but with the help of a little self-denial, a little tact and a cheery face most of the monotony and discomfort can be overcome. We shall act like ordinary human beings.

I marvel at this. Is it courage? Is it stoicism? Is it wilful lack of imagination? Through the inverted telescope of history I try to parse his meaning. For him being 'ordinary' meant a belief in duty and service, in moderation, mutual respect and self-control. It meant a determination not to whine, to whinge or to exaggerate one's suffering – in short the characteristics of an exemplary English

Edwardian gentleman, frequently encountered in fiction and rarely observed in life.

Distinctions of rank and class were intrinsic to those beliefs: my grandfather had been an officer since the age of thirteen. But, if I'm to believe his journals, during the three years of the expedition he shared living accommodation, sledging duties and danger with others without any class distinctions. Complaints about his companions were reserved for his commander, Scott. A typical entry: 'Had a row about last night's fire (some Dundee jute had spontaneously combusted) ... I expected to be blamed for it and was not disappointed.'

Charles Royds was born in Lancashire to a family of bankers. He was tall – over six feet – good-looking, sporty and a gifted musician. He trained in meteorology for the Antarctic expedition and was Scott's first lieutenant, responsible for the running of RRS *Discovery,* which was the last wooden three-masted ship to be constructed in the UK, purpose-built for the expedition. It now rests in its birthplace, Dundee.

He had a conventional upper-middle-class upbringing, and married, at the age of forty-two, a less than ordinary woman: my grandmother, Mary Blane. Although from a similar background, in 1904 Mary had eloped with an amateur racing driver, and decided to become an actress, which caused more grief to her parents than the elopement. She adopted the *nom d'acteur* Malise Sheridan – the initials MS echoing the name of her husband, Guy Sebright. Her acting career was longer-lasting than her marriage: after two years, in 1906, she was divorced on the grounds of her husband's adultery. All three of her brothers were later killed in action in France during the Great War.

Charles Royds married Mary Blane in 1918 and my mother, Minna, was born in 1921. Charles's naval career continued to ascend. In 1921 he became Director of Physical Training for the Navy, then in 1926 he became a rear admiral, an ADC to King George V (they swapped stamps), and was knighted. He then retired from the Navy and was appointed Deputy Commissioner of the Metropolitan

Police. Six years later he had a heart attack during a rehearsal for a fancy dress ball in the Viennese style at the Savoy Hotel and died on the way to hospital. He was fifty-five.

My mother was eleven when he died and by the time she married – the day that France fell, 10 May 1940 – my grandmother was ill. She died soon after, and my mother assumed responsibility for the nanny who had brought her up from a baby. They were tied together for life – baby and nanny, mistress and servant, mother and children. 'Nanpan', as my mother called her, lived with us until her death in the 1960s. My mother was always cowed by her and lacked conviction in her maternal rights, so my sister and I were never quite certain whose authority we should defer to. On her wedding night, at the Great Northern Hotel at King's Cross, Nanpan insisted on accompanying my mother as her chaperone. She slept in a separate room but demanded that my mother spend part of the night with her, away from her husband, which incensed my father and exasperated my mother. This, by the way, is not prurient speculation on my part: when my parents had both died I found a small suitcase full to the brim of blue elastic-banded airmail letters infused by lavish, mutual lust. They lovingly and graphically described their sex together – and with different partners – from their wedding night to the end of the war.

My mother always referred to Charles Royds as 'Daddy' and our house was crowded with reminders of him: his pocket-sized sledging diaries; his leather-bound journals; countless photographs and letters; cutlery and crockery specially made for the Expedition; the tooth of a walrus; a large knife in a sealskin sheath; a letter opener made from the bowsprit of the *Discovery*; exquisite watercolours by his friend Edward Wilson (who died on Scott's second expedition) and – still my favourites – painted wooden cut-outs of emperor penguins, which he had made for the crew to hold the menus for their Christmas dinner. These evocative totems menaced my father, who resented the mute presence of his father-in-law. 'Charlie boy' he would call him, to shrink him in my mother's eyes. His own father was an exact contemporary of Charles and was as far from being an 'ordinary

human being' as it's possible to imagine. He was the only one of my grandparents I ever met.

My paternal grandfather had served in the Army without distinction, retired on his Major's pension and lived in a late-eighteenth-century house in North Devon, many of whose windows had been blocked up during the window tax, making it look as if its eyelids had been sewn together. His hair was cut close to his scalp and he always dressed in breeches with puttees, a Norfolk jacket and a shirt with a high-necked stiff collar. His Edwardian clothes echoed his living conditions: no central heating – fires were only allowed from 1 October to 1 March – and no electricity. Lighting was provided by candles and oil lamps, cooking was on a large black open coal-burning range in a kitchen with a smoke-stained ceiling and a flagstoned floor. Water was pumped from a well in the yard.

My grandfather, Hastings Eyre, presided over meals with an air of silent disdain interrupted by eruptions of volcanic severity. On one occasion my sister – then probably about ten – said that someone had talked to her on a train. My grandfather slammed his fist on the table, shaking the glasses and the cutlery, and shouted: 'No one's ever spoken to me in a train, thank *Christ*!' He would beat my father with a riding crop for minor misdemeanours and his wife, worn out by systematic bullying, had died of a stroke when she was fifty-eight. Outside his family my grandfather's displays of violence caused him to be bound over to keep the peace for horsewhipping motorists. 'That'll teach you, you bastard!' he'd exclaim as he lashed them for the insolence of driving a car instead of riding a horse.

He taught my father to ride before he could walk, tied to a saddle before his legs could reach the stirrups. Always more at ease with animals than people, my father found it difficult to admire people who didn't embrace his love of horses or those – like me – who had less rigorous childhoods than his. He became a naval cadet at the age of thirteen and the consistency and anonymity of the rigid military discipline must have seemed like a benediction.

My father served at Dunkirk, in the Baltic and in the Atlantic, commanded a destroyer in Southeast Asia and an anti-submarine training base in Portland, but retired in 1958 at the age of forty-two. He became a farmer and, although he worked extremely hard with only one farmworker to help him, he always wanted to be called 'Commander' and to be known as a 'gentleman farmer'. He even subscribed to an organisation called the Country Gentleman's Association.

My father, known as Snowy for his lanky blond hair, had a binary view of society: it was divided into Officers and Other Ranks or, in his words, Gentry and Electors – the latter the undifferentiated mass of people whose lack of lineage, regional accent and choice of vocabulary condemned them to an irredeemably inferior status. They were, to him, ordinary human beings – not despicable, but not blessed by birth either. It was a sort of secular Calvinism, the world divided into those who had entered an earthly heaven and those who would never gain admittance. Paradoxically perhaps, face to face with an 'Elector' – or indeed a gay, Black or Jewish person – he was unfailingly and genuinely charming. His charm was not so much infectious as guileless. He had a contagious energy and his enjoyment in hosting parties – fuelled by rivers of gin – was insistent. To me it seemed a sort of tyranny of fun – there was no room for dissent.

He was also physically courageous – an amateur steeplechase jockey – and to my eyes at the age of eight, a superhero. I'd stand at the edge of the racecourse at a high fence, listening for the thunderous drumming of hooves at full gallop before the horses smashed through the birch, splattering mud and shaking the earth. Once I watched him fall when he was out in front. He curled into a ball as the other horses cascaded over him, large as tanks, and crawled to a stretcher at the side, bellowing to the first-aiders not to touch him until he reached the medical tent, where a doctor pushed his dislocated shoulder into its socket as if he was forcing a leg into the seat of a chair. He was equally stoical as he almost bled to death when I was fifteen, helping him on the farm. He was putting barbed wire on a fence when the

wire slipped from his hand, uncoiled like a rattlesnake and pierced an artery in his arm. Under his instruction I made him a tourniquet from his shirt and probably saved his life.

I was the first in my family on both sides to go to university and the first not to join the forces. My father didn't appreciate my decision to read English Literature. He loved P.G. Wodehouse and Damon Runyon but was infuriated by Hardy's novels for their opaque descriptions of sex and thought that Shakespeare was 'absolute balls'. We disagreed on most things: class, politics, art. He was an English patriot and a Tory anarchist, and he thought my profession was pointless. He didn't see any of my theatre productions, but he watched films of mine on TV. His fury about *Tumbledown*, my film about the Falklands War, was violent and visceral, almost as ferocious as when he saw me wearing a CND badge as a teenager and shouted: 'We fought a fucking war for you!'

My sister and I fantasised that we were not of the family, that we were both changelings, but she was intransigent, volcanic, mercurial and incendiary, like our father. I'm more placid, like my mother. At times, miserable together, we would console ourselves that we'd been fucked up by our mum and dad. But the older I get, the more I wonder: 'Didn't we do it to ourselves and blame our parents?' Neither of us could have lived up to Charles Royds's criteria. We implicitly scorned his invocation to 'self-denial, a little tact and a cheery face' but we were children of the sixties and by then his aspirations for human behaviour had been vaporised by two world wars, Hitler, Stalin, the atom bomb and the Holocaust.

And we had lost an empire. On my desk as I write, as well as the wooden goggles, I have my grandfather's leather-bound calendar: the day, the date and the month can be changed by turning little milled wheels. There is an inscription on the back: DISCOVERY/THIS WAS THE CHARTER OF HER LAND/RULE BRITANNIA/24TH JULY 1901. When I was sent off to boarding school in 1951, I carried with me a new Bible that had a map of the world on the frontispiece: half the

globe was coloured pink. Seventy-one years later the pink has shrunk to a small archipelago off the edge of Europe. We are no longer sure what to call ourselves, lamed by our past and muddled by our present: we are uncomfortable with being ordinary rather than exceptional.

While my father was serving in Southeast Asia, his ship visited Sarawak in northern Borneo, from where he sent me a postcard telling me he'd met a 'remarkable chap'. The man was Tom Harrisson, ex-Army ornithologist, explorer journalist, ethnologist, film-maker, conservationist and, like my father, an enthusiastic drinker and womaniser. He shared my father's dictum: 'Enough is too little, too much is enough.'

Harrisson was the co-founder in 1937 of Mass Observation, an organisation which aimed to create an 'anthropology of ourselves'. They recruited a team of observers to study the everyday lives of 'ordinary people' in Britain and in doing so introduced the notion of 'ordinary' in the sense used to this day – the managed as opposed to the managers, the governed as opposed to the governors, the ordinary as opposed to the expert.

Like 'common sense' the calibration of 'ordinary' is elusive – philosophical rather than physiological. It's abused by journalists, derided by sociologists and waved like a rhetorical regimental banner by politician after politician. Nigel Farage egregiously announced that Brexit was 'a victory for common sense and the ordinary, decent, people who've taken on the establishment and won'. Boris Johnson talked of ordinary people as 'the families travelling at the back of the plane' and aimed to endear himself to those 'ordinary' people by scattering his speeches with buffoonish references to Peppa Pig and fourth-rate jokes about 'wiff-waff'.

The Labour Party stakes its claim to represent 'ordinary working people', sounding both patronising and exclusionary. Who wants to be described by a politician as 'ordinary', particularly when 'working' doesn't mean 'in work' but is a euphemism for 'working class'? I can't hear the word spoken without hearing a sneer, however slight,

that implies that 'ordinary' is a synonym for 'commonplace'. Which is to say someone not as clever or individual or special as you are. Someone, in short, who is inferior to you, the opposite of what my grandfather Charles Royds meant when he wrote: 'We shall act like ordinary human beings.'

I've been working in the theatre since the mid sixties. To me a theatre production is a model society: you have to share a common aim and be bound by the same social rules, work to a mutual pulse, even if each person moves at a different tempo. You have to subscribe to a democracy of talent, underwritten by a generosity of spirit. By the end of a piece of theatre a kind of alchemy can occur: the disparate individuals who make up an audience become, for a moment, united: a community of the ordinary. Not in the sense that both my grandfathers might have meant it, even less in the sense of politicians' descriptions of ordinary people, but in the sense that every human being is ordinary and, at the same time, exceptional. Similar but never the same. And never commonplace.

Even so, we tether ourselves to the unexceptional as if to avoid setting ourselves apart: conventional families are as rare as happy ones. A friend said this to me recently:

> 'I had a very ordinary upbringing.'
> 'Really?'
>> (A pause.)
> 'Although my uncle had a second family that none of us knew about.'
> 'Really?'
>> (A pause.)
> 'My aunt used to break China cups and bury them in the garden.'
>> (A pause.)
> 'Then she used to chase my mother.' ∎

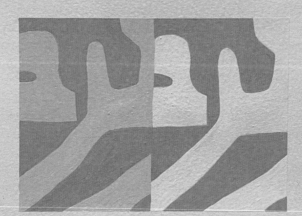

ELIF YANYA
Untitled

A LIGHT BIRD

Maylis de Kerangal

TRANSLATED FROM THE FRENCH BY JESSICA MOORE

Towards the end of the meal, sentences began to tumble like stones onto the plates and, progressively, the thousands of infrasonic hissing sounds produced by two people eating together in the kitchen of an old apartment – scrape of cutlery against earthenware, creak of wicker chairs, glug-glug of water poured into glasses, bodily sounds – all this overtook the room. These changes in acoustic tone had come to signal that Lise was preparing to speak about her mother, and I instinctively pulled back. I saw her put down her cutlery, calmly wipe her mouth, lean forward, and turn her face towards me, cast in relief by the overhead light, and perhaps also shaped by the face of Rose, who she sometimes resembles in such a troubling (though fleeting) way. She caught my eye with such intensity it was no longer possible for me to evade her. Dad – I heard the agitation in her voice, controlled but audible, and the excess of solemnity that signals an imminent declaration: Dad, I want you to erase Mom's voice from the answering machine.

A current of icy air rushed past, and I capsized against the back of the chair. For a few seconds I felt like a man standing on a frozen river that suddenly cracks and splits, fracture lines starring outward all around me, racing off as far as the eye could see. Lise's eyes did

not leave mine as the silence rose between us, thicker and thicker, vehement. And then she placed her hand on mine, and repeated more slowly, please, do it now, put an end to this. She got up then to clear the table, turning her back to me, plunging her hands into the sink, making it clear that this dinner and this conversation were finished.

But I hadn't finished with her, nor with her mother's voice, this voice that can indeed be heard on the answering machine of the telephone in the apartment, even though my wife has been dead now for five years, one month and twenty-seven days. So, leaning on the table, I stood in turn and shouted, no! – a distinct and round 'no', as dense and dull as a lead shot from a rifle at a fairground stand. Lise jumped, letting out a high, uncontrollable sound, and the cutlery she dropped bounced on the tiles in a clatter of metal. She gripped the edge of the sink, head down between her shoulders, neck outstretched, shoulder blades jutting beneath her pastel cotton top. She was breathing hard. I could see her reflected in the window that had become a mirror with the arrival of night, her eyes closed, mouth open, corners of her lips trembling with anger: my loving and reasonable daughter, my hard-edged girl.

This wasn't the first time she had asked me. And she wasn't the only one to ask, either. Others would often beat around the bush, but finally admit they found it 'unsettling' to hear Rose's voice on the answering machine – 'unsettling', a twisted understatement; 'indecent' or 'morbid' would have been closer to what they meant, but they didn't have the courage to speak these words, felt they were sparing me, while I, of course, did not spare them. The pain of Rose's death, extended well beyond all propriety – pulverizing the limits set by social norms and the psychological slurry of magazines dedicated to well-being and mental health – this pain, but maybe also the desire I had to keep Rose in the hollow of my ear, irreducible, incarnate – this offended them now. The irruption of the voice of the dead into the world of the living undoes time, implodes borders, the natural order

goes haywire, and the recorded voice of my wife played its part in this chaos. No matter how much I argued for my sovereignty over the old answering machine in my home, the intimacy of my relationship with her, with her death, with her voice, Lise always replied that my machine was a space open to all, a social intermediary. Don't you see it makes you look crazy? she murmured now, from the bottom of a well of sorrow, and when she finally turned towards me, her face was so close to mine that I could see myself reflected in her irises, bathed in tears.

Hi, you've reached us, but we're not here – leave us a message and we'll call you back! Like a light bird, Rose's voice moved through the room, brushing against walls, windows, shelves; it expanded into the space, conserving enough energy towards the end of the recording to produce a curious vibration, as though it were growing distant without being erased, diminishing without disappearing completely – the mysterious remanence of a fade-out.

There we were, Lise and I, folded in on ourselves in the dark living room like two blind people in a canoe, paddling countercurrent. Sitting on the ground with her head tipped back, Lise waited for the message to end, eyes on the ceiling. Hers is the first voice I ever heard, she said, very calm, as though she were speaking from the depths of a dream. I knew it before I was even born, I could make it out among thousands of others. I clutched the armrest of the couch, taut, listening. Lise raised a hand to her temple and, with her gaze down on the ground now, intoned: it lives inside my ear, that voice, it has never left me, it's not erased and I'm not afraid of losing it: it's hers. Just then, the lights of a car leaving the parking lot of the building across the street cast the room in a very yellow light – the ceiling seemed to grow round like a cupola, more vast, more sonorous, and in this shifting light I saw my child stand, suddenly brought back to grief, and all at once find the way in: her recorded voice is in the present moment forever, but it's a different present, a present in which her

death hasn't happened, a present that will never coincide with mine, with my life, and it makes me crazy, it hurts, it hurts so much. After a silence she spoke again, heart-rendingly: in spite of what you might think, it only makes my grief worse each time I have to hear the message, and it makes me stop calling you because I'm scared to hear it. Think of other people. Please, erase it.

Hi, you've reached us, but we're not here – leave us a message and we'll call you back! The night Rose died, when I got back from the hospital, I sat down in this very same spot, already in darkness. When the first call came in and I heard those words – 'you've reached us, but we're not here' – I started to shake, as though in all my life I had never heard a more naked truth: no, we weren't here, would never be again, it was over. The telephone rang until late into the night but I didn't answer, not once: I wanted to hear her voice return, this voice like none other, this voice that contained Rose completely, embodied though ethereal, physical as only a voice can be. But by dawn, having listened to it so many times, something else began to stir in me: I imagined that Rose's voice had decamped at the very last moment from the body that sheltered it – that it had saved itself, so as not to become this cold corpse covered by a rough sheet – so it might return here (and so that this 'us' might persist?) and continue, reactivated with each play, in a sort of infinite present. Her voice survived her, in recorded form, indestructible, in the form of a light bird. In the morning I realized there was no other recording of Rose's voice, and I kept it.

Hi, you've reached us, but we're not here – leave us a message and we'll call you back! From the very first word, the scene comes rushing back: the day before we left for Greece, the hurry to set up the answering machine, Rose in jeans and a striped T-shirt, feet bare, painted toenails, round sunglasses and a booklet open on her lap, following the instructions step by step to record the message, trying a few different formulations, laconic or overblown, and finally landing on this phrase, keeping the first take. It's a clear and golden voice, a voice

from a Grecian isle in June, a voice dilated in a breath: the voice of a woman on the verge of leaving.

And yet, it's not this memory I'm trying to bring back when I phone the house, sometimes from the ends of the earth, sometimes in the middle of the night, just to connect for a moment to this sound, so real, to hear her inviting callers' messages, pronouncing that unforgettable 'us' – this is what I answered Lise who was waiting for me to speak, and had come closer now, resting her head against my knee, her fine blonde hair creating a halo of brightness in the dark, her ear as delicate as a chickadee's nest. What I'm after, I told her, forcing myself to put simple words to the complex emotion that goes through me every time, what I'm after is the sense of her presence: just that Rose is here. Of course I know the voice is not Rose, who is dead and won't come back, but for me, it's still a manifestation of her alive, the day she recorded this radiant message, the day before we left on vacation.

Is Rose's absence too present in my life? Does it take up too much space? Lise sometimes asks out loud whether the spectral envelope of my wife's voice hasn't become a morbid passion. She says I'm under the hold of her ghost, suggests a denial of reality, even claimed the other day that I was trying to keep the dead alive – and I liked that expression, I recognized it as true. And yet it's Lise who's still wearing her mother's slip-on shoes, the putty-coloured trench coat that makes her look like a passenger of the night, the oversized men's shirts, and even her gloves – she's the one ferreting about in the traces her mother leaves behind. For some time now she's been talking about Rose's last trip – Rose would go away alone for a few weeks each year, with her drawing book, pencils and camera – talking about taking the same trains, making stopovers in the same places, pausing to contemplate the same landscapes. Even though it pains me, I encourage her: these concrete actions that continue to form links between the living and the dead, beyond cemeteries, beyond urns forgotten in the shadows

of alcoves, beyond anniversaries and frames that hold photographs of the dead on the walls of houses, in plain view of everyone, these actions that call us to rise, secretly, to the height of absence, always seem to me more unfettered, and above all more analgesic than the painful abstraction of grief.

Lise cried silently for a long time, and I cried with her – my only child. This had never happened, one of us had always kept our eyes dry, probably so as to better help the other. And I knew then that I could do it: put time back in order. That the moment had come to relieve my daughter, to become the man no one could call crazy any longer. Everything happened very quickly: I got up and walked to the machine with my arm outstretched, ready to press the red button and erase the tape with just one finger – but at that moment, caught off guard, Lise shouted: wait! Her voice pulled me back just in time and I saw her dark shape rush through the shadows: she grabbed my cell phone from the desk, punched in the passcode – Rose's birthdate – opened the voice recorder, pushed play on the answering machine, and Rose's voice took wing again in the room, flew along the cornices, down near the ground, past the windows; it soared for a long moment, and Lise recorded it, migrating from the answering machine into my phone's memory, becoming an archive. And then she did exactly the same thing with her phone – it's for me, she murmured, concentrating, her irises very black beneath bronze eyelids.

An instant later, the recording of Rose's recorded voice – this double capture – became in my ear something else entirely: a woman on the verge of leaving announced our absence, sounding her faraway vibration from this night-time room where we had spoken, side by side, Lise and I, and cried together. You can erase the machine now – our daughter looked at me in the darkness, intent, the phone resting against her solar plexus. I pressed the red button and freed the light bird. ■

CITY BY THE SEA

Kalpesh Lathigra

In November 2022, *Granta*'s photography editor Max Ferguson spoke to Kalpesh Lathigra about his photoessay 'City by the Sea', which documents his relationship with the city of Mumbai.

MAX FERGUSON: How did this project begin?

KALPESH LATHIGRA: I was on a commission for *Die Zeit*; a road trip from Glasgow to Calais before the Brexit referendum. I was born in this country, but my parents are from East Africa – Zanzibar and Kenya – and my grandparents left India from the state of Gujarat in the late 1940s. That road trip made me question what home was. I experienced racism, and saw racism. It made me think about what had happened to this place that I called home. I remember driving back into London, feeling relief that I was home, but then I began to wonder: what is home? I began to question the idea of nostalgia. Why did so many people vote for Brexit? Were they nostalgic for a lost time? What were they yearning for? And what was my nostalgia? Why do I feel nostalgic about this country, India, that's meant to be my home? Why do I long for this place?

I have two links with Bombay. One is that I have always felt at home in big cities, with their mix of people. More importantly, my

grandfather ran away from home when he was fourteen and ended up living on the streets in Bombay for two years. He died when I was about four. I remember him: he'd take me to my nursery, and give me cups of tea on a saucer, and blow it cool for me. And he had travelled a lot: from Gujarat to Bombay, and then on to Rangoon, now called Yangon, which is the largest city in Burma. From Rangoon he went to Karachi, then Nairobi, then the UK. The travel that I do, as a photographer or an artist, connects me with my grandfather.

I call it Bombay, by the way, because of nostalgia; I grew up with that name. But Mumbai is the original name from the Maharashtra people who named it after Mumbadevi the goddess.

FERGUSON: What does Mumbai feel like as a city?

LATHIGRA: When I was younger, I used to feel like a Western guy walking around with a superiority complex. It felt uncomfortable. But now, I feel more comfortable about my position in that place. I recognise my privilege, and that some people there are going to see me as a brown sahib, which is a hangover from colonial days. If you were a sahib, a white sahib, you were treated with respect, because you were from the mother country. Even today, because I'm a foreigner, I have that privilege; my class transcends. In the UK I'm working class, born working class, but in India I am not. I'm treated as a middle-class Indian, but I have the privilege of a British passport too. I also have a different way of talking to people.

London and Bombay aren't actually so different. If you take out the congestion and pollution, and some of the rough-and-ready infrastructure, many things are literally the same – shiny buildings, mirrored finishes, aluminium, whatever. The restaurants, except for the brown people around you, could be in Canary Wharf: you can order craft beer, and food from everywhere, Portuguese, British or Mediterranean. The homogeneity of cities is a form of madness, but it's also comfortable because it's a recognisable madness.

FERGUSON: You've worked as a documentary photographer and a news photojournalist, you've been embedded with the British Army

in Afghanistan, and you've taken portraits of celebrities for some of the world's largest magazines. How does this new work fit into the context of your long career?

LATHIGRA: I've always believed in evolution of practice. I was a press photographer for a good ten years, and something stopped me from doing more of that. I wanted to move away from the position of neutrality, and start telling stories from the subject's point of view, rather than from an objective view. Maybe it was just romanticism I was looking for, or maybe the truth – I don't know where the line between those two is.

For me, this work is about freeing myself from certain ways of making photographs. Of course, there are still narratives within the photographs. But they're all non-linear. In the old days, you had a dot-to-dot path in projects. One picture would lead to another, and you hoped that would tell a story.

Somebody could read this work as a series of single images, or they could relate to them in their own way and put together their own path through the work. It's about not being trapped by structure. My practice has evolved to the point where I've let go. I've allowed myself the freedom to make photographs, to tell stories I want to tell.

Before my book *Lost in the Wilderness*, I made quite traditional black-and-white work. I had struggled with colour photography all my life. Then I found myself sitting in the Tate Modern in London, staring at a Rothko, trying to work out how he gets so much emotion on the canvas.

I moved away from a very stylised form of reportage to a more basic way of working, with only two cameras. But the most important thing was doing proper theoretical research. Another factor was collaborating, working with people on the ground, asking questions and listening. Visually, I was influenced by the American colour movement, people like Stephen Shore, Alec Soth, William Eggleston and Mitch Epstein.

FERGUSON: There's a photograph in this series of a wedding taken from a distance. I'm interested in what makes this photograph important to you, as I know you were pleased when we selected it.

LATHIGRA: I enjoyed seeing somebody start a new life. That moved me, because I was miserable, and melancholic. When I'm making photographs, I'm often in a depressed state of mind. Somebody else having a moment of celebration allowed me to put aside my own fragility.

It's an anonymous moment. A celebration in the middle of this mad city. The fireworks have gone off, people are hanging around, and there's smoke in the air. A mythological moment, but it's hidden. I think it's just a simple joy.

FERGUSON: It's so clear that you're watching it as a stranger. There's no pretence that you're part of it. And I guess that's one of the things that photographs do so well: allow us to be the outsider.

LATHIGRA: Absolutely. There's a voyeurism too. And I don't have to be part of it. I'm watching something unfold in front of me. But I don't feel completely dislocated from it either. It's much more of a tableau going across, you're noticing all these little moments that we all recognise within ourselves – they are there to be deciphered.

FERGUSON: I've got another for you to decipher. The photograph of the cow and the train tracks.

LATHIGRA: That's an overtly political picture. I made that photograph as a statement about what's going on in India. People are being lynched for allegedly eating beef, and the current government are constantly pushing ideas of Hindu nationalism. I wanted to make the image overtly uncomfortable. It's a religious statement about India, but it's also communicating a real unsteadiness.

I'm not a practising Hindu, but I was born into a Hindu family. We were told the cow's milk is pure, the urine is meant to be holy, etc. Ghandi spoke about a cow being the mother of the land, and how it was holy. All those things converge in this photo. It's about how a symbol can inflame people to such a degree that they are willing to kill over it. ■

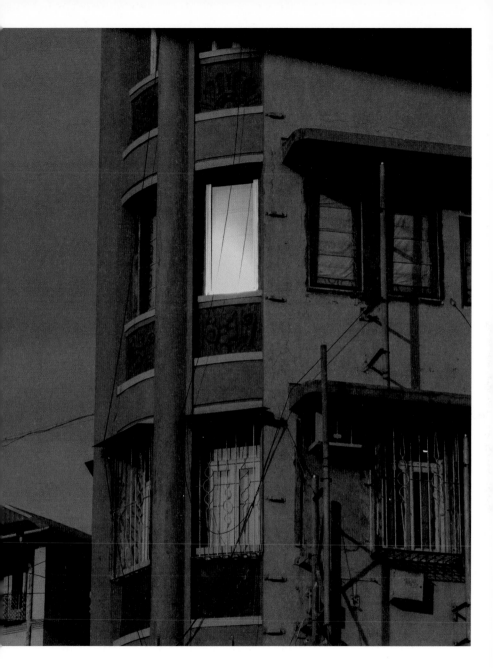

THE WORLD TODAY

CHATHAM HOUSE'S INTERNATIONAL AFFAIRS MAGAZINE, BRINGING RESEARCH TO LIFE SINCE 1945

SIX EDITIONS A YEAR | EXCLUSIVE ONLINE CONTENT INCLUDING
A SEARCHABLE ARCHIVE OF THE PAST 20 YEARS | WEEKLY INSIGHTS
INTO WORLD AFFAIRS | SUBSCRIPTIONS FROM £33

To subscribe go to www.theworldtoday.org. For any enquiries relating to marketing and
subscriptions, please contact Roxana Raileanu by email: RRaileanu@chathamhouse.org

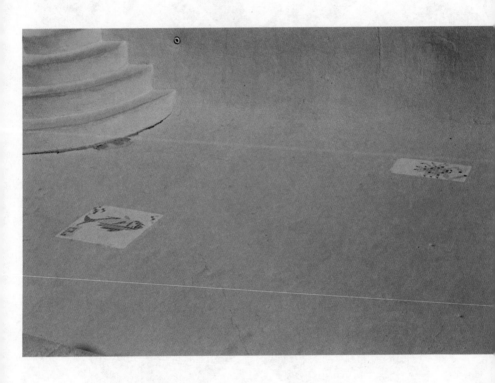

LORENA LOHR
Untitled, 2021

THE LAST PLACE
WE WERE HAPPY

TaraShea Nesbit

Our hotel, Las Palomas, had an elm growing through the lobby, its roots in the dirt beneath the floor, as if the hotel had been built around something stronger and older than itself. We needed proximal strength.

Our daughter had been born one month early, unbreathing. My husband and I drove to the last place we were happy. We stayed in the same Santa Fe hotel we had stayed at a year before, when we were newlyweds. We had recently moved to Denver, and were visiting Santa Fe for a weekend trip, and so that I could do research for a book.

This time we were upgraded. Our hotel room was a small apartment. The stationery in the bedroom was outlined with doves. I wrote some of these notes there on that stationery.

As soon as we arrived, my husband went out to find the grocery store, the liquor store and the bookstore. I was still too sore from birthing our daughter to walk for long, and too sad to see anyone, especially a stranger asking me how I was doing in a checkout lane. I had overextended my pelvic floor earlier that week trying to run my grief away. When I wanted to stop, I chastised my body for failing me.

While he was gone, I opened the sliding glass door. Across from our apartment, diagonally, along a concrete pathway, was another apartment. I heard a man making a phone call.

How can I explain the stillness of that day, and yet its buoyancy? It was quiet, the sky cloudless, the air seventy-three degrees.

I walked around the apartment noting things, the fancier things we would not have paid for – the fireplace, the living room, the leather couch. It was April, shoulder season.

I registered a conversation happening in the other apartment. A man on his own, forty maybe, an actor. He was on the phone, talking to someone from years ago, catching them up on ten years of his life. Lonely, I felt then. He told the person on the phone he had at least three more weeks on set in Santa Fe.

I can't explain it, but I felt in that moment that this actor was making final calls. I wondered if he was reaching through the years to a previous intimacy, checking to see if there was anything there to stay tethered to.

I lay down on the white duvet and waited. The man on the phone had a daughter. She lived with her mother in California.

My husband texted. He was at a bookstore, not the one in town but the chain bookstore.

Wolitzer? Ten Year Nap?

The Interestings, I texted, twice.

I felt insistent at this, at the idea that this novel would be a way to turn myself away from grief.

When he came back, he brought wine and fruit and *The Ten Year Nap,* which I frowned at. There must have been dinner, too. There must have been tacos, but this I don't recall. Only the small bottles of hard liquor, the cut fruit, Meg Wolitzer and bright tumblers of sangria on the patio.

My husband read John McPhee. I laughed out loud reading the Wolitzer and he laughed hearing me. Neither of us was crying. We read silently but together on two Adirondack chairs beneath a vast blue New Mexico sky. In that certain light, one could almost feel the world tilting to a plane in time when our child was not dead.

Why did the conversation I overheard, the actor on the phone,

move me so? Longing so close but separate from my own. The sangria swaying me. There would be more places where we would be happy, we would go on to have a child, but I did not know that then, and the rooms we lived in those days were tiled with the interminable. I was moved by this man, a shared connection he did not know we had. Loneliness, perhaps, but I could be wrong.

The actor, inside his apartment, saying to someone across the country, *I'll let you go. I'll let you get to dinner with your family. Take care.* ■

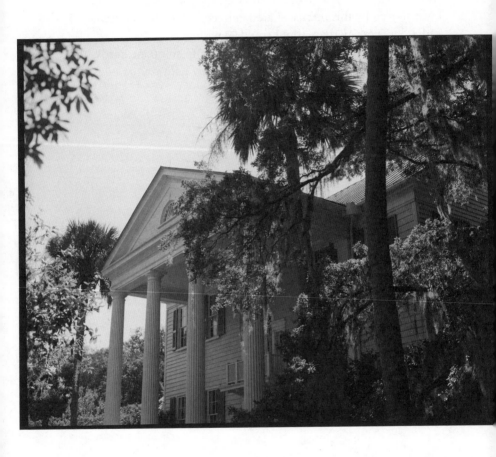

RAHIM FORTUNE
Front facade of the McLeod Plantation, South Carolina, 2021

THROUGH THE SMOKE, THROUGH THE VEIL, THROUGH THE WIND

Roger Reeves

S ometimes, I make promises to myself that cannot be kept. Yet, I make them out of some hard-to-articulate principle, one that is quite clear in my mind. It was clear to me as I descended through the night sky into Charleston, South Carolina, the land below me fields that my foremothers and forefathers planted, harvested, chopped and picked whatever would come from its soil either as sharecroppers or enslaved peoples. The promise I made to myself while descending into the dark of Charleston to visit the McLeod Plantation to give a poetry reading in June 2019 – not to be overwhelmed.

I was there to trouble history, not to be troubled by it. Or, if troubled by history, not to be made an incomprehensible mess by it. If there was any disturbance to be done, any razing, it would be of the former plantation owners moldering in their graves and afterlives by putting my Black body where they never intended it to be – giving a poetry reading on the grounds beneath a canopy of trees, a cotton field that refuses to bear cotton behind me, the white clapboard cabins the former enslaved bunked in to my left, the Georgian-style plantation house with its large white columns and wraparound porch in front of me.

Disturb, disturb the bones, terror and trauma of history. Or at least that's what my host, Katherine, thought we were there to do

and said as much when we sat on rocking chairs on the gray-painted veranda of the big house earlier that Sunday afternoon awaiting our tour of the grounds – the gin house, the dairy building, the cabins, the carriage house. She remarked how disturbed the last owner, Mr McLeod, would have been to have a White woman and a Black man leisurely sitting on his porch on a Sunday afternoon. In front of me, I saw it – the whole scene, all of the former owners of the plantation, standing there, silently staring at us, angry at our consorting in this fashion on a Sunday, the Lord's Day, no less. It made me smile, and I rocked a little harder in my chair, leaning farther back in it as if trying to relax into the thought of it, into the perturbance and all those angry faces in their bonnets and long white linen Regency dresses and one-tail frock coats and ruffle-collared dress shirts and riding boots and whalebone corsets and petticoats and deep, deep chagrins and rage, rage in their small eyes, all of them watching us.

But then the wind. The wind began to pick up and drove the dirt from what was once a cotton field into my eyes, and the clouds gathering overhead seemed to be trembling toward rain, and our guide, Shawn Halifax, came out of the big house and ushered us into its interior, as if to say we will start here.

I don't remember much about the plantation house other than the second floor was off limits, and the first floor had these large rooms that smelled like the old colonial homes that I had entered and visited as a child growing up in southern New Jersey. Like South Carolina, New Jersey is one of the original thirteen colonies of North America, and, often, the towns and boroughs are older than the nation itself, so one gets used to going into old homes that are now libraries and historic monuments to observe some obscure bit of early American history on field trips in grade school. Or to visit a friend's family who now lives in one-half of an old house originally built in the eighteenth century. Or the local library in Mount Holly, New Jersey, once the Langstaff family mansion, now a library with a hedgerow labyrinth behind it that my sister and I would wander through during the summer after checking out library books. The books in plastic

bags banging at our sides, we ran through the tall, green corridors of the maze. The traffic outside the labyrinth inaudible from within; so inaudible that you felt as if you might truly disappear and possibly never be found. Even the birds, the sound of the birds in the trees that overhung the labyrinth seemed never to make it down into its corridors, which unnerved my sister. I would always have to backtrack to find her, hiding somewhere in the labyrinth refusing to move.

We moved through the big house, and I kept drifting, drifting back to New Jersey, where I thought of a friend's house in my hometown, a house formerly owned by Quakers through the eighteenth and nineteenth century, a house that once harbored part of the Underground Railroad in its basement. The smell of that place was the smell of the McLeod Plantation. I know it was the wood, humidity in the air and age of the house, but I couldn't help but think of termites gnawing at the bones and boards of the house and the Black people walking on top of those old bones or huddled beneath them, underneath the work of the termites.

Something about the big house seemed like smoke, or it existed as smoke, as something disappearing, something which was not there though whenever I stepped in it was firmly and treacherously there. While touring the house I kept looking out of the windows to see where we were in relationship to the cotton field, to the clapboard cabins, to the gin house.

It was the gin house that I had been meaning to get back to, the brick and chicken wire, the darkness, the old beams holding it all up at the bottom of a short hill. Though I was receiving my official tour on the day of my reading, I had been to the plantation the day before, walking the grounds with Katherine, my host, who thought that I might want my own time at the plantation and the unmarked graveyard across the street. She was right. I wanted my own time there, to map and mark my own course across the grounds, to wander and see and touch and stay. Stay with whatever and whoever might call me. And, it was the gin house that called me, and no matter where I wandered, I always returned to it, to this small detail among the

brick and chicken wire and darkness. A child's fingerprint. A child's fingerprint in the brick.

At the McLeod Plantation during slavery, children who were not yet old enough to work the fields, or in the carriage house with the horses, or in the plantation house as servants, were put to work turning over hot bricks to dry after they had come out of the kiln or pulling them out of their molds before they went into the kiln. I imagine the children, in their potato-sack and burlap-bag clothing (if any clothing at all) clambering and climbing over, up and down rows of brick sitting in the sun, the brick hot against the tips of their fingers, the children moving, moving over the brick and the heat from it burning the pads of their feet, their wrists and fingertips. Or, did they fashion themselves a glove, some sort of mitt to help staunch and rebuff the heat?

I shouldn't do that. The evidence – their fingerprints in the brick – shows they used their bare hands. And, with my bare hands, I wanted to lay my finger in the indentation left in the brick, but should I? All weekend, I returned to the same brick and stared – the gin house that once held all of the harvested cotton from the plantation was reduced to this one brick for me. You might think my hesitation unnecessary, even overly cautious, but hear me out. My hemming and hawing at touching the brick had less to do with the preservation of the physical structure of the gin house, less to do with whether the oils of my hand, my finger, would bring about the rotting or degradation of the brick as material. My hemming and hawing had everything to do with the limits of empathy, catharsis, historical reckoning and the ease with which we think we salve the open wounds of history and the ongoing catastrophe of racism and discrimination in America with personal epiphany and gesture, with tears and the gnashing of teeth. And besides, I had made the promise to myself not to be overwhelmed.

If I allowed myself to be overwhelmed, what would I be missing? What might my focusing on my own tears and heaving, my inconsolability obscure? In other words, how might I miss seeing

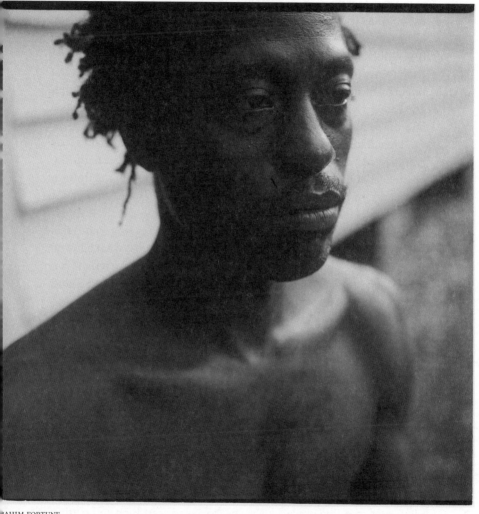

RAHIM FORTUNE
Portrait of Roger Reeves, South Carolina, 2021

the child whose hand had to turn this brick, this child who was not supposed to be seen or remembered; or, if remembered, remembered in the way that property is remembered, as another line in a ledger, as useful or as useless as a shovel or a hairbrush, as something outside of history? How might my focusing on my inconsolability replace this child's absence in this neat body-swapping, which brings me back to my hemming and hawing, my desire to touch the brick, the fingerprint in it. What would sliding my finger into the indentation erase, overwrite, make opaque? What is gained in putting my hand into this lacuna of history?

The child does not move closer to me if I touch the brick. Their ambitions, their love or disdain for corn, for syrup, for the night sky or the feel of their mother touching their brow are lost in the flotsam of history, of genocide. It is unrecoverable. And, as an American, I must reckon with this absence without seeking to escape it through the catharsis of weeping, through merely placing my finger into this hollow in the brick. Because my finger does not address what allowed the brick to be made, does not address that this brick (which is a synecdoche for a certain form of structural inequality and labor and death) still holds up a gin house, still holds up the fraudulent and disingenuous storehouses of American wealth. Our collective fingers pushed into the fingerprint of the child, our photographing of it, our placing our head against this wailing wall, our own wailing does not tear down the walls of this house.

Nothing easy. Nothing without work. Which is what I was at McLeod to do – to work, to trouble history, which is quite un-American. We Americans like to leave our history like we treat our garbage – thrown down a chute into some invisible darkness or left at the curb to be carried off by men and women who wave at our children from behind beatific smiles while standing on the thinnest of platforms, standing precariously close to a blade crushing and cutting our sweltering and stinking waste, the trash truck's maul churning, churning our garbage as it moves off and out into the distance.

And we go back into the house; we move on. 'Move on' is what this country wants Black folks to do. Touch the old wounds, the old brick, cry a little if you must, and shut up about it.

But the old wounds are not so old. They have not been closed or dressed. In fact, some of the old wounds, most of the old wounds, are raked and pressed and torn at again and again with the reinvention and renovation of the old lash. Though our children are no longer on plantations, turning over hot brick, they are still being deracinated and forced to bear unspeakable acts that call back to and echo the disciplinary technologies of slavery. In Arkansas, a White schoolteacher recently forced her Black kindergarten student to clean a toilet stained and drenched with feces with his bare hands. Slave breakers and masters often forced enslaved people to drink urine and eat excrement as ways of subduing and subjugating them. I do not recount these horrors to be salacious or to muck about in spectacle but to exemplify that the disciplinary acts that have been used historically to make slaves have been recalibrated and reinstituted in our public schools, which are responsible for making citizens. What is that teacher making in that moment? What is she teaching us about the nation and what we love and whose children must be subdued and who does the subduing?

The Black child in Arkansas in 2021, the children on the McLeod Plantation in the eighteenth and nineteenth centuries, worlds apart, face, faced annihilation, and here I am bringing my mouth and hand to it. Something in me wants to touch all of this despite what I know or think I know about the irreconcilability of touching the brick, despite my potential touch making nothing happen, despite my oath not to be overwhelmed, not to put my body in the way of history and its lacunae.

Despite my oath, I touch the brick. I touch the fingerprints. I photograph them, but I know I've done nothing in the touching. I've reconciled nothing. There's no relief in the touching, only the sense that I've transgressed my oath to myself, but the transgression is necessary because I affirm that yes, I'm alive. I am more than a mind,

more than a reckoning, more than a lofty principle that evacuates and voids the body of its sentience. I touch the fingerprint because I am trying to get beyond the imposed limits of my Black life. Which is to say I'm trying to get to life and that more abundantly. A life beyond what history can imagine. A life beyond the gates and brick and lash, where the velocity of the dead's ambition is in the wind – is the wind.

The tour of the plantation, my memory of it, is slipping from me. I remember standing at the carriage house with Shawn and Katherine discussing what we would do if it rained and the poetry reading could not be held outdoors at the edge of the cotton field. However, I don't remember anything about the carriage house, its function, its history, the significance of it in the everyday life of the plantation. I was still distracted, not only by the child's fingerprint in the brick but also by the story of the plantation and enslaved folks who resided in the small white clapboard cabins at the edge of it at the end of the Civil War.

Here's the story as it was told to me. The Union Army established themselves on James Island, a tidal island separated from downtown Charleston by the Ashley River, at a far edge known now as Folly Beach Word, somehow, made it to the enslaved folks on the McLeod Plantation that if they could reach the Union Army stationed on that beach then they would be free. But they had to journey tens of miles of woods and wetlands infested with Confederate troops and encampments to get there. A group of enslaved Black folks ranging in age from ten months to eighty years struck out into the forest and swamp at the edge of the plantation at night. Somehow, they made it undetected through the woods, to the beach, to this New World or at least their version of it.

Since hearing of their flight, their journey out of slavery through the pines and stinging insects, into the marshes and wetlands, I imagined or tried to, at least, imagine what that flight must have felt like, moving off a plantation that you possibly have never left before, walking toward the Atlantic, then coming upon that big body of

water. A body of water that you possibly crossed a few years before in the hold of a ship in shackles. Now, ironically, you must walk back toward it to gain your freedom. And, if you haven't crossed it before, surely you have heard of it, maybe learned of it, of torturous trips across this abyss. Or, maybe you haven't. Maybe, the water lapping against the shore and rolling out to more water is your first glimpse of freedom. To see out onto the water, out onto its largeness must have felt simultaneously like an apocalypse and an act of creation. I can't help but think of moments like this as radical imagining. These folks walking off that plantation had to imagine into several abysses. The abyss of the woods, the abyss of the water, the possibility of capture, disappearance, liberation. Abyss, abyss, abyss. Moving out into those many abysses required what the old parishioners in the Pentecostal Church I grew up in called 'stepping out on faith', which is a kind of art and artistic practice. 'Stepping out on faith' is the practice of inhabiting the invisible, moving off feeling and sound, negotiating the future not by sight but by touch even if what must be touched has not yet arrived. This might not make sense, but you might have to expand what you know of sense – what it is to feel, what it is to come to something, to come to something like freedom – to touch what can and cannot be felt. This feeling for the future is a matter of art, the art of self-making, of fashion and fashioning a life in bondage and a life out of it. This is not just the King having no clothes on, and strutting down the street in his birthday suit, this is the people rejecting the King's story altogether, taking to the woods with what they can carry in their hands and building their own thing, their own sound, their own story, sewing their own clothes. The 'it' here is freedom – the making and inhabiting of it. Allow the King to bear whatever suit – real or imagined – he wants, without a gawking or judgmental eye because the people are no longer concerned with the kingdom. They have left for the future, stepping out into the abyss.

'Stepping out on faith', stepping out into the abyss of escape is about occupying a nonexistent form and turning that into fact.

In the case of the enslaved on the McLeod Plantation, the fact was freedom; the form – that it existed, in the middle of the catastrophe of slavery. I can't help but think of Frederick Douglass who wrote in *Narrative of the Life of Frederick Douglass, an American Slave*, his first slave narrative, that after fighting back and whipping the slave breaker Edward Covey that 'however long I might remain a slave in form, the day had passed forever when I could be a slave in fact'. Douglass understood that freedom did not exist in some amorphous future but could be occupied in the middle of his enslavement. And occupying that freedom required a willingness to do the unthinkable, the ungovernable – to step into the sublime – to fight. I would caution us not to sequester fighting to only the realm of pugilism and combat. Fighting can take a whole host of forms. And running away, stealing away, which is a type of silence, is one.

Where was I? Shawn, Katherine and I were somewhere in one of the white, clapboard slave cabins lining the drive that dead-ends at the big house. The cabins, in their quietness and vacancy, reminded me of mourners, their head bowed, as if to offer a counterargument to the line of trees arching over them leading toward the picturesque plantation house with its stately columns. It was as if in the cabins' hush they were whispering, 'don't be fooled by this constructed beauty. What lies ahead, that big house, isn't beauty. It is actually the absence of beauty.' Or as if the quietness, the curated dilapidation were saying something about what it takes to build a big house and a plantation – amnesia, moral decrepitude and death.

Regardless, I was somewhere inside one of the cabins. An outline of a cross was high on what I would call the front wall of the cabin, a wall where a pot-bellied stove might have stood. Stenciled along the other walls were scripture, passages from the King James version of the Bible, but the sun had faded the passages so that they were difficult to read. I squinted and tried. Shawn explained to Katherine and me that this particular cabin used to be a church; that, in fact, the descendants of those enslaved on the plantation had lived in the cabins – the slave cabins – into the 1990s. I was – and am – stunned by this fact, and

shouldn't be. That Black folks lived, married, loved, raised children, prayed, worried in these cabins in some form or fashion through the Civil War into the twentieth century up to Jim Crow and past Jim Crow and the Civil Rights movement and the Berlin Wall falling. They lived in these cabins during the assassinations of Patrice Lumumba, Malcolm X and Martin Luther King. They lived in these cabins well into the first Bush administration, the LA Riots, the first Gulf War, the beginning of the tech boom. These cabins not much bigger than two walk-in closets at best. These cabins with no electricity or running water. These cabins Black folks rented – rented! – in hopes of buying from the descendants of their former masters, working the same land as sharecroppers that their ancestors worked as enslaved. They had to pay for the pleasure of this.

I was overwhelmed but trying not to show it. I was trying to make it through the tour without breaking down there in the dark heat of that cabin, but the day, the heat, the history started to press against me; was all moving inside me, fraying me, and it wanted out. Or, at least, wanted me to register it, touch it, without some hard-to-articulate principle guiding me through the flotsam and jetsam of it. And, I wondered if it was time to relinquish the promise that I made myself – not to be overwhelmed – while taxiing on that dark runway, whether it was a worthwhile promise at all. Should the promise be scrapped? Or, had it offered me a reprieve, a moment to sit in the complexity and largeness of something like three hundred years of Black people forced to work and love and make do on a piece of land? Had my promise allowed me to contend with the ongoingness of that catastrophe, an ongoingness that was still there in the cabins?

Yes, laudable to want to face history without centering the self, to allow the past its full body without obscuring it with my own, but my body couldn't be ignored because my body was sign of the ongoing and uninterrupted phenomenon of Black folks trying to make life in and despite America – sign in the sense that we never stopped making family, never stopped making song and sound and moaned and thought and read and ran, even when we were told not to. We

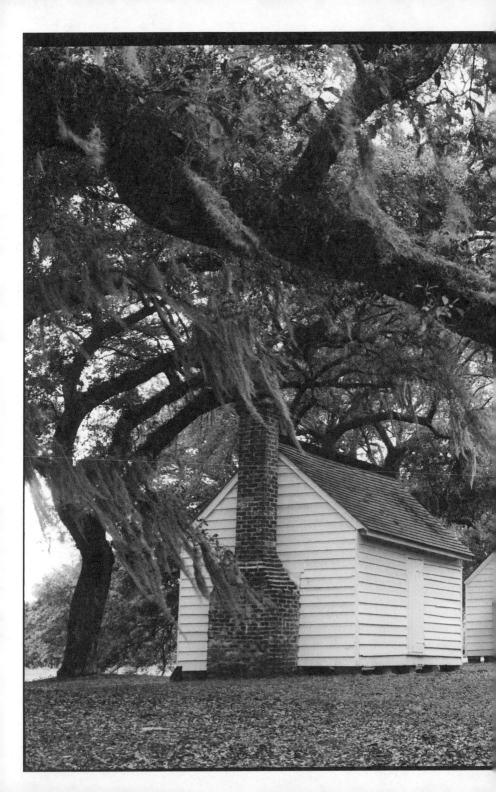

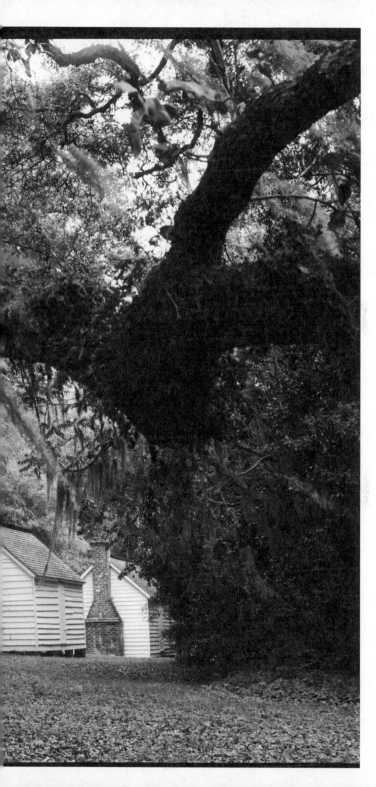

RAHIM FORTUNE
Quarters for enslaved
people on the McLeod
Plantation, South
Carolina, 2021

compelled ourselves toward life and that more abundantly despite the plantation and prisons, slave patrols and vagrancy laws, Black Codes and cabaret licenses and redlining and apartheid and the police and counterintelligence programs and the FBI surveilling our writers, artists and movement makers and Tuskegee Experiments and sterilization programs aimed at Black women and their uteruses and reproductive rights and Moynihan Reports and bombings of Black churches and the bombings of private Black citizens by city governments and restrictive covenants and telling us we can't wear our hair how we want and the disbelief, the constant disbelief that we are unable to breathe.

I was able to make it out, make it outside the cabins without breaking down. The clouds overhead roiled and pitched, covering everything in gray. I looked out onto the cotton field for a moment of relief, for something other than the heaviness of that dark. The wind slunk across the field tossing up wisps of dirt. And my mind, like my eyes, drifted into the woods just beyond the edge of the field, and I was thinking again of those enslaved folks journeying away from the plantation out to the shoreline at the end of James Island. Had they looked back at what they were leaving – the cabins, the field of cotton, the plantation house? Or had they run into the pines, concerned only with what was out in front of them? Did any of the children whose fingerprints were in the bricks of the gin house go with them? I imagined some looked back and some didn't. But if they left at night, what would they have to look back upon? Then, I remembered – no, not remembered, I was not there so I can't remember – more so realized – realized in a way that feels closer to memory than epiphany – I realized that some had to leave something behind – a child, a mother, a favorite tree, a memory – something that could no longer be touched. I wasn't overwhelmed with this thought as much as I was full with it, standing there in the door of that cabin, looking out into that cotton field that refused to bear cotton.

I thought I had made it through the gauntlet of history and terrible feelings and come out on the other side, a little weary, ruffled

and singed but nevertheless whole. The white chairs for the poetry reading sat in neat rows beneath the canopy of trees next to the cotton field. The sky had decided to hold on to its rain, and I was turning my mind toward what poems I would read that would be in conversation with the landscape and the history of the plantation. Maybe a poem about Emmett Till's body coming to rest next to a dead horse in Money, Mississippi. Or a poem about running through Austin, Texas, being followed by a White man who decided to yell 'nigger' at me.

But history was not through with me. And neither was the tour. Shawn motioned for me to follow him to the back of the cabins. We stepped through the unevenness of the underbrush and stood there in this little copse of trees, our feet entangled in some sort of creeping vine, kudzu perhaps. Around us, the ground undulated in what looked like little burial mounds, kudzu completely covering the little hillocks. I asked, what was this. It felt as if Shawn had brought me to something that was not on the official tour. It felt as if we had stepped into a broom closet or crawled into an attic, into the rafters of some great hall and were touching the bones of something, the bones of God perhaps, the bones of something that was never to be touched.

When the city decided to turn the plantation into a historical site, according to Shawn, they emptied the cabins. Tossed everything out. Mattresses, clothes collected by the church for charity, hymnals, Bibles – anything left in the cabins by the descendants of those that once sharecropped, worked and were enslaved on this land was beneath our feet. It was all beneath our feet.

I don't remember if I turned away from Shawn, but I do remember crying, walking out of the trees, walking back toward the cotton field and watching the wind blowing over it. Everything was present, too present – the child's fingerprint in the brick, the big house, the enslaved running away from the plantation to the edge of the world, the old church in the cabins, the little death mounds of discarded clothes. I wanted to bear it all without being overwhelmed, without crying, but I couldn't. It was silly of me to think I could.

My tears were not merely my version of a belated elegy for the folks

that lived and worked and died on the plantation. I was in awe at Black folks' imperishability. That despite the several hundred years' attempt to alienate and divorce Black people from their bodies, from creating loving and meaningful bonds with each other, despite the nation's many attempts to extinguish Black folks' desire for freedom, for touch, for intimacy, for nearness, Black people consistently and constantly slipped that yoke, troubled their trouble until it yielded something else. In the middle of disaster, we made the unimaginable – joy. Political will. Mutual aid societies. Churches. Women's leagues. College funds. Clubs from Nowhere. Fraternal orders. Panthers. Deacons for Defense. Washing machines. Vacuums. The Blues. Jazz. Rock and Roll. The Stanky Leg. Funk. Dat Dere. And Dis Here. If there's anything worth doing in America, it was because some Negro got near it and touched it – put their shoulder, mouth and mind to it.

We troubled history even as history troubled us, even as history wanted to keep us outside of it. This, this, this was all in front of me, touching me, moving through me. It was in the wind and beneath the wind moving over the cotton field that refused to bear cotton.

There beneath the umbrella-ing oaks, I wept and watched the wind warp and bend across and over the nonexistent rows of cotton as if the wind were remembering the bodies that once stooped over in this field, separating boll from white, shoving it all down in a croker sack before drifting to the next boll and repeating. It was as if the memory of the workers was still there in the thick marsh air. Or was it their presence, the spirit of the formerly enslaved, the trace of their physical selves tethered to the land, to the landscape, even after their deaths. Or was it the motion of their work haunting the present? What was making itself known? I couldn't tell. All I could do was feel full and cry and watch the wind work over the dirt, the dirt lifting into plumes of what I was sure was memory shattering in the air as the wind raised it, raised it from the earth.

What was I facing? What was I witnessing? And who was I, not known for visions, to see what it was that I was seeing? I had a sudden impulse to record the wind – not the sound of it but its motion, the

dirt kicking up in the field. I wanted to make a short film, wanted others to see the wind moving over the shoulders, hands, backs and faces of the formerly enslaved, wanted others to feel and see this history, in these almost invisible gestures made by the wind. In this way, I wanted companions, co-conspirators, a record of this history because the wind was acting as history, making known the lives of men, women and children who may have been no more than a line in a ledger; the wind remembering the arch and curve of their backs, the angle of their bending; the wind acted as an archive of the dead's ambitions – was the dead's ambitions. Something about witnessing the wind in this field felt liberating. The air moving, moved because of the dead. I was beyond science and scientific explanation of the wind – the uneven heating of the earth by the sun and the earth's rotation causing air to move. The wind was under the auspices of a different science, a science that bears its fact and truth not through observable data only but through movement felt along the skin, the dead's presence still in a field long after they are no longer in the field. The dead walking and working in the air, walking with me, wanting me to know they were still there, are still here – alive and living. Working. Working after death, working the day beyond their coerced labor. Working life into me, into us despite the trials and tribulations at every city council and school board meeting and legislative session, despite the surveillance of our communities by the police, despite . . . despite . . . despite . . . The dead are in the field toiling with us.

But then came doubt: would this be enough? Would a film about wind carry, would it matter to Black folks that are facing voter disenfranchisement in Georgia, police brutality in Texas and Minnesota and all over this vast land, gentrification in Charleston along the Gullah Rivera? Would looking out into a field, looking out on what might or might not be moving, would that matter? What is the place of opacity in art that seeks to plumb the long and difficult history of the erasure of Black folks in this country? Born in 1980 and therefore a grandchild of the Black Arts and Power Movement, a child reared on vinyl records of Malcolm X's and Martin Luther

RAHIM FORTUNE
'The Oak Avenues' on
the McLeod Plantation,
South Carolina, 2021

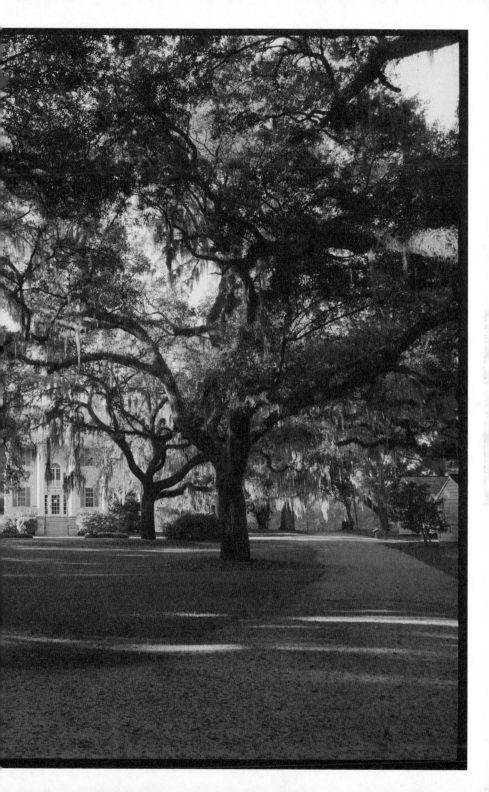

King's speeches playing on a wooden console that sat beneath the large picture glass window, a place of honor, in my grandmother's living room, I worry about the efficacy of what might be called abstraction, making a film that does not explicitly answer the call of what Black Power scholar and artist Larry Neal defined as one of the central concerns of Black art and artists – 'to speak to the spiritual and cultural needs of Black people'.

But the field is – it is speaking to the spiritual and cultural needs of Black people, but it's not doing so explicitly but implicitly, imaginatively one might say; another might say spiritually. The field's refusal to bear cotton is not merely symbolic. The field is offering us a type of vision, a pronouncement of the future. It is as if the earth is reading history, reading the history of the land and oppression that has transpired upon it, and has decided to quit, to go on strike. The earth, there, is reading the gentrification of the Gullah and the sea islands off the coast of Georgia and South Carolina, reading the problem of run-off water from development projects in the area, and it is saying 'no más'. No more. No more. It is as if the cotton field in Charleston anticipated the coronavirus pandemic, the world shutting down, and now is asking us: what should we refuse, what should we break, what should no longer work?

How ironic is it that the crop that ushered America into the world economy will no longer grow in this American field. It is as if the field anticipates America slipping from the pedestal of world power. I can't help but think of Martin Luther King's fear that he was 'integrating his people into a burning house' because of the US's commitment to injustice, violence, and oppression not just at home but abroad as well. Maybe, this field is also articulating the burning-house-ness of America. An America in decline. A fallow America.

There is something in this field, in watching the wind move in it. And being moved by it. It offers us a type of imagining, a way of seeing, of knowing which reminds me of the poetic (the poem, the lyric) – something simultaneously tied to the past yet free of it. A renouncement that is also an enactment. An ending that is also a

beginning. Just like the lyric poem, the field does not submit itself to narrative and its attendant discourses of time, which is unfortunately how we've come to understand change, particularly political change. Everyone wants a narrative – beginning, middle and triumphant end; some happy future that derives from this ignominious present. But what if history is a lyric? What if the freedom you seek can't be narrated in some linear or teleological fashion? What if this field, the watching of it offers us the space – both literal and meditative – to steal away, plan, study? What if in the watching, our minds drift, and we find some answer to how to get medicine to our sick family? What if we drift and the field brings us back to some incident of pain, of sorrow that we have yet to reckon with? What if our freedom, some instantiation of it, some idea of it, is in watching wind move over a field?

A nd, there in the wind, in the dirt, the memory of the dead moving off into the pines behind the field. There is no definitive narrative to escaping, to freedom. It is – only is. ∎

RAHIM FORTUNE
Folly Island, South
Carolina, 2021

CONTRIBUTORS

André Alexis was born in Trinidad and grew up in Canada. His novel *Days by Moonlight* won the Rogers Writers' Trust Fiction Prize, and *Fifteen Dogs* won the Scotiabank Giller Prize, CBC Canada Reads and the Rogers Writers' Trust Fiction Prize. His other books include *Asylum, Pastoral, The Hidden Keys*, and *The Night Piece: Collected Stories*. He is the recipient of a Windham Campbell Prize. His most recent novel is *Ring*.

Raymond Antrobus is the author of the poetry collections *To Sweeten Bitter, The Perseverance* and *All The Names Given*. He also hosted *Inventions in Sound* for BBC Radio 4 and *Recaptive Number 11,407* for BBC World Service. He is a fellow of the Royal Society of Literature and his poems are part of the UK's GCSE syllabus.

Marina Benjamin's books include the memoirs *The Middlepause* and *Insomnia*. She has written for the *Guardian*, the *Paris Review*, the *New York Times* and *Aeon*, where she works as a senior editor. Her latest memoir, *A Little Give*, is forthcoming in 2023, and will complete her midlife trilogy.

Chanelle Benz has published work in the *New York Times, Guernica, Electric Literature* and the *O. Henry Prize Stories*. Her novel *The Gone Dead* was a *New York Times Book Review* Editor's Choice. Her story collection *The Man Who Shot Out My Eye Is Dead* was shortlisted for the 2018 Saroyan Prize.

Annie Ernaux published her first novel in 1974 and has since written more than twenty books, including *Simple Passion, The Years* and *A Girl's Story*. In 2022 she was awarded the Nobel Prize in Literature. 'Hôtel Casanova' is an excerpt from Ernaux's book *Hôtel Casanova et autres textes brefs*, published by Editions Gallimard.

Richard Eyre has directed in theatre, opera, television and film. He was Artistic Director of the National Theatre from 1988 to 1997. He has written several stage adaptations and books including *National Service*, a diary of his time at the National Theatre and *What Do I Know?*, a collection of essays.

Des Fitzgerald teaches medical humanities at the University of Exeter. His first book, a critique of urban nature, will be published in 2023. He is currently working on a memoir project.

Carlos Fonseca was born in Costa Rica, but spent his teenage years in Puerto Rico. He is the author of the novels *Colonel Lágrimas* and *Natural History*, both translated into English by Megan McDowell. He teaches at Trinity College, Cambridge University. 'This Is as Far as We Come' is an extract from his novel *Austral* forthcoming in 2023 from MacLehose Press in the UK and Farrar, Straus & Giroux in the US.

Peter Gizzi's recent books include *Now It's Dark, Sky Burial: New and Selected Poems* and *Archeophonics*. A new book, *Fierce Elegy*, is forthcoming in 2023.

Caspar Henderson is a journalist and an editor. He has contributed to BBC Radio 4, the *Financial Times*, the *Guardian, Nature, New Scientist* and *openDemocracy*. His debut, *The Book of Barely Imagined Beings*, won the Roger Deakin Award of the Society of Authors and the Jerwood Award of the Royal Society of Literature. *A New Map of Wonders* was published in 2017.

Maylis de Kerangal spent her childhood in Le Havre, France. Her fifth novel, *Mend the Living*, was longlisted for the Man Booker International Prize in 2016, and won the Wellcome Book Prize in 2017. 'A Light Bird' is a chapter from her book *Canoes*, first published by Editions Verticales (Gallimard) in 2021 and forthcoming in English translation in 2023 by MacLehose Press in the UK and Talon Books in Canada.

Amitava Kumar is a writer and journalist who has published several works of non-fiction and three novels. His most recent title is *The Blue Book*. Kumar's writing has appeared in the *New York Times, Harper's, Guernica*, the *Nation* and several other publications. He has been awarded a Guggenheim Fellowship and residencies from Yaddo, MacDowell and the Lannan Foundation.

Emily LaBarge is a Canadian writer based in London. She has written for *Artforum, Bookforum*, the *London Review of Books*, the *Paris Review* and *4Columns*, among other publications. *Dog Days* will be published by Peninsula Press in 2024.

Catherine Lacey is the author of four books: *Nobody Is Ever Missing, The Answers, Certain American States* and *Pew*. She is a *Granta* Best of Young American Novelist, a Guggenheim Fellow and the winner of the 2021 New York Public Library's Young Lions Fiction Award. 'Biography of X' is an extract from her novel of the same title, forthcoming in 2023 from Granta Books in the UK and Farrar, Straus & Giroux in the US.

Kalpesh Lathigra is a photographer who was born in London. In 2000 he was awarded first prize in the arts section of World Press Photo. In 2003, he received a W. Eugene Smith grant and a Churchill Fellowship for a project documenting the lives of widows in India. His first book, *Lost in the Wilderness*, on the Lakota Sioux and Pine Ridge Reservation, was published in 2015.

Megan McDowell is the recipient of a 2020 Award in Literature from the American Academy of Arts and Letters, among other awards, and has been short- or longlisted four times for the International Booker Prize. Her most recent translated book is *Our Share of Night* by Mariana Enríquez. She lives in Santiago, Chile.

Michael Moritz is a partner at Sequoia Capital, which he joined in 1986. He is the author of several books including *Return to the Little Kingdom*, the first major book about Apple, and more recently *Leading* with Sir Alex Ferguson.

TaraShea Nesbit is an American novelist and essayist. Her second novel, *Beheld*, was a 2020 *New York Times* Notable Book of the Year. Her first novel, *The Wives of Los Alamos*, was a finalist for the PEN/Robert W. Bingham Prize. Her essays have been featured in the *New York Times*, *Literary Hub*, the *Guardian* and elsewhere.

Cian Oba-Smith is an Irish Nigerian photographer who was born and raised in London. His photographs can be found in publications including the *FT Magazine*, *Time*, *Le Monde*, the *New Yorker*, the *Guardian* and others. In 2020 his work won a Portrait of Humanity award, and in 2022 his work was selected for the Taylor Wessing Photographic Portrait Prize.

Roger Reeves is the author of *King Me* and *Best Barbarian* and the recipient of a National Endowment for the Arts Fellowship, a Ruth Lilly and Dorothy Sargent Rosenberg Fellowship from the Poetry Foundation and a 2015 Whiting Award, among other honors. His work has appeared in *Poetry*, the *New Yorker*, the *Paris Review* and elsewhere. *Best Barbarian* was a 2022 National Book Award finalist in poetry. He lives in Austin, Texas.

Aaron Schuman is an American photographer, writer, curator and educator based in the UK. He is the author of three monographs: *Sonata*, *Slant* and *Folk*. He is Associate Professor of Photography and Visual Culture at the University of the West of England (UWE Bristol).

Xiao Yue Shan is a poet living on Vancouver Island. *How Often I Have Chosen Love* was published in 2019. *Then Telling Be the Antidote* will be published in 2023.

Alison L. Strayer is a Canadian writer and translator. Her work has been shortlisted for the Governor General's Award, for literature and for translation, and for the Grand Prix du Livre de Montréal. Her translation of Annie Ernaux's *The Years* won the 2018 Translation Prize in the non-fiction category from the French–American Foundation and the 2019 Warwick Prize for Women in Translation. It was shortlisted the same year for the Man Booker International Prize. She lives in Paris.

Gary Younge is an author, broadcaster, Type Media Fellow and Professor of Sociology at the University of Manchester. His most recent book is *Another Day in the Death of America*.